CW0656264

I AM OF KERRY

I am of
Kerry

VALERIE O'SULLIVAN

CURRACH
PRESS

First published in 2003 by
CURRACH PRESS
55A Spruce Avenue, Stillorgan Industrial Park, Blackrock, Co Dublin

www.currach.ie

Cover by Bluett
The front cover photograph is of Jim and Gavin McCarthy.
The back cover photograph is of the Great Blasket Island, © Valerie O'Sullivan.
Author photograph by Michelle Cooper-Galvin. Killarney
Origination by Currach Press
Printed in Ireland by Betaprint, Dublin

ISBN 1-85607-901-5

Acknowledgements

The author would like to thank the following people:
Brian Lynch of Currach Press; Vera O'Leary and staff of the Kerry Rape and Sexual Abuse Centre, Tralee; Pat Moore, Irremore (Upper); Mickey Ned O'Sullivan, Kenmare; Patrick O'Donoghue and Staff, INEC Centre, Killarney; Mary O'Connor, Derrynane Hotel, Cahirdaniel; Jacquie O'Sullivan, Killarney; Paula Murphy, Listowel; Oonagh O'Connor, Killarney; Elaine O'Donovan, Killarney; Moira Murrell, Killarney; Riona Mac Monagle, Beaufort; Hanna Majella Moynihan, Killarney; Joe Murphy, St John's Theatre, Listowel; Jim Twomey, Tralee; Brendan Landy, Listowel; Ciaran Walsh, Siamsa Tíre, Tralee; Barry Murphy, Murphy Print; Tim and Elaine Hartnett, Moriarty's One Hour Photo, Killarney; Jim McCarthy, Annascaul; Kathleen Browne, Kerry County Library; Louis Mulcahy, Dingle; FEXCO Ireland, Killorglin.

A big thank you to all of the contributors who gave so generously of their time to put together their contribution to this anthology. It will always be appreciated.

The publisher and author gratefully acknowledge the following permissions to use copyright material:
Tom Cournane, Cahirciveen for *The Military Funeral of Martin Curnane RIP to Holy Cross, Sunday 24 September 1995*; Mercier Press for 'Jim the Rubbish Man' from *A Place too Small for Secrets* by Paddy Kennelly; Bloodaxe for 'A Motion' from *The Book of Judas: A Poem* by Brendan Kennelly; and Lilliput Press for the quotation from *Turtle Was Gone a Long Time: Volume One* by John Moriarty.

All rights reserved. No part of this book may be reproduced or transmitted in any form or by any means, electronic or manual, including photocopy, recording or any information storage and retrieval system, without permission in writing from the publisher. The moral rights of the author has been asserted.

The royalties from the sale of *I am of Kerry* will be donated to the Kerry Rape and Sexual Abuse Centre, Tralee.
Further donations to the Centre can be made to the following account: 62512100 sort code 936391, AIB, Castle St, Tralee. Co Kerry.

Copyright © 2003, Valerie O'Sullivan

Contributors

Vera O'Leary

We were taught growing up that pride is one of the seven deadly sins. It is impossible, however, to be other than proud as the Director of the Kerry Rape and Sexual Abuse Centre. I have been here for ten years. It has been a time of challenge, triumph, struggle, sharing, optimism, apprehension and above all, hope. The stories told to us have usually being painful to relate and difficult to listen to. Women and men have come to us and shared their most private thoughts. For me, this has been both humbling and uplifting.

Many people deserve tribute for the development of the service. The staff here have kept me going through their commitment and professionalism. My faith in human nature is maintained by the volunteers who give and give again, and whose enthusiasm inspires me. I have received more from my clients than I have ever given them. They have given me their trust and hope and together we have travelled so many roads. We have taken turns telling each other that the light at the end of the tunnel is not a train coming at us!

On a practical level, the Centre could not survive without the funding and support we receive. The Southern Health Board and the Southern Regional Committee on Violence Against Women deserve our thanks. There are many individuals and groups down through the years that have helped and encouraged us. The generosity of the people of Kerry continues to inspire us.

The reality of abuse is still depressing and real, but the dream goes on that someday, one day, all children, women and men will live in safety. As Patrick Pearse said:
'Wise men riddle me this, what if the dream comes true?'

Vera O'Leary is Director of the Kerry Rape and Sexual Abuse Centre, Tralee. Orginally from Miltown, Co Kerry, she now lives in Killarney. She is a trained nurse and midwife and came to the Kerry Rape and Sexual Abuse Centre in 1992, where she is now Director. She is involved with all aspects of the Centre and according to Vera, 'words cannot really describe the privilege it is to witness the positive change the Centre brings to peoples lives'. She is blessed, she says, 'with a supportive husband, Mike O'Leary, whose passion in life is sport, especially Dr Crokes'. They are the proud parents of two sons, Mark and Michael.

I am of
Kerry

Weeshie Fogarty

Karen kissed her boyfriend Ger goodnight and set off to cycle home to Muckross. Minutes later she lay fatally injured and dying on the road. Mercilessly mown down by a hit-and-run driver. Days later, a man was arrested, and eventually brought to trial and jailed. The senseless brutality of Karen's death was difficult to comprehend for family and friends and near impossible to accept.

My beautiful niece, bubbling, beaming and so full of life whose very presence would light up any gathering. Her passionate love affair with rowing with the Muckross Rowing Club on the Lakes of Killarney, was a huge feature in her life.

It was 12.35am on Sunday 4 August, 1996 when Karen was killed. The following Wednesday she had been due to leave Muckross and complete her apprenticship in confectionary at the Kevin Street Institute of Technology. The deep shock and horror of that awful night and the harrowing days of Karen's funeral will forever remain etched in the memories of all that knew and loved her.

Now, seven years later as her parents Gene and Maureen and their lovely daughters, Ann, Claire and Susan, look back on how they came through that most tragic period of their lives, they attribute it to their faith, religious beliefs, and the support of friends.

Two days after Karen's burial I penned these lines recalling my own favourite memories of her:

Karen

Smiling, laughing, dimpled checks
Vibrant, busy scaling peaks,
Waving, greeting young and old,
Face of beauty still and cold,
Cycling, always on the go,
Music meetings, never no.
Work her favourite, aprons white,
Trays and traffic, what a sight,
Muckross rowing, lakes serene,
Just twenty-one, what might have been,
Time and tide, days too short,
New job waiting, soon to start.

Cycling homewards, traffic speeding,
Father, mother, sisters grieving,
Romance, boyfriend, last goodbyes,
Her moon, her stars, her love-filled eyes.
Void of darkness, hearts so broken,
Special person, love unspoken,
Memories vivid never end,
On waking, sleeping, of time not spent.
Rest above the lakes so loved,
Watch forever from above.
Anger, grief, great confusion,
Friends' tears in huge profusion.
Nights of sadness, days so barren,
Busy laughing, loving Karen.

Aloysious (Weeshie) Fogarty is sports reporter and Gaelic games analyst with Radio Kerry, where he presents the hugely popular live show 'Terrace Talk'. He is a retired nursing officer in St Finan's Psychiatric Hospital, Killarney. A native of Killarney town, he played Gaelic football for Kerry at all levels, and is also a former inter-county referee. Weeshie has served as chairman, secretary and PRO of Legion GAA Club, Killarney. He is married to Joan and they have three children, Denise, Carol Ann and Kieran.

I am of
Kerry

Liam Ó Maonlaí

My involvement with Kerry was immediate. I had been speaking Irish in Dublin over my first four years, experiencing it as a game my father and I would play and then as a part of this school business.

One day we went to Cork, where we picked up my father's sisters and parents. We kept on driving and the next thing I knew, we were in Dún Chaoin and everyone spoke the language. The red-haired girl in Tigh Mallaí thought I was saying *bainne*, when I was in fact saying *beidh* with a Connacht dialect. She was gorgeous and I adjusted to the language of the land.

The Land. My father made a point of sharing with me the name of every hill, field, rock and townland he could. That was a lot, yet only a fraction of what there is. Everywhere there are stories to go with the names. Land came alive for me and it still moves me wherever I go. It is a common thing among all honest cultures to recognise their land and to know her as a being. So as I find myself travelling, I feel an empathy with the Native American way, the Maori way, the Aboriginal way.

To be in Corca Dhuibhne is to be with an unbroken people. All over this island, Éire, the language has been successfully stolen and destroyed on us. Only in the *Gaeltachtaí* can we experience the consciousness of the Gael. 'Big deal,' some say. Life is life. I agree. The land will speak eventually even through a foreign tongue. We have a way of making it our own.

Still, I feel honoured to have been allowed participate in a community of immeasurable depth, subtlety, and humour. These qualities are the children of a language independent of imperial dogma and of the lust for domination. A peoples' language. I believe it links us to the land that feeds us. *Go raibh maith agat a Dhaid as ucht mo chroí, mé a threoiriú go dtín nGráig an Buailtín Dún Chaoin, Baile Eaglaise, an Seantóir, Ceathrú an Fheirtéirigh agus ó Thuaidh!*

Liam Ó Maonlaí was born in Dublin. He is a founder member of the Hothouse Flowers. His musical independence came from 'traditional Irish music which brought me to towns and townlands around the country competing, and more importantly, playing informally with musicians from all four directions of the land'. He enjoys socialising and solitude. He has had a deep connection with Kerry since 1971.

I am of
Kerry

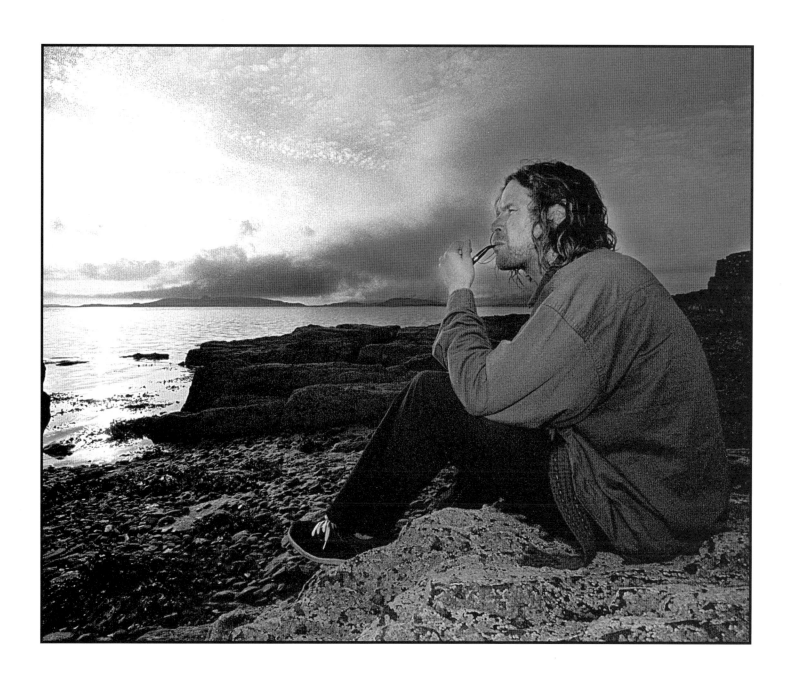

Jim Twomey

Whispers

More than anything flyfishing is about silence. Within this silence I have over time discovered the whispers of my soul and found the truest sense of belonging.

I gather my flyrod, flies, bodywaders, and a few other bits 'n' bobs, but nothing that necessitates a bag and I am away. Living in Kerry means that I never have to travel far to find water and very soon I am standing beside a bubbling stream. At its best it is a warm midsummer evening. Clouds of flies hover under the trees and the smell of meadow sweet fills the air. Before I begin I stand on the bank for a while and watch the stream and try to learn some of its secrets.

When I am ready, I gently I ease my body into the water and let my waltz with nature begin. Lifting my arm I slowly weave the fly above my head, once, maybe twice, guiding it under the trees, eventually allowing it to rest on the stream. Collected by the water it moves along slowly and begins its search. I close my eyes and gently tease the line in my through my hand, measuring it with every finger for the touch of a fish. Sushhhhhhhhh… any moment now, any moment now…

Within this very moment is everything. I am totally at rest and yet alert to every minute passing of time. I am not thinking, not feeling, just suspended in the moment, living in the now. Without ego and without judgement this is what is left. This is who I really am, this is me. Cradled by the water, as innocent as the day I was born, I begin to remember the simple rhythm of it all. The uncomplicated truth of life as it pulses from everything around me and from within me. I am happy here. I feel at home. This is where I was the moment I was born and where I most likely will be at the moment I die. I remember again that living my life from this place, living the truth of who I am is what matters most.

I continue to walk the stream, often fishing well into darkness. Sometimes there are fish and sometimes not. It never seems to matter because when it is time to go I am delivered on the bank of the stream rested, reborn and ready to try again. If I belong to anything. I belong to this.

Jim Twomey was born in Poweraddy Harbour, Cork. He moved to Kerry twelve years ago and now lives in Derrymore with his wife Karen and their three daughters: Molly, Katie and Róisín. Jim is widely respected as both a pioneer and expert in the field of multimedia training and development in Ireland. He has worked extensively as a photographer and a television cameraman and over the last seven years has developed and delivered a national training course in Digital Media with FÁS in Tralee. Having recently returned from shooting a video in Kenya and Tanzania, it is no surprise that apart from his passion for flyfishing, all of Jim's other interests include wild adventure of one kind or another.

I am of
Kerry

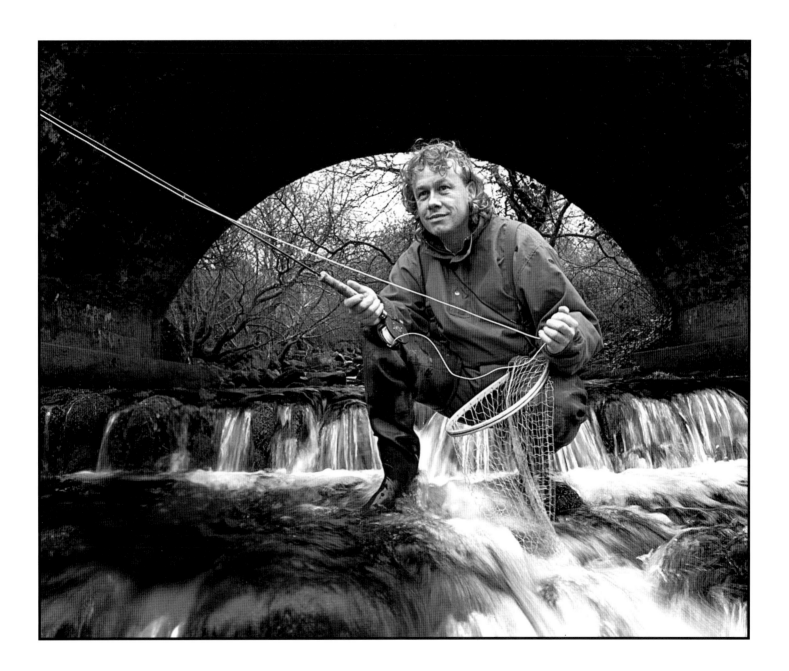

Paddy Kennelly

For most of my adult life I have had close associations with two villages – Ballylongford, where I live, and Asdee where I worked for twenty-nine years as a teacher. Not surprisingly, I have become attached to these places, and have grown to respect and admire their inhabitants. Village community life has some major drawbacks – a tendency towards insularity, a distrust of change, a pressure to conform, to mention but a few. But village life has also many things to recommend it. It fosters a sense of community inter-dependence which, at its best, is a lofty expression of a Christian ideal. It gives one a sense of identity, of belonging, of sharing with one's neighbour, of responsibility to one's fellow-man. George Eliot, the famous English novelist, referred to English villages as 'the places where the English civilised themselves'. Surely it is not an exaggeration to suggest that a similar process has taken place, and continues to take place in our Irish villages.

It is sad to see the economy of these villages undermined. Perhaps this undermining is the inevitable expression of forces that will lead eventually to the death of all villages. But somehow I doubt it. The villagers that I know have a pride and resilience that will surely save them from extinction. It angers me when outsiders, despite, or perhaps because of, their obvious ignorance of village life, are only too ready to adopt an attitude of dismissive condescension, and to consign villages to the dustbin of history. In the past few years, for example, both Ballylongford and Asdee have been the subject of articles written by journalists representing national newspapers. The tone of these articles verged on ridicule; they were distinguished by an overweening condescension, by an attitude which might best be summed up as 'We are superior because we are from Dublin; you are inferior because you live in a village.'

In the following monologue, taken from *A Place Too Small For Secrets*, a book about village life, one villager, Jim The Rubbish Man, replies to those whose blinkered provincialism leads them to view our capital city as the centre of the universe and everywhere else as outposts in space.

Jim The Rubbish Man

Whatever you do, Mac an tSionnaigh,
when ever you write the latest history of
this place
And the story of our closing shops
And our empty classrooms, our deserted
streets,
And our fall from grace
Among the literati who see us now
As superstitious backwoodsmen
Out of step with the times,
Espousing an antiquated religion
In post-Catholic Ireland –
Whatever you do then,
Don't, for the love of God
Go sentimental.

None of your bullshit, please,
About our likes not being seen again.
Where's your Knockorian sense of humour,
man!
So – concede their every argument
About this economic backwater;
Tell 'em that we apologise
For our location on the map,
That we go to our graves
Sorry we're not from Dublin
And that we deeply regret any offence
We caused the sneering journalist
Who foraged here to gather
What might fill a page with mockery.

Don't dare to mention
That bright young men and women
Who, each weekend, return
In jam-packed busloads,
rejecting the enlightened
And politically correct metropolis
for a dose of devilment,
Nor say, wherever men conspire
Around a winter fire
To tell fantastic tales
Of errant wives
Or husbands cuckolded,
Knocklore still lives.

Paddy Kennelly was born in Ballylongford in 1946 and has lived there for most of his life. He worked as a schoolteacher in Dublin for some years before returning to Kerry. Paddy taught in Asdee National School from 1972 to 2001 and retired in October that year. He is the author of the novel *Sausages for Tuesday* and the recently published poetry book *A Place too Small for Secrets*, from which 'Jim the Rubbish Man' is selected. He is married to Kathleen and they have four children, Mary, Alan, John and Maebh, and grandchildren Ryan and Colm.

I am of
Kerry

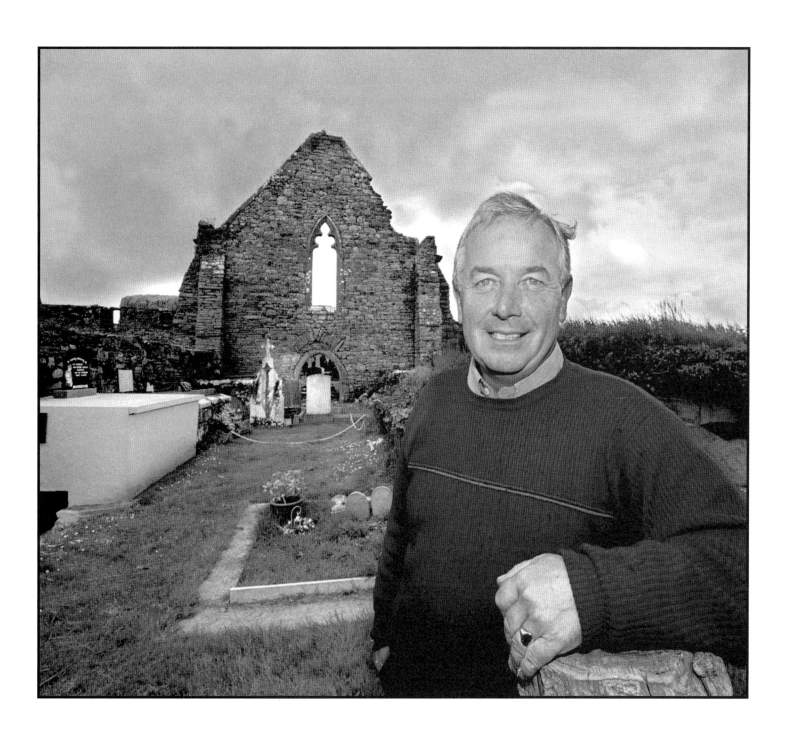

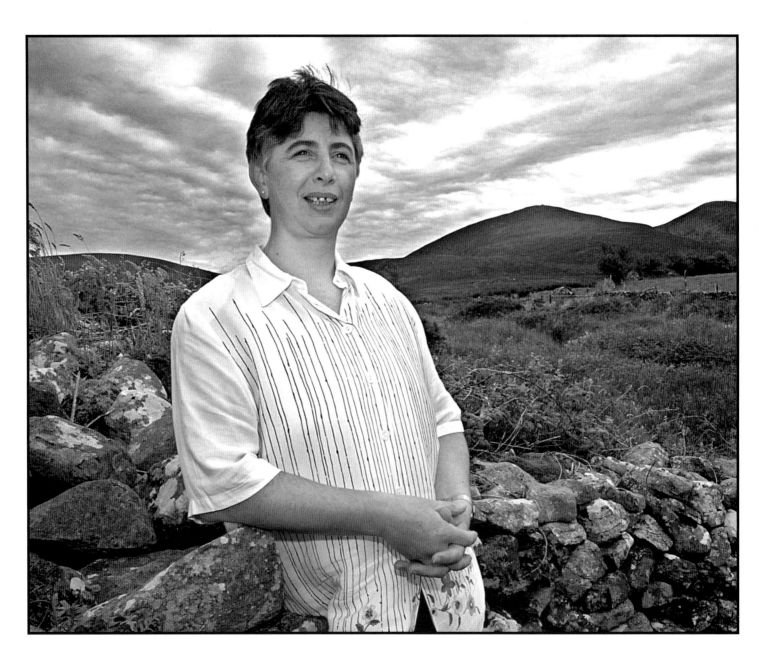

I am of

The City of Shrone, at the foot of the Paps mountains is just five minutes drive from my home and has always been a special place for my family. It is an ancient site of worship, and *Lá Bealtaine*, a day of pilgrimage, is celebrated there on May Day. It brings people from near and far to 'do the rounds' and afterwards for some *caint, ceol agus craic*.

The rugged beauty of the area, the good humoured friendly people, the many traditions – you just never want to leave.

Julia Lucey was born in the townland of Bounard, Gneeveguilla, in the heart of Sliabh Luachra, renowned for its richness in music, poetry and culture. She attended the well-known national school in Meentogues where her interest in local folklore and music began. Julia was raised on the family farm and has lived there ever since. She is the daugter of Hanna Mary and the late Jeremiah Lucey. She has one sister Noreen and one brother James.

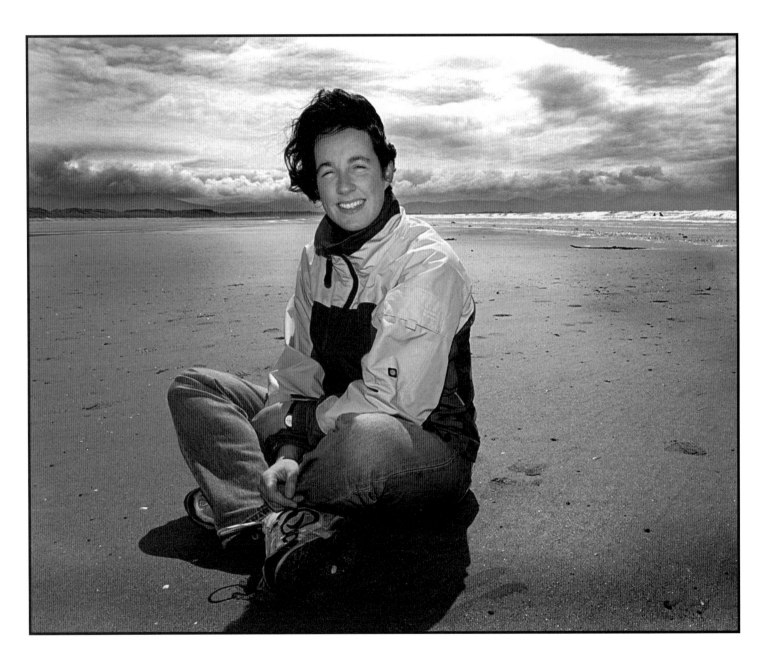

I am of
Kerry

Marguerita O'Neill

Banna is my favourite beach. In fact of all the places I have seen so far on this earth, this is one of my favourites. On arriving in Car Park I, a smile broadens across my face for there in front of me, lies the immense Atlantic Ocean, to my left the majestic Slieve Mish and Brandon range, and to my right the patchwork of low fields which is Kerry Head. There is always the immediate urge to get out and walk, to journey amid such beauty.

Most days I take a left and head for Barrow and the mountains. I enjoy my senses being reawakened. I love hearing the waves, the sound of the wind, the birds. I love smelling the ocean, feeling the wind, sun and rain on my face, seeing the shades of blue, grey, green and purple and touching the sand. I am grateful for all of these and for the joy that they give me. I say a prayer of thanks and walk on.

I pass the entrance to Car Park II. The path leading up the dunes into Car Park III recalls many cherished childhood memories. This was our summer haunt with parents, cousins and grandparents. We knew every dune and had 'Indian' names for each outcrop so that the 'cowboys' would never find us. We slid racing down the dunes on bits of brown cardboard and it didn't bother us that the rushes pricked us till we were spotty red. Back then our world was Car Park III, we never ventured elsewhere, alien territory. And now I walk with ease from I to II to III. The perceived long distances of my childhood have shortened. I reminisce and express thanks for such a happy childhood.

I stroll further toward Car Park IV. My thoughts continue to come and go. Perhaps it is the fresh sea air or the wonderful peace of being alone and feeling at home that clarifies things for me. It is here that I do my best thinking. Indeed I am grateful to be living in Kerry and grateful that Banna is on my doorstep.

At the tidal river which flows in and out of Poll Gorm, I return now facing the Black Rock and behind it Kerry Head. Invariably I am reminded of all that I have learned on this beach – football, tennis, hurling, frisbee, leap frog, compass reading, and of the people who patiently taught me.

I love this beach in all seasons. Out here each day is different. Nature is constantly changing appearance and her varying hues leave me in constant awe.

Banna, for me is a precious old friend, whom I adore to visit. When I go on long journeys I leave with sadness, but know that as soon as I return, I will visit her once again. May I never take this blessed gift for granted.

Marguerita O'Neill has taught German at the Institute of Technology, Tralee for five years and is currently on a career break, studying Social Studies at National University of Ireland, Maynooth. Originally from Tralee, Marguerita grew up in Bishopstown, Cork with her parents Seán and Mary, and siblings, Alicia, Antoinette, Marisa and Shane. She enjoys hill walking, travelling, meeting friends, theatre, *lectio divina*, tennis and hockey, and she is also involved with the local youth club in Tralee.

Tom Boyle

One of the most fulfilling things with being involved in building is to imagine the finished product before you start. To stand on a building site and in your mind's eye to see the completed building before a block has been laid, gives you the courage to achieve the dream.

The nightmares of workers not showing up, bad weather, overrunning costs, settles down as the finished article unfolds. You strive for a match between the building and the place you are in.

Tom Boyle was born in Gullane, outside Ballybunion. A gifted craftsman, he worked in London for many years before returning to Ballybunion with his wife Margaret in 1985. They have seven children: Anthony, Patricia, Christina, Siobháin, Tommy, Sophie, and Veronica. He has been involved in the building trade all his life. His hobbies include travel and cooking.

I am of
Kerry

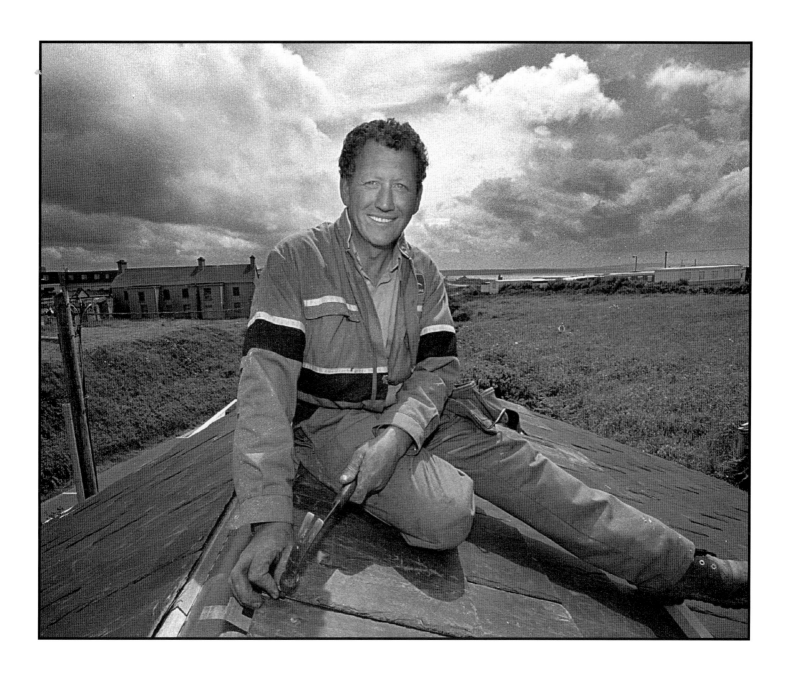

Deirdre O'Sullivan

Namaste

is a Sanskrit word used as a form of greeting in India and Tibet.

Its translation is:

I honour the place in you, in which the universe dwells,
I honour the place in you that is love and light, of peace and of truth,
When you are in that place in you
And I am in that place in me.
We are one.

The more I can be in that place in myself, the more peaceful, joyful
And fulfilled I am.

I sometimes find myself in that place, when I am singing, writing, making dinner, at Mass with my family and friends, when I am going for a walk, working in the garden, listening to music, aware of something beautiful, meditation, more and more in the small details of my life and most of all when I just let myself be.

This place is inside us all. For me It's a place where I feel connected.
It feels like home to me.

Deirdre O'Sullivan is a domicillary-community nurse working with the Brothers of Charity early intervention service in Killarney, and is currently in her second year of the applied counselling course in the Institute of Technology, Cork. Born in Aberdeen, Scotland, she lived for a while in Dublin and now lives in Faughbawn, Muckross, Killarney. Deirdre has four children: Liza, Brian, Aifric and Kate. She is a member with the Friary Folk Group, practices Reiki and studied aromatherapy and massage. Her passion and interest is in personal development and growth.

I am of
Kerry

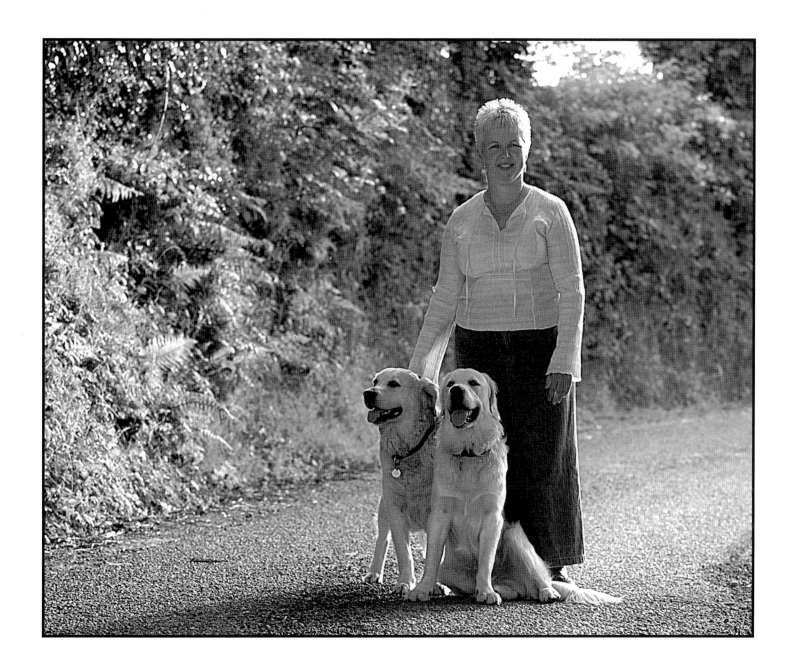

Dara Ó Cinnéide

Tógadh i gCiarraí mé agus bhíos tógtha le Ciarraí chomh fada siar is a théann mo chuimhne. As na daoine a bhuail liom agus as dinnseanchas na comharsnachta a múnlaíodh mo thuiscint agus mo thuairimí i leith Chiarraí. Dá bhrí sin, sé an turas go Fothair na Manach é. 'Sé Scamall Johnny lasnairde don bPiaras é. 'Sé an Branar Dearg agus gach aon chuaisín idir Chuas a' Bhodaigh agus Tír Bhrain é. Éist le 'Port na bPúcaí' nó le 'Beir mo Dhúthracht go Dúthaigh Duibhneach' – tá sé iontu san. Léigh filíocht Uí Rathaile nó drámaíocht an Chathánaigh agus tá éachtaint eile le fáil ansan ar cad is Ciarraí ann. Thar aon ní eile sé an geansaí glas is óir é. Dhá Chraobh Uile Éireann agus tríocha lena chois buaite le caid mhaorga, mhacánta. Ríocht na bhFlaithis agus Ríocht Chiarraí – ní mór atá eatarthu!

Dara Ó Cinnéide lives in Baile na hAbha near Cuas a' Bhodaigh at the northern tip of the Corca Dhuibhne peninsula, from where it is believed Saint Brendan set sail on his voyage to Newfoundland. He works as a news journalist with Raidió na Gaeltachta in Baile na nGall. He has been a member of the Kerry football team for ten years, winning All Ireland medals at junior, under-21, and senior levels. He played centre forward on the Gaeltacht team that captured its first ever County Championship in 2001. Dara is the second eldest in a family of four, having one brother and two sisters. Apart from football, his principal interests include mountain climbing, reading, music, film and travel.

I am of Kerry

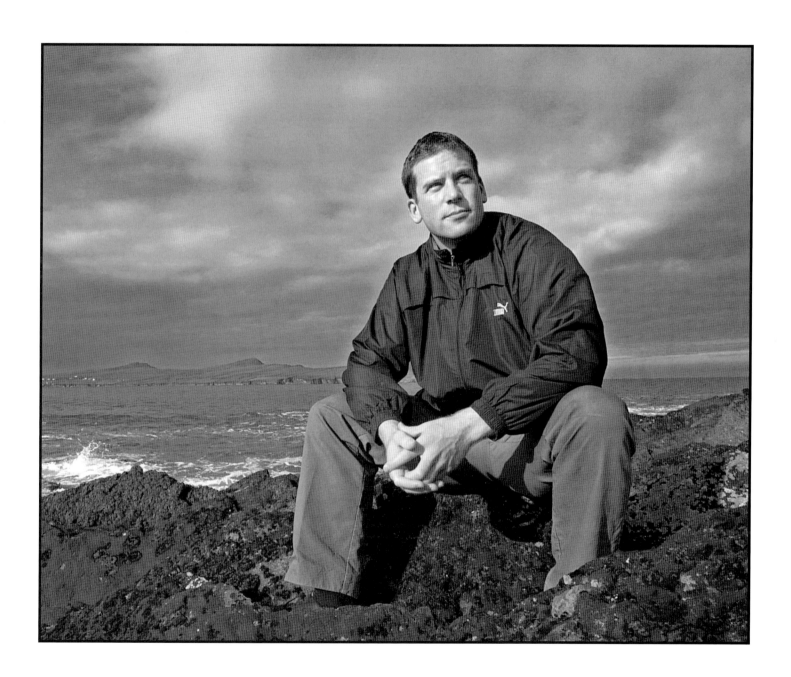

Mark Leane

I am the music
I am the celebrations,
I am the hopes and dreams
I am the hard times.
I am a son of the beloved motherland
And I take the people and spirit of Kerry with me
Wherever I go.

Mark Leane is a native of Tralee. He was voted the number one Elvis tribute artist in Europe and fourth in the world. Mark has performed on stage in Las Vegas, Canada, and England, and is the only Elvis tribute artist to be used by Elvis' record company to promote Presley. He has been cast in the leading role of a new movie 'Whiskey in the Jar'. He is very proud of his achievements so far and encourages people to visit his website, www.emeraldelvis.com!

I am of
Kerry

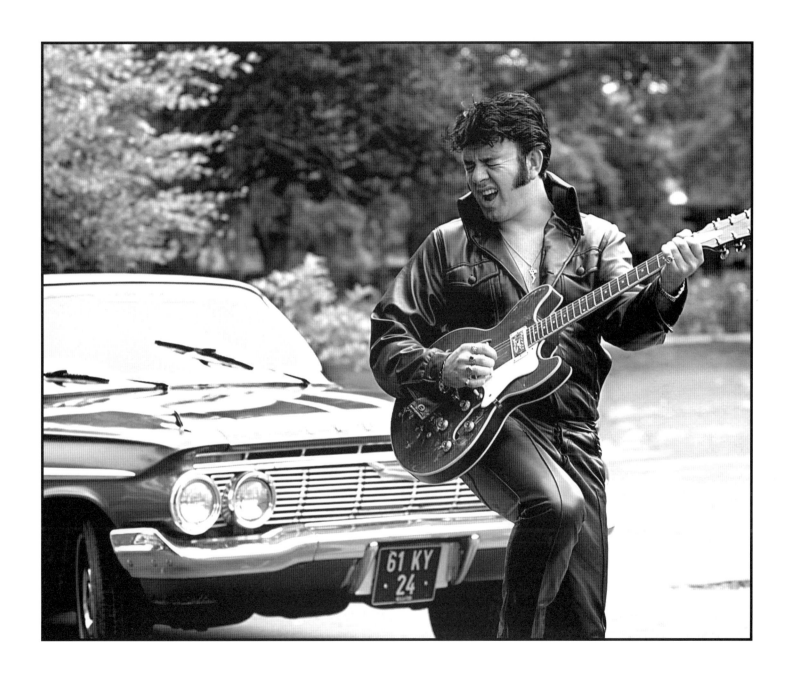

Ann Rohan

Winston Churchill said 'Dogs look up to us, Cats look down on us.'

I have great time for animals and birds. They are well able to look after themselves, yet are so vulnerable when they are injured or hurt. When a dog sits down alongside you and you stroke his chest you can feel the affection they have for you.

Personally, I find it hard to bond with cats. Maybe they do look down on us! I see elderly people improve when they have daily contact with a dog. But you have to be a boss with a dog, otherwise they will trick you.

I find greyhounds very friendly, but they defend themselves in a way that other animals won't. Like the racehorse they look so well when they are running. The beauty is to have the good one, but that is hard to find.

Ann Rohan was born in Rathea and lives in Dromclough near Listowel, Co Kerry. She is married to Kieran and they have three children: Bart, Margaret and Sinéad and six grandchildren. Ann cares for her sister-in-law at home and is involved in the creation of an imaginative crib in Irremore Church every Christmas. A lover of dogs, she also enjoys gardening.

I am of
Kerry

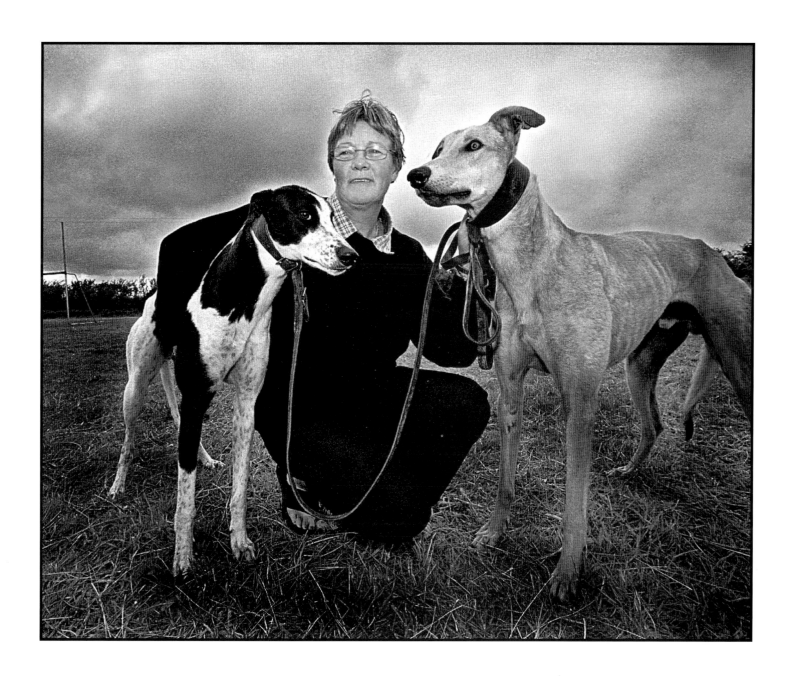

Sylvia Thompson

Home is something which happens to a person.

And now it has happened again here in Kerry. I had thought that Belfast was going to remain as home, but then on 31 August 1994, I found myself driving down the motorway in tears as I headed for my new life in Kerry. The car was packed. I had planted a tree in Antrim to mark my leaving. Bliss the cat was crying in her basket too, and my farewell gift of an amazing piece of artwork, 'A Vision of Peace' was on the back seat. A sudden newsflash brought the announcement of the first IRA ceasefire. What a farewell gift! Then the tears really began to flow.

Could I ever find such a strong sense of community again, such a sense of purpose, such friends, such challenges? Eight years later, I can only say thank God for what went before and what has happened since. Now I have a woodland of native trees – such as alder, ash, willow, and oak – growing in the field beside my house here in Ballymac(elligott). It was here in Kerry that I finally came across the gift of Christian meditation and *lectio divina*. I found a parish, in fact two, as I live so close to Tralee that St John's can be my early morning place of prayer. Missing the richness of my ecumenical Christian family in Belfast, I found others who longed for this too and so meeting, working and praying with friends from other churches is also part of my life. My friends grew even more diverse, coming from such far flung places as the former Soviet republics and the countries of Africa, not to mention all corners of these islands. Now my spiritual path crosses other faiths and is strengthened as we take time with each other so that all can be at home in this place.

How did it happen to me? Was it that knock on the door, the dinner brought when I was sick, my cat minded while away, visits from nieces, a listening ear from an *anam chara*, trees planted, a station Mass, eggs left on the doorstep, the welcome into the hearts and lives of neighbours, colleagues, children, friends, and cousins that helped it all to happen?

Who knows! Now there are wet days on Brandon, snowy days on Carrauntoohil, quiet days at home, days at work enabling those with communication difficulties to speak for themselves, evenings spent discussing parish liturgies, Kerry Earth Day, World Religion Day, relaxing evenings at concerts and plays and so much more, all making up such a tapestry of blessings.

'By stillness in the Spirit we move in the ocean of God.' These words by the late John Main OSB are on my wall. This timeless and mysterious ocean stretches all around me. Sometimes I'm aware of it as I walk down the road in the evening or sit for meditation. At other times it's in the smile or laugh of a child or in the simplicity of the communion bread placed in my hand. Then it eludes me for long stretches while I gallop and race through life until I allow God to catch me again and home happens once more.

Sylviva Thompson is a speech and language therapist with Enable Ireland in Tralee. Both her parents were from Kerry. Sylvia worked and lived in various parts of Ireland before moving to Kerry in 1994. She continues 'being busy with living life fully and helping others to do the same'.

I am of *Kerry*

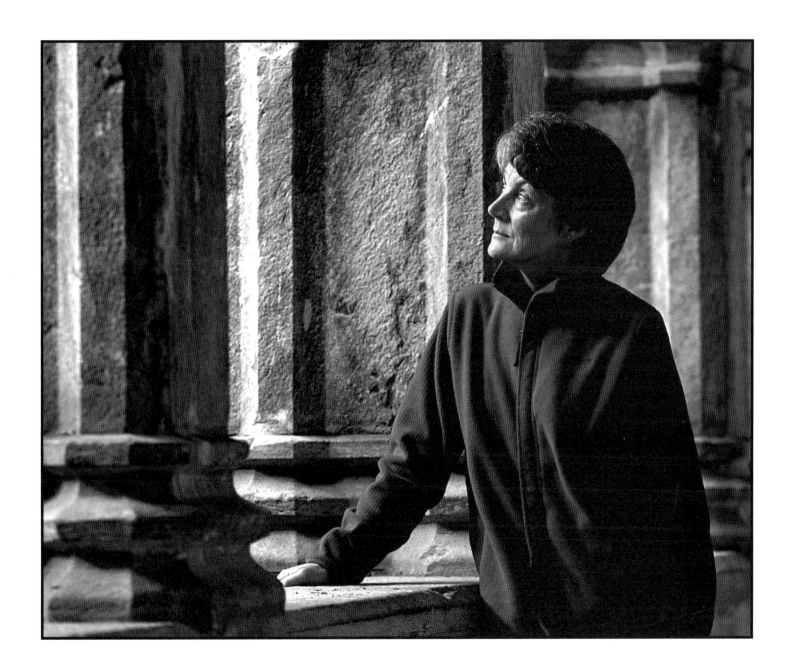

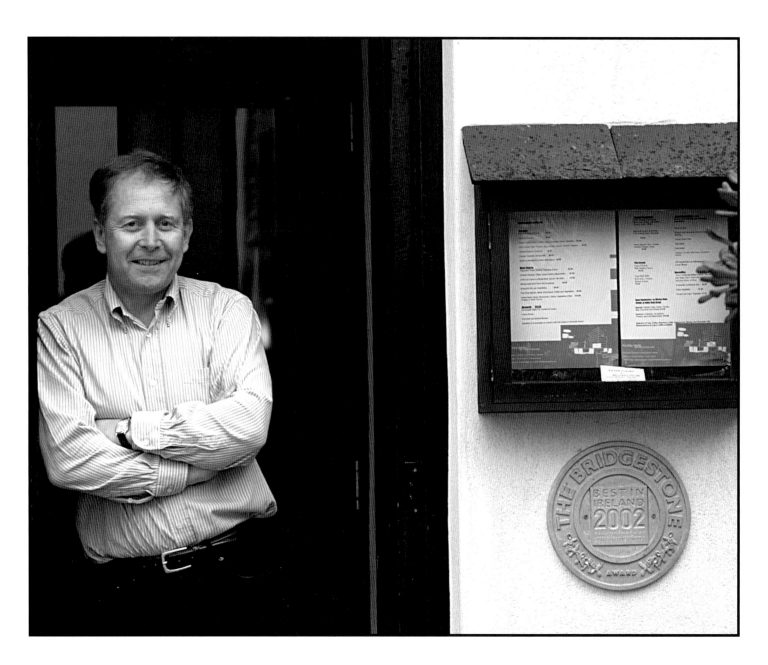

I am of
Kerry

Mickey Ned O'Sullivan

Growing up in Kerry during the '50s and '60s I was afraid that many of the social 'push' factors such as emigration and unemployment would not allow me live and work within the county. My family has its roots in Kerry for generations. Being able to identify with a place is very important to me. I love everything about living in Kerry: the passion of its people for sport, the community spirit, and the sheer beauty of its mountains, sea, rivers lakes and valleys.

Most county boundaries have been artificially created, yet physically, culturally, economically, and socially, Kerry has proven to be a unique entity. I believe that the landscape has a profound effect on its people and no where is this more evident than in Kerry. It has given us our unique accent.

Through the generations, the people of Kerry, due to the shortage of fertile land, have had to diversify and adapt in order to survive. As a result, they have gone on to make major contributions to the worlds of literature, the arts, economics, and sport.

I had no say in where I was born, but I feel privileged to have been born in Kerry. Having lived and travelled abroad, I have always, and will always, feel part of the landscape of The Kingdom.

Michael (Mickey Ned) O'Sullivan is a native of Kenmare, Co Kerry. A member of the glorious football team of 1970-80, and captain in 1975, he was manager of the team from 1989 until 1992. Michael teaches in Coláiste Gobnatán, Baile Mhuirne, Co Cork, . He is married to Marian from Currow and they have two sons, Brian and Eamon. They own and run Mickey Ned's Bar in Kenmare town and are avid hill walkers and enjoy all outdoor and GAA activities.

Colette Garvey-O'Doherty

'During the last ten years, I have been actively involved in community activities in Tralee, particularly with a local youth group call SAM (Sharing and Minding), with which my husband Donal and I were involved from the start. This group works with the elderly and special-needs adults, as well as fundraising for many local services. I facilitate personal development courses for the group's members and have had the pleasure of working with over 800 teenagers. In my work with the SAM Youth Group, I get to experience the valuable contribution of the young, who offer up their time to help those less fortunate than themselves. One of the most rewarding events with SAM had to be the countywide fundraising effort for Rwanda in 1995, which raised over €70,000. It was a fantastic achievement for all involved.

It was as a result of my fundraising efforts, that I was invited to oversee and fundraise for a women's refuge in Tralee. Eight years later, I am delighted to be still working as Co-ordinator for the Refuge and as Vice-Chairperson of the National Network of Refuge and Support Services in Ireland. Through our Refuge service, I am privileged to meet such courageous women, and fortunate to work with a dedicated team who work to support them.

My move to Kerry was a life-changing one. It provided me with the opportunity to live in a community where people support each other. I continuously get to see the generosity of people in Kerry both through my own work in ADAPT Kerry and the work of SAM.

Another huge attraction of my adopted county is the scenery. The variety of walks, hill climbs, views and landscapes is unmatched in any other county. One of my favourite places in Kerry is Banna beach. It is the one place I go, if ever I feel I need to think or get away from it all for a few hours!

I may not have been originally from Kerry but this beautiful county is now my home and I am proud to be of Kerry.

Colette Garvey-O'Doherty is Co-ordinator of ADAPT Kerry Refuge & Support Services. The Refuge is located in Tralee and provides crisis accommodation and outreach services to women and children who are victims of domestic violence. Her family moved to Tralee when her father was transferred there as Gárda Superintendent. The oldest of eight children, she is married to Donal O'Doherty, from Killarney.

I am of
Kerry

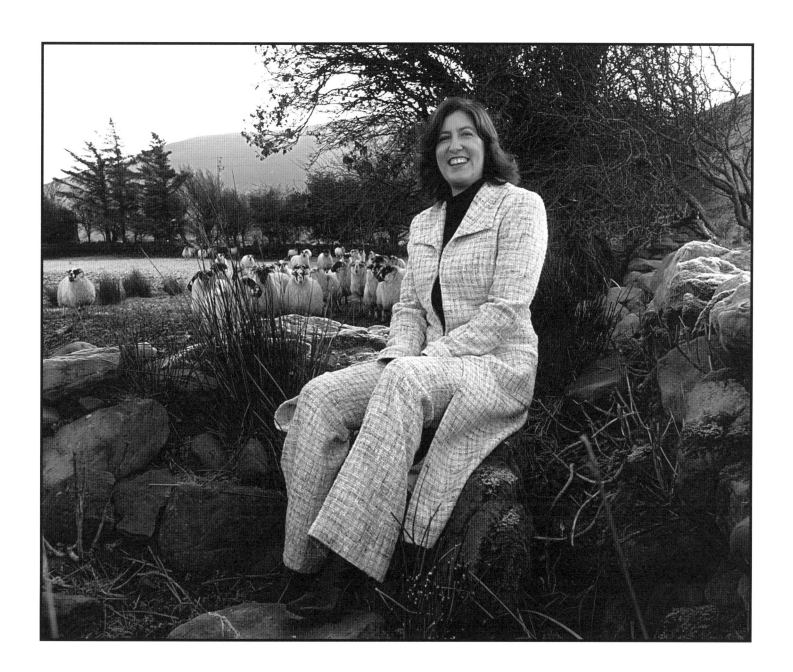

Michael & John Leane

Michael Leane

I live on a small farm west of the Giddaugh River at the foot of Carrauntoohil. It's here I was born and reared, like my father, grandfather, and great-grandfather before me. I have two brothers and one sister. I am the smallest at six foot. I married a girl from a neighbouring parish, Glencar, ten miles away. Our family is now all reared and weaned.

Times have changed a lot since I went to school when there was 240 pence in a pound. When I left school, I helped my father with the farm work. I learned a lot of skills, such as cutting tuft with a slawn, cutting hay with a scythe and ploughing with horses. I also learnt to shear sheep with a hand shears, one of the trades I passed onto my sons. John is a champion.

The first big change was the electric light in 1965. There weren't as many hill walkers back them. A lot of them needed a guide and I gladly obliged for a few shillings, which was much appreciated. When Mary Ann, our oldest girl, finished college she went to Boston where she played Gaelic football with the Boston Shamrocks. Davy, our oldest boy, manages the local football B-team which won the Barrette Cup for the first time in 2001. When Joan and myself reach pension age we would like we would like one of the children to take over the farm and carry on the traditional farming as before.

It is now 12 August, the last day of Puck Fair and I must go, for as the saying goes 'I never died a winter yet or never missed a Puck'.

Michael Leane is a sheep farmer, living at the foot of Carrauntoohil. He is married to Joan and they have six children: Davy, Mary, Anne, John, Siobháin, Mike, and Muiríosa. He has worked as a farmer all of his life and 'will continue to do so for the remainder'. He enjoys socialising with friends, storytelling, the odd pint as well as having a passion for walking, mountain climbing and swimming during the summer.

John Leane

One of my uncles died of cancer two years ago. At his funeral service the priest said that he had been very giving of the talents that God had given him. That has become my motto number one, to try and be giving of my talents.

I now work as a director of a charitable organisation in Cork City, Doorway to Life Ltd (Abode). I took over the seat on the board of directors from an eighty-year old lady who has been involved in charitable work in the Cork area for the past fifty years. In her farewell speech to the organisation she said her only child was born disabled, and he only lived a day. After they buried him, she decided to dedicate her life to charitable work to try and improve the lives of the less well-off. My motto number two is to always try and make some good come of a bad situation.

John Leane works as an architect. He was paralysed from the chest down following a road traffic accident in 1995. After completing rehabilitation training he attended college and studied architecture in Cork where he is now working and living. His hobbies include socialising, singing, and playing darts. John intends publishing his own book, which is to be based on his experiences of 'life, love and tribulations in reverse order!'

I am of
Kerry

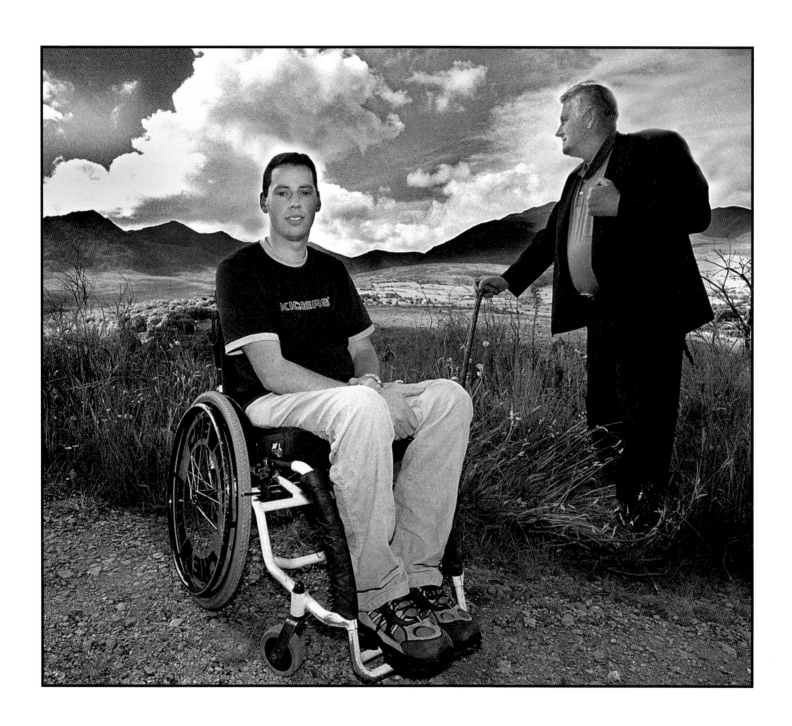

Sharon Reidy

First Impression

21 March 1980
The slow train to Kerry
Clickety clack, clickety clack
Swaying from side to side
Up and down, on and on

A purple and grey sky
Sleet and rain lashing against the window
Trees and branches bare
Empty fields
Puddles of water everywhere

6.00 pm
The rain has stopped
The air is still
The strange smell of a turf fire
Greyhounds barking in the shed
A bell tolling from the depths of a smoke-filled kitchen

An old woman in a black dress
An old man with a gentle smile and a small nod of a head
Two chairs either side of the range
A religious picture with a red lamp burning beneath
The damp smell of an old unheated house
And the cold creeping into every inch of my being.

Sharon Reidy was born and educated in Durban, South Africa. She came to Ireland with her husband Clayton in 1980 to live on a sheep farm nine miles north of Tralee. She joined Kerry School of Music teaching voice and drama and has performed the leading roles in musicals such as 'My Fair Lady', 'The King & I', and 'The Sound of Music'. She has recently recorded an album of Irish ballads accompanied by Aidan O'Carroll. Sharon is Musical Director of the Kerry Choral Union, and she continues to teach voice at her home in Abbeydorney. Clayton and Sharon have three children: Seán, Brendan, and Shanda.

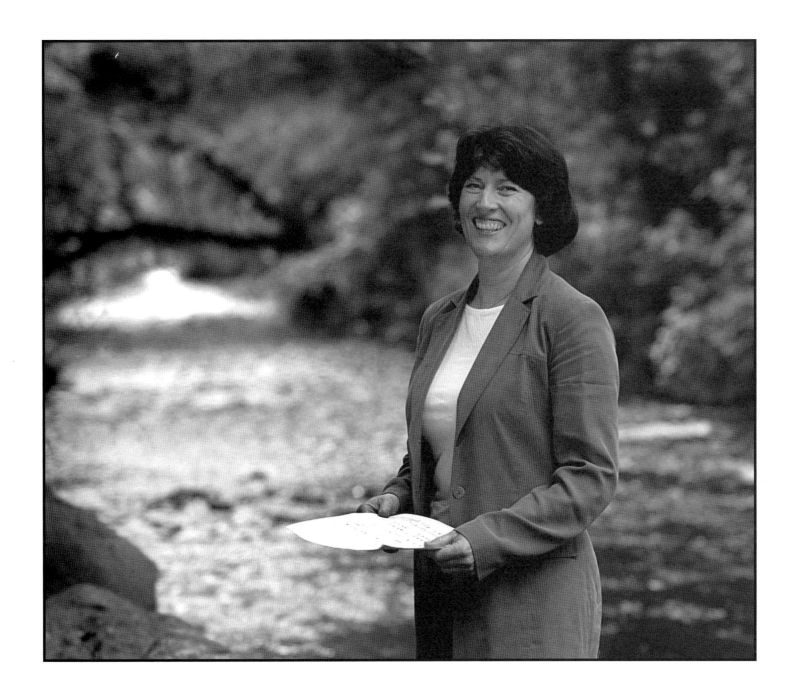

Mossie Horgan

I started working as a page boy in the Great Southern Hotel in the winter of 1961. I have been the Head Hall Porter with responsibility for the Conference Centre for the past twenty years.

Every day is a great challenge: meeting new people of different cultures and nationalities. I have met Taoisigh and Presidents of Ireland, diplomats, actors and royalty. I was delighted to meet Sarah Fergusan, Trevor Howard, Robert Mitchum, Halley Mills, Telly Savalos, Gabriel Byrne. Actors like David Leen used to drink in Jimmy O'Briens pub in College Street, and when Trevor Howard went for a pint nobody recognised him at all! Over the years, the Irish Management Institute conferences always brought great speakers, including Dick Spring, who is one of the finest, in my opinion.

The company has spent a lot of money refurnbishing the hotel, restoring it to the glory days of the GSH. In the 1960s the hotel had its own farm and grew all the vegetables, and stocked pigs, chickens and cows. The fire that still burns in the foyer used 100 weight of coal a day.

All of my family have worked in the hotel industry. My father worked in the Great Southern Railway Station and today my sons work in the hotel during their holidays. I have seen enormous changes in the tourism industry.

The hotel has had wonderful staff. People like the late Jimmy Cullinane and Vera Chapman. Everyone knew these people.

The Great Southern Hotel is an institution in Killarney and I am responsible for the welfare of each guest that stays in the Hotel.

Mossie Horgan is the Head Hall Porter at the Great Southern Hotel, Killarney. A native of Killarney, he is married to Betty and they have three children: Colm, Caroline and Shane. Mossie campaigned with Mary Robinson during her presidential election campaign in 1990, and he was Chairman of the national negotiating team which drew up the Great Southern Employees Handbook. Mossie is an avid sportsman, especially greyhound racing, and he is involved with St Paul's Basketball Club and Dr Crokes GAA Club, Killarney.

I am of
Kerry

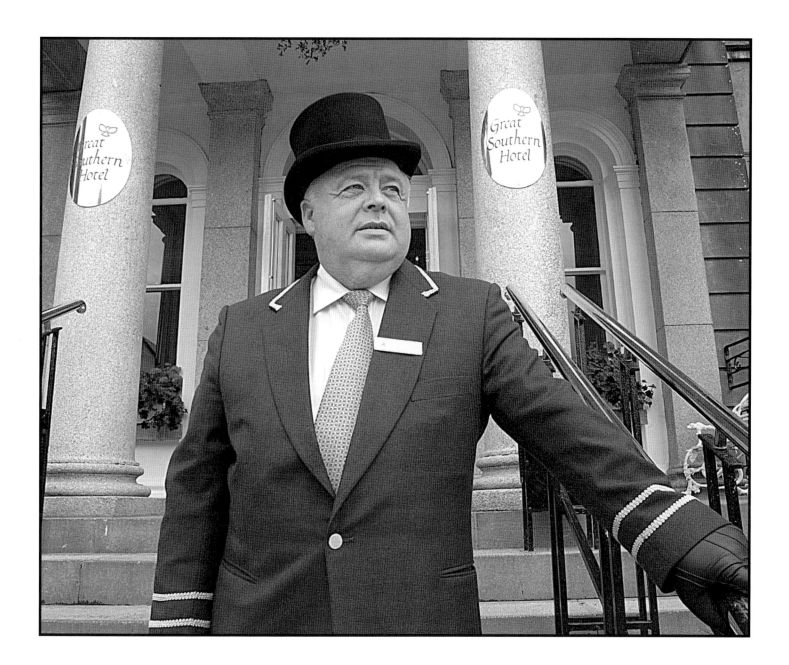

43

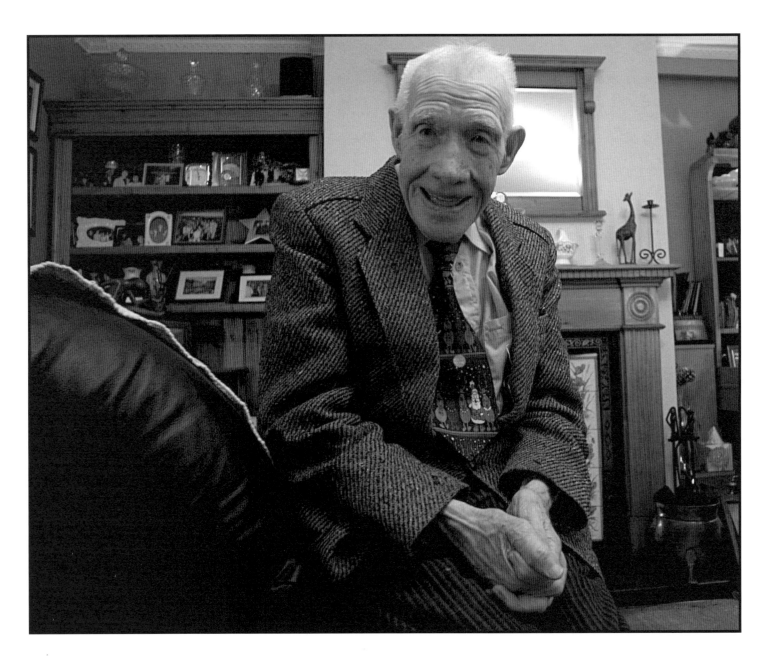

I am of

A beautiful sport … a beautiful life!

I was born on 'Top of The Rock' in 1909, the street of football champions in Tralee. My father Thomas O'Regan came from Cork and was foreman in the CWS bacon factory, which was the only English co-op in Ireland at the time. I went to Edward Street Boys' School and to St Mary's Secondary School on the Green. My science teacher was Br Turner, who was passionate about football. My career in football started from there.

I was captain of CBS when I was twelve years old. The day of the Schools College final, my mother died. I couldn't play, and Dublin beat us by a point. In 1930 I was a Kerry minor and we won the Junior All-Ireland. Four of us were promoted to the senior Kerry team: Tim Landers, Paddy Whitty, Dan O'Keeffe – the only Cork Man – and myself.

The morning of the 1931 Munster senior football final between Kerry and Tipperary, I was coming out from Mass, when John Hickey, a Kerry selector, approached me. He told me I was playing that day, that John Joe Sheehy couldn't play. I scored four goals that day. Later that same year we bet Kildare 1-11 to 1-8 in the All-Ireland Final.

In 1933 in the semi-final against Cavan in Breffni Park, we were playing for the five-in-a-row, we were 6 points ahead… and there it ended. As *The Irish Press* wrote the following morning: 'O'Regan Injured – Kerry collapsed'.

In those days Dr Eamon O'Sullivan trained us. Usually after winning a Munster he would tell us to 'pull up our socks' and really the big push happened three weeks before an All-Ireland.

Rock Street was the place to live. Imagine there were six Kerry forwards living on the street: Jackie Ryan, Mick O'Doyle, John Joe Sheehy, Bill and Tim Landers, and myself. I have collected five senior football championships: 1928 1930, 1931, 1932, and 1936. In those times, Joe Barrett, John Joe Sheehy and Jackie Ryan were the greatest forwards. In 1936 we won the last county championship for Rock Street when we beat Dingle. It took Rock Street another thirty-seven years to win a championship again, when my son Tommy took them into the final in 1973.

The day I was born, my godfather Jackie Kidney, a stone mason, was working on the spire of St John's Church. He must have known I was going to be a star!

Martin 'Bracker' O'Regan is the last surviving member of the colourful and talented Rock Street Sporting Brothers. He was born in 1909, one of a family of five brothers and four sisters. He married Mary Dundon (RIP) and they had four sons: Tommy, Jimmy, Martin and Denis, and two daughters, Mary and Ina. 'Bracker' is a passionate greyhound racing supporter and still makes it to all the races in the Kingdom Greyhound Track, Tralee. He also enjoys, snooker, coursing and backs a horse every day of his life.

James Kennedy

I have always loved the sound of the electric bass guitar. Even as a child I felt drawn to it. I play because I love it and feel a great need to do so. In a creative environment I can lose myself in music. It's a great outlet and often acts as a form of therapy or release.

I have been fortunate to have played with some great musicians. I particularly enjoy playing with singer /songwriter John Hurley, guitarist Brendan Williams and my rhythm section partner the great drummer Dick O'Shea.

As human beings I feel we all have a creative side that needs to be expressed. I regard myself as being very lucky to have such a gift in my life.

James Kennedy is a bass guitarist, an instrument which he plays and teaches. He lives in Tralee with his wife Eileen, a painter, and their two children, Clare and Ciarán. Apart from music, James' other pastimes include outdoor activities, walking and reading.

I am of
Kerry

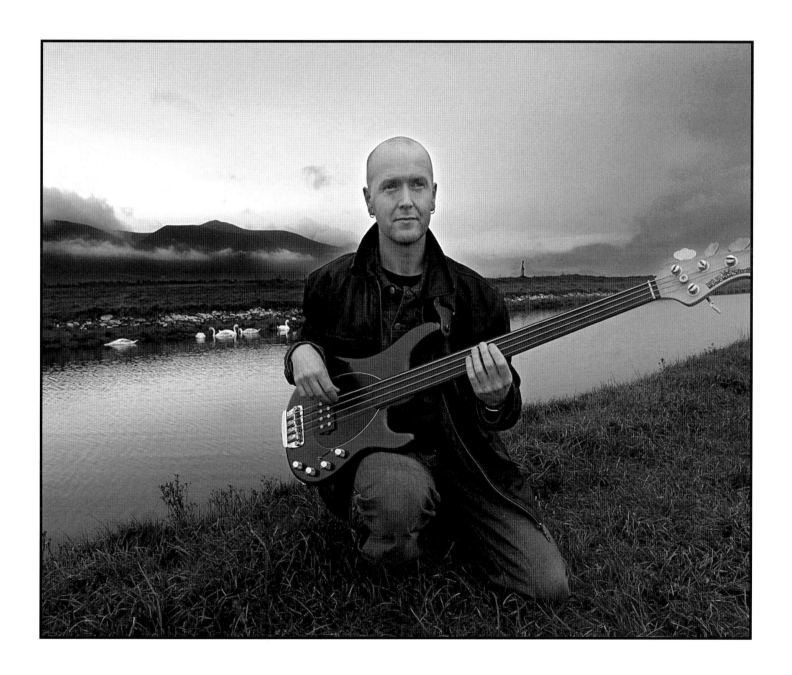

Mícheál Ó Dubhshláine

Tá trí bliana déag ar fhichid ann ó thána go Dún Chaoin chun dul ag múineadh sa scoil ann – fad shaoil Íosa Críost.

Cúpla lá tar eis dom teacht bhuaileas le seanduine ar shráid an Daingin.

'Conas a thaithníonn an áit leat?' ar seisean liomsa.

'Go mór, ach go bhfaighim an Ghaolainn deacair.'

'Ná bíodh aon eagla ort,' ar seisean, 'níl sí go maith agat ag teacht, ach ar m'anam go mbeidh sí go maith agat ag imeacht.'

Thug an méid sin misneach dom.

Leanas orm.

Phósas bean bhreá, Áine, ó Chorcaigh agus dheisíos sean-bhothán ó aimsir an Ghorta dom féin ar an nGráig.

Ceathrar clainne, agus iad ar fad fanta san áit.

Ceithre ghlúin fé aon díon amháin.

Pribhléid dom go raibh aithne agam ar dhaoine mar Sheán de hÓra, Tomás, Cáit agus Neil Ní Chinnéide, Meag na gConnors, Maidhc Daingil Mistéal agus, gan dabht, muintir an Oileáin, an chuid is mó acu ar shlí na fírinne.

Chuireas aithne mhaith ar an áit. Cad eile a bhí le déanamh agam?

Agus an Ghaolainn?

N'fheadar an bhfuil sí fós agam. Ach beidh sí go maith agam is mé ag imeacht.

Mícheál Ó Dubhshláine is principal at Scoil Dhún Chaoin. Originally from Kilkea, Co Kildare, he arrived in Kerry in 1970. He lives in Gráig in Corca Dhuibhne, overlooking Clogher strand, one of the most beautiful spots in Ireland. He is married to Áine, an artist. They have four children, Donie, Sorcha, Sinéad and Breandán, and one grandchild Nicole. He is very interested in the Irish language and the traditional culture, music, songs and stories of Corca Dhuibhne. He has produced two books on the history of the area, and hopes to produce a few more.

I am of
Kerry

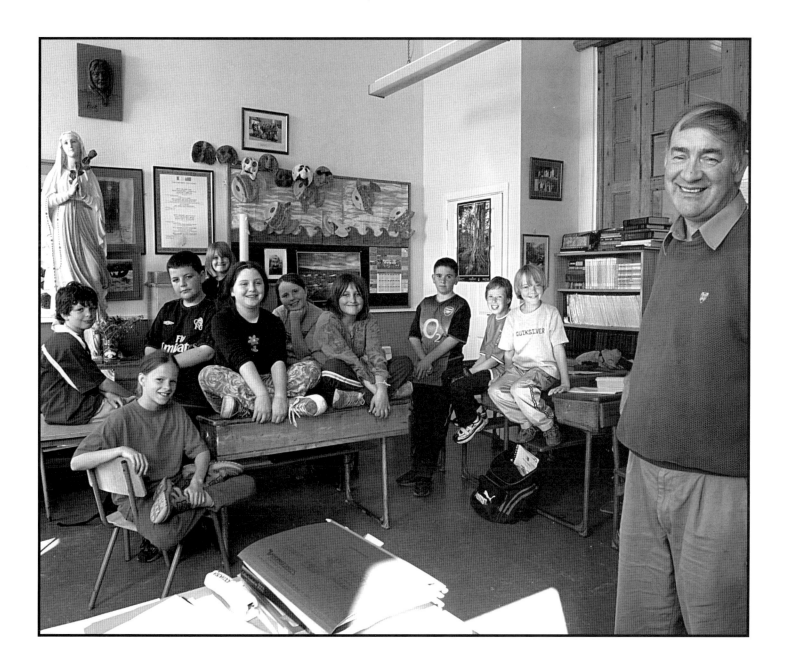

Kathleen Hickey

I have always thought that those of us living in Killarney are especially lucky in life. Indeed, I often say to myself what a lovely place it would be for a holiday if I wasn't resident here. I don't have to leave home to see the beauty of Killarney. Each morning when I look out the front window, I get an uplift from the lakes, the woodlands and the mountains. It's an ever-changing scene, never the same any time I set my gaze on it.

The reflection of both the rising and setting sun creates varied and sometimes dancing light on the mountains, picking out crags, rocks or hollows I had not seen before. Ironically enough, Killarney can look its best after a good shower of rain. That's when you get the clearest view. And, following heavy rain, cascades rushing the down the mountains create a wonderful spectacle. At night, the reflection of the moon creates a mirror-like impression on the lake. Ross Castle is flood lit. Even in the darkness, Killarney looks beautiful.

I love to walk in Killarney National Park which has a different walk for every day of the year and much more. My favourite is the circular walk from the Demesne to Ross Castle, where at any given time you will see deer, ducks, cranes and several other wildlife species. There are also fabulous lake views along the route, views which compel one to stop for a few minutes and take in the grandeur of it all.

Truly, as the old saying goes, the beauty of Killarney is proof of what God can do when he is in good form.

Kathleen Hickey works as an office assistant. She was born and raised in Ballydesmond, Co Cork, and now lives in Tiernaboul, outside Killarney. She is married to Donal and they have three children: Tadhg, Aileen and Triona. Kathleen enjoys reading, cooking, swimming, walking in Killarney National Park, Kilcummin and Raecaol bogs.

I am of
Kerry

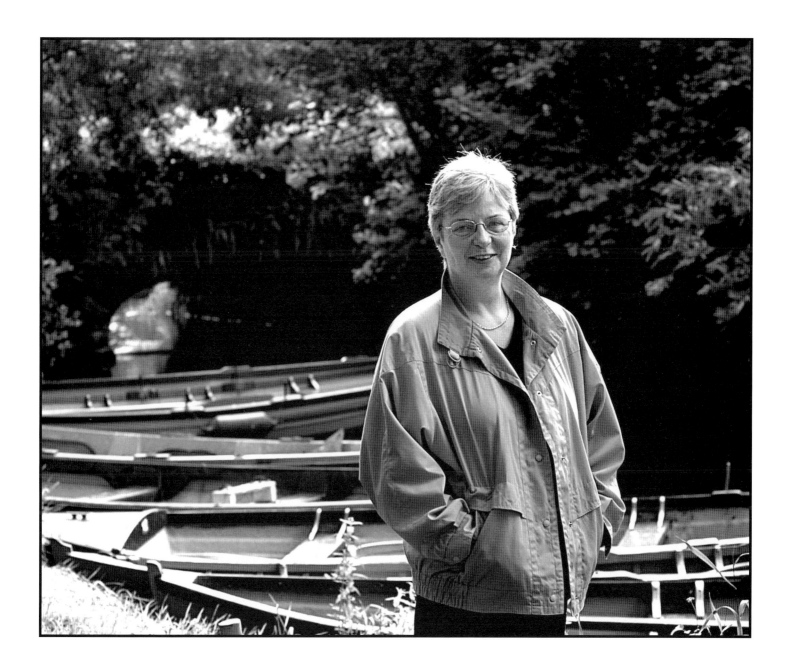

Brendan Kennelly

A Motion

I decided The Church's name should be changed
To the Losers' Club. I put the motion to The Church.
'Why?' queried The Church.

'You've become unhinged
With caution' I replied, 'You've lost the sense of search –
You're out of touch with your origin, the man
Who died for me, you wear pompous clothes,
You eat too much, you're too fond of money,

When did you last smell the Mystical Rose?
Everything you do smacks of vanity and defeat,
You take heaven for granted,
You need to get back in the gutter, you need
To bleed profusely for a while,
You need to dynamise your style, you need to admit
You're the Losers' Club before you're new again.'

'Motion rejected,' smiled The Church, 'Let us now pass on.'

Brendan Kennelly requested Paddy McElligott from Listowel, to chose his contribution. Paddy plays Moloney, one of the main character in Brendan Kennelly's *Moloney Up and At It*. Brendan says: 'Paddy makes Moloney available to people. He has that strange thing they call 'genius', he gives energy and conviction to Moloney. Moloney lives on with Paddy.'

Paddy explains: 'This appeared in the epic poem, *The Book of Judas*, published in 1991. The Church, probably the hierarchy, is being addressed, as opposed to the real Church that is found only in the 'gutter' and searching. It has a David and Goliath feel, with the hierarchy, Goliath, being implored by the poet, David, to join with the sisters living and working with the poor; to join the priests and brothers who have dedicated their lives to working with the underprivileged; to join the lay people who do a power of good in their communities; to get rid of the 'pompous clothes'. To live Christianity as opposed to standing back and taking its picture. The sentiments were never as pertinent as they are today, especially with the hindsight that the last decade offers. Ignoring reality won't make it disappear, and covering your tracks can be very energy sapping. If Christ spent that much time looking over His shoulder, He wouldn't have left Nazareth, and where would we be then?

Celebrated poet and dramatist Brendan Kennelly was born in Ballylongford, Co Kerry. He was educated at St Ita's Primary School, Tarbert, and at Trinity College, Dublin, where he has been Professor of Modern Literature since 1973. He has published more than twenty books of poetry including six volumes of selected poems. He is best known for two controvesial poetry books, *Cromwell* published in 1983 and his epic poem *The Book of Judas*, 1991. He has edited several anthologies including *The Penguin Book of Irish Verse* and *Between Innocence ond Peace*. Brendan is a also a distinguished dramatist whose plays include versions of *Antigone, Medea, The Trojan Women* and *Lorca's Blood Wedding*. The Brendan Kennelly Festival takes place in his hometown of Ballylongford in August every year.

I am of
Kerry

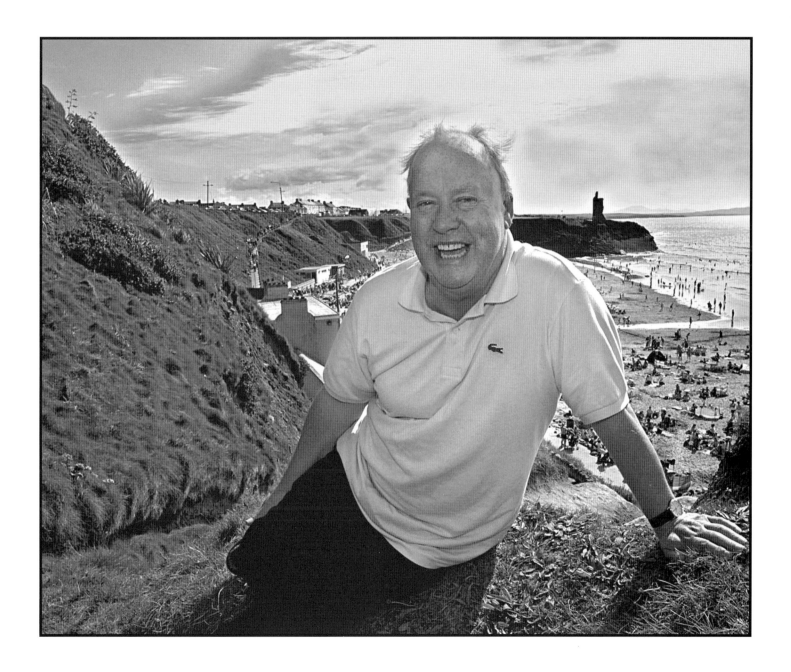

Andrea Thornton

As a child my parents always encouraged me to draw or paint on whatever material was available. They weren't so happy, however, when that was often the nearest wall! Despite these little incidents my interest in creativity developed into a deep love, urged on by teachers and mentors, both at primary and secondary school. My original 'stick men' were soon replaced by a more human life form. I felt privileged to be asked to design some object or create posters for local events. It encouraged me to continue my hobby and it boosted my self-confidence.

I recall a particular occasion when I was in fifth class and the inspector was due to call. He arrived and strolled around, viewing our precious masterpieces. He stopped, nodded. Our eyes followed his every move. My body stiffened as he asked who owned a certain painting. It was mine. I shall never forget that moment.

I am due to take my Leaving Certificate examinations in June. I am positive that my chosen path will be in the area of creativity.

Andrea Thornton lives in Irremore, Co Kerry and attends the Presentation Secondary School, Listowel. She lives with her parents, Mike and Mary Thornton. She enjoys sketching portraits. She has also taken part in many school dramas including *The Sound of Music* and more recently in a youth production of *The Odd Couple* held in St John's Theatre, Listowel. She enjoys reading, drama, basketball and other sports.

I am of *Kerry*

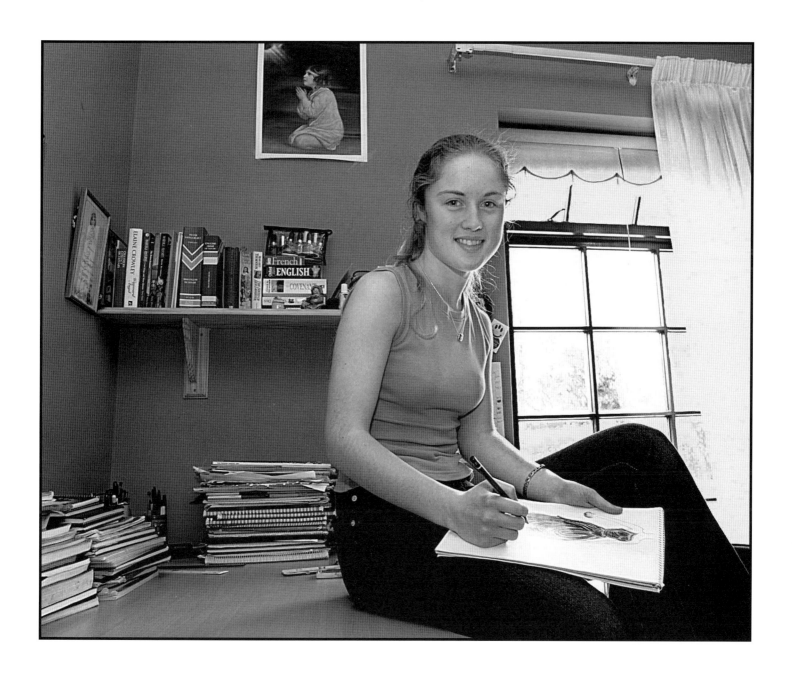

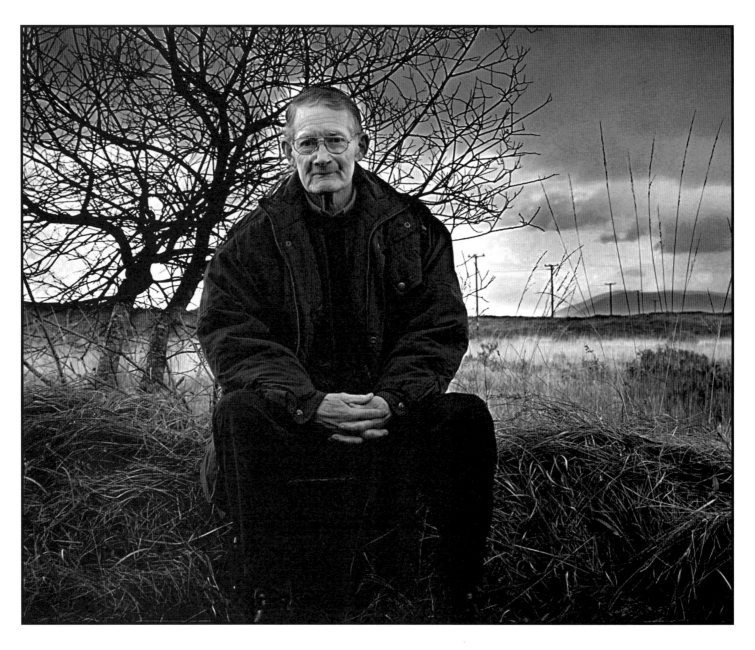

I am of

Johnny O'Leary

The gift of music!

I started playing on a ten keyboard accordion seventy-two years ago. I can't understand people practising! I just played by ear. I'd hear a tune and then play it back on the accordion. I used to listen to Tom Billy Murphy from Ballydesmond, The Blind Fiddler, who travelled around on a donkey teaching my uncle Dan O'Leary the fiddle. Coming from Sliabh Luachra the music was in us. Tom Billy Murphy would play the tune and I'd be able to play it straight away! It is my gift I suppose.

Long ago we played in houses, especially after a day's thrashing. We played after the big fair day in Knocknagree, which was held on the 20 January every year. Padraig O'Keeffe of Scartaglen was another fine musician I played with. He was a brilliant player. We played in the pubs of Jack Lyons and Tom Fleming in Scart. I started playing with Denis Murphy in Thady Willie O'Connor's Hall, Gneeveguilla. We had a great partnership for thirty-four years. I started playing in Dan Connell's pub in Knocknagree on Steven's night 1964 and have been playing there ever since. Friday and Sunday nights!

I still prefer the slides and polkas of Sliabh Luachra to any other tunes. Many years ago Seamus Ennis came to collect music for The Folklore Department at the BBC. Ciarán Mac Mathúna was another great collector. Thanks to these people and Comhaltas Ceoltoirí Éireann traditonal music has never been as strong as today. They have kept our music alive.

I bought my present accordion in Clancy's, Market Cross, Killarney in 1971. I'm a purist by tradition. When it comes to playing tunes, I keep the same style and tempo as I was taught them. One of my favourite tunes is from an old 78 record of Michael C. Hannifan from Callinfercy. He made the record in America. It containts two polkas: 'Dark Girl Dressed in Blue' and 'My Love is but a Lassie'. I love that record.

Johnny O'Leary is one of Ireland's most talented musicans. He was born in Maulykevane, between Rathmore and Gneeveguilla, the heart of Sliabh Luachra. He is married to Lil and they have three children: Sean, Ellen and Maureen, and nine grandchildren. He worked with Bord na Móna in Kildare and returned to Kerry to work with Cadburys Ireland, Rathmore. He retired in 1983 after thirty-four year's service. His muisc has brought him to America, Scotland, England, Wales and France, but Johnny is most regarly found in Dan Connell's pub in Knockagree; Buckley's Bar, Killarney; and in Miltown Malbay during the Willie Clancy Week. As well as recording six albums, he has published a book of 384 tunes.

Anthony O'Brien OCSO

A Monk's Memorial to John B.

I listened last night to the voice of John B.
The lilt of that North Kerry accent sweet song
To an exile's ear after many many years
Of praying my way with the heavenly throng,

Sixty-eight was the date when God called me forth
To leave my own county and my father's kin
And don the white robes of St Bernard's court
Fastening man to his God with a Kerry linchpin.

The bells go at four while the birds are asleep
A crazy old hour to be down on your knees.
Yet morn after morn that vigil we'd keep
In a stark, lofty church where God alone sees.

We'd pray for the one who was nabbed doing wrong,
For Michelle and Matty that parents they'd be.
We'd remember the traveller in psalm and in song
And the dead, that in heaven they'd laugh with John B.

Sure life has been good, the field has been green,
I've learned to live in my exile.
Just the odd niggling yearn for Kennelly and Keane
And that county I will always be proud of.

There that bell goes again calling God's haggard men
Last prayers of the day before shut-eye.
The sun whispers low o'er Cnoc an Óir.
'Ciarraí is the Kingdom of God'. Aye!

Anthony O'Brien is a Cistercian Monk in St Mary and St Joseph's Abbey, Roscrea, Co Tipperary. Originally from Ballylongford, Co Kerry, he came to the Abbey in 1968, was professed in 1974 and ordained in 1980. Anthony worked on the farm in the Abbey for years until last year. He now carries out pastoral care. He is shortly moving to Norway where he is taking up a position as chaplin to a new monastery at Tautra MariaKloster. Anthony, better known as Páid in his native Kerry, has one sister Mary Lyons who is married to Tom Lyons from Asdee. He enjoys Gaelic football, all outdoor life, and is a lover of nature and enjoys welding.

I am of
Kerry

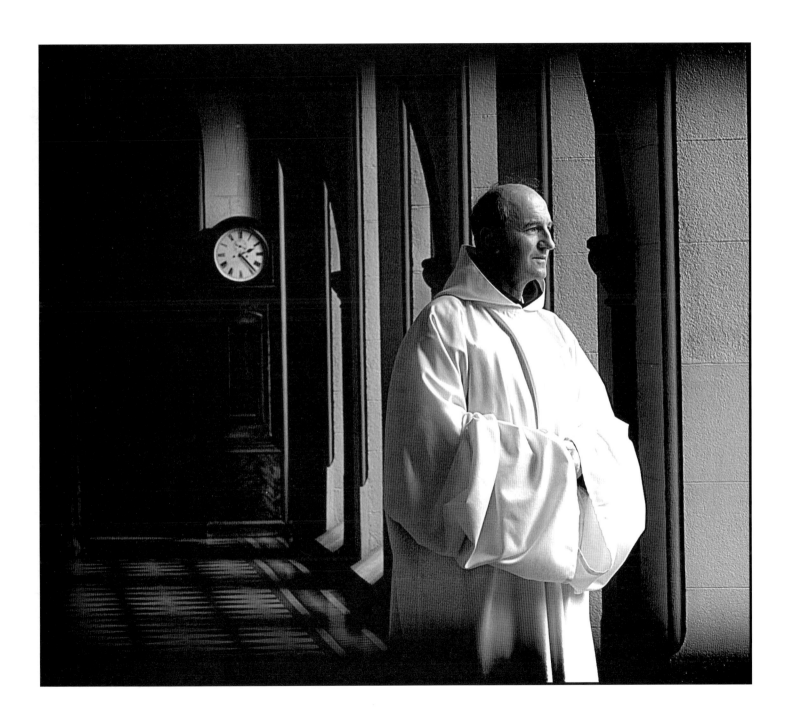

Dolores Lyne

As an artist, to have been born in Kerry is something I am very grateful for. Growing up in Killarney was to be always in the presence of wild uninhibited beauty, a place that indulges the imagination and provides a fertile ground in which to dream. Myths and legends seemed all the more believable because of the charged atmosphere created by the mountains and lakes. A sense of scale and drama is something I learned from living here. In Killarney I inherited a sense of belonging and shared magic.

Dolores Lyne is a professional artist and designer in theatre. Since 1989 she has been exhibiting in galleries around Ireland including the Rubicon, the Royal Hibernian Academy, Triskel, Galway Arts Centre and Festival, Siamsa Tíre, the Kenny Gallery, the City Centre Arts Centre, and Iontas. Married to James Harrold, she is the daughter of Peggy Lyne and legendary Kerry footballer Jackie Lyne (RIP). Dolores won the 1999 *Irish Times*/ESB National Theatre Award for her design of Island Theatre Company's Pigtown.

I am of
Kerry

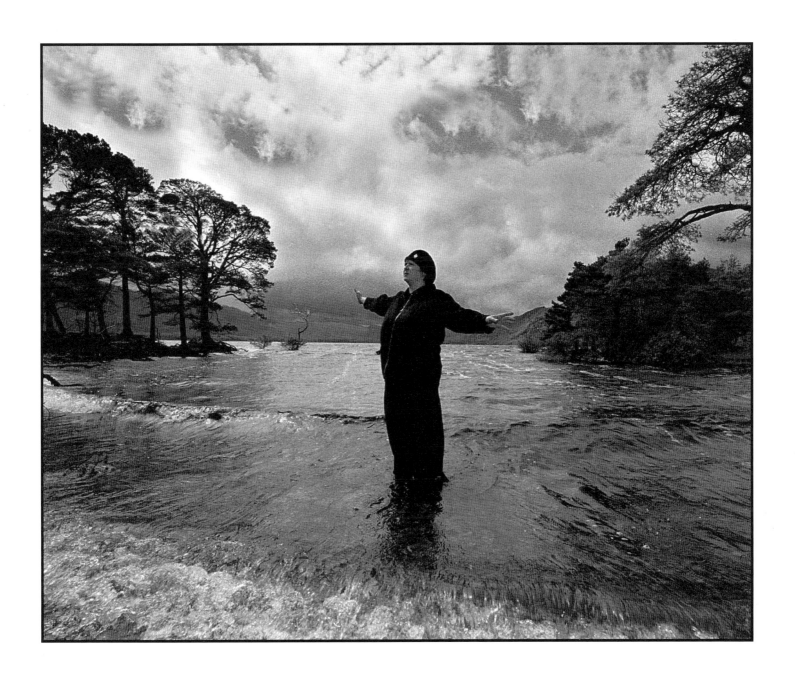

Mark Murphy

The Munster Rugby Team

The Munster rugby team is an outstanding team. They have great players such as Ronan O'Gara, Peter Stringer and John Hayes. They came second in the Heineken Cup in 2000/2001. Many of the Munster players also play for Ireland.

My favourite Munster players are Mick Galwey and Ronan O'Gara. I will always support them even if they were on a losing streak.

My dream is to be a mascot for either Munster or Ireland.

Mark Murphy is twelve years of age. The son of Paul and Paula Murphy from Cliveragh, Listowel, he has two sisters, Sarah and Amy, and a brother, Brian. He is a pupil of Scoil Réalta na Maidine, Listowel. Mark is a member of the Listowel Junior Rugby Club. He also plays Gaelic football with Listowel Emmets, as well as pitch 'n' putt. He loves play station and collecting model cars.

I am of *Kerry*

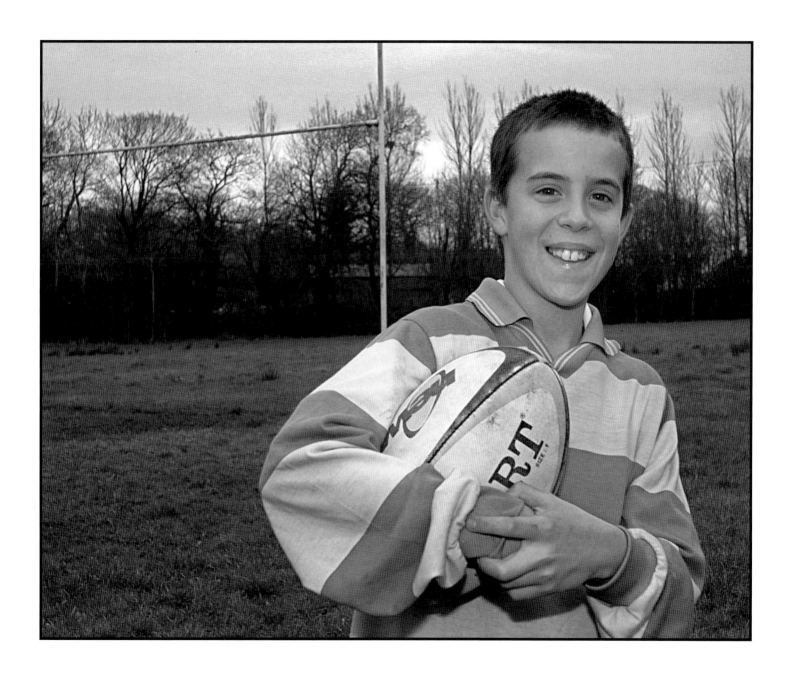

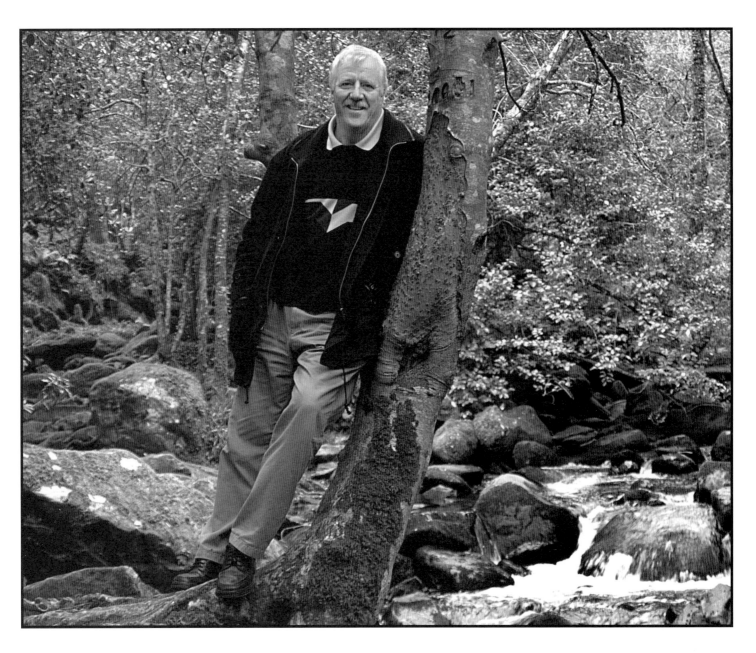

I am of
Kerry

Dan Breen

I was born in 1957, the second youngest of eleven children. I have a twin sister, Kitty. My parents, Mary and Jim Breen, ran a small shop at Kelly's Cross, Sneem. Growing up was fun, for the most part!

In my earlier years most of our entertainment came from the people who came to buy groceries in our shop. The creamery stop was just across the road, so from early morning, until late at night there was always someone in and out of our house. At night people gathered in our kitchen, and there would be a game of thirty-one. That was nearly every night. Us children would sit just above the turn of the stairs listening to the conversation going on in the kitchen, when we were supposed to be in bed. At that time no one travelled too far out of the locality, unless it was to hospital or to emigrate, so the conversation was always very interesting, as it was usually about some local person, or event.

My first school, Glenlough National School, was about a quater of a mile away. I went there for a few years, until it closed, and we were brought by bus to Sneem, to go to school there. I later attended the Vocational School in Kenmare. After school I went to Sarsfield Barracks in Limerick, after which I went to England and worked there for some years. Later I returned home as I had inherited the farm from my father.

This farm had been in our family for eight generations. I still work the land, but farming around here has to be supplemented with an off-farm income. I worked with local builders for some years, until my career took a change of direction. I now work with the Department of the Marine.

I have always loved sport, and have been involved in all types: rowing, running, badminton, tug-of-war, weight-lifting, golf, and of course Gaelic football. I trained diligently while I was a member of our local team, and was also involved in the administrative side as chairman, secretary and treasurer. I now devote my time to our local Bórd na nÓg, of which I was Chairman for three years. I introduced indoor hurling to Sneem three years ago.

I now live a few hundred yards from where I grew up, with my wife Evelyn and my two sons Ryan and Gavin. Rural life is very different now. People rarely visit each other's houses anymore. This is probably true of many parts of rural Ireland, and is why I treasure the memories I have of growing up in a rural community.

Dan Breen is a fishery officer with the South Western Fishery Board, based in Kenmare. His area covers Kilgarvan, Kenmare, and Blackwater. He is involved in all aspects of life in Sneem and surrounding areas: the local search and sea rescue, community alert, the GAA, IFA, and FCA. He also enjoys writing poetry.

Colm Cooper

My first day in Croke Park

My first day in Croke Park was 17 March 1992, when I was chosen as the mascot for Dr Crokes GAA Club in the All-Ireland club football final. I was delighted to be selected and as any other kid would be, I was extremely excited. It was a day I would never forget. Not only was it an historic day for Dr Crokes, but two of my brothers were playing on the team. From that day on it was my goal to play in Croke Park on All-Ireland Final Day.

Every child in Kerry has a dream of playing in Croke Park and I was no different. Little did I know that in 2002 I would be playing for Kerry in an All-Ireland against Armagh in front of 80,000 fans. It was an unforgettable experience. I have been lucky enough to make it on the Kerry team again this year. Hopefully we can be even more successful in the future.

If I had any advice for kids it would be to get involved in sport and I hope they would get as much enjoyment as I have received from it.

Sport is life!

Already a sporting hero at nineteen, Colm Cooper plays for Kerry and his club Dr Crokes. In his first year on the county senior team he scored an impressive five goals and seventeen points from play. He played for Dr Crokes when they won the 2002 county championship. A business studies student at the Institute of Technology, Tralee, he also plays with the College football team. Colm is a native of Killarney. His parents Michael and Maureen have four other sons: Danny, Mark, Mike and Vincent. Colm enjoys golfing, swimming and socialising!

I am of *Kerry*

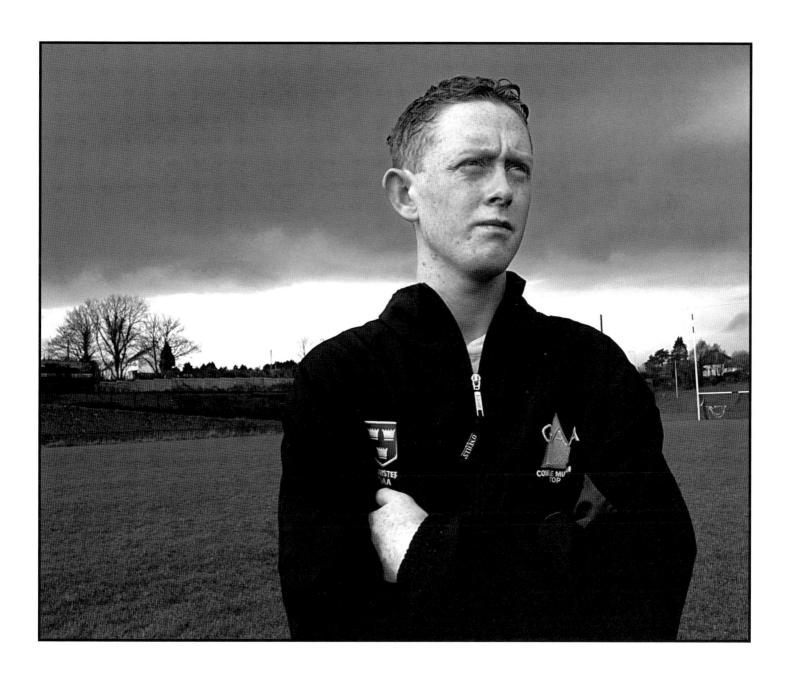

Padraig Kennelly

Kerry is the place

To be born in Kerry is an accident of birth over which one has no control. To then decide to live in the county is a conscious decision that makes a person a Kingdomite.

The rest of those born here, but who settle elsewhere are spiritual Kerry persons, whether their home is Dublin, Detroit or Dubai. They hold the Kingdom dear in the memory. They rally to the cause of Kerry at football or other events. They join Kerry organisations and they visit their Mecca, not once, but many times.

The third group consists of Kerry persons by adoption. That status is conferred on those who born elsewhere, but who become ensnared by Kerry and all it means. They transfer residence to any place west of a line drawn between Fealesbridge and Kilmakilloge. They are our citizens just as much as if they were born here. They bring new genes to the Kingdom's genetic pool. And their offspring are proud to be of Kerry.

All three strands of Kerry people should each day chant the mantra 'A day out of Kerry is a day wasted.'

Padraig Kennelly founded *Kerry's Eye* newspaper in 1974. His wife Joan and sons Padraig, Jerry, Brendan and Kerry all work at the newpaper. Padraig was educated at Tralee CBS and the College of Pharmacy, Dublin. He retired from pharmacy in 1956 to start a career in photo-journalism. He also worked as a freelance cameraman with Telefís Éireann. His son Jerry subsequently set up his own media business, Stockbyte, in Tralee. *Kerry's Eye* is now under control of the second generation, and is one of the biggest printers of regional newspapers in Ireland. Padraig's interests include Kerry, local history, local government, planning law and swimming.

I am of
Kerry

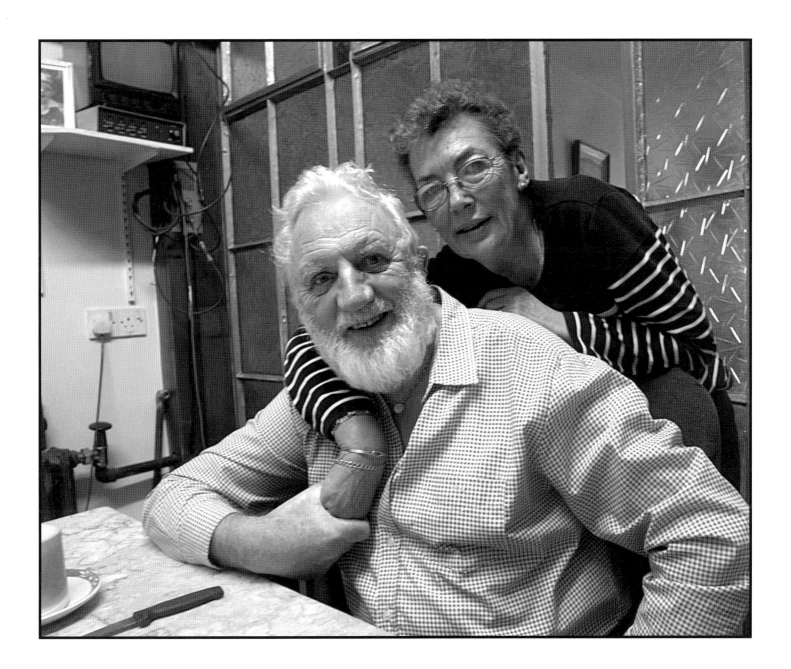

69

Bernie McCarthy

I came across this poem when I was doing some training and it sums up what listening is about for me. Too often we are not really listening at all, we are preparing our answer or our piece of advice while someone is talking.

Maybe if we could learn to really listen when we are asked, people could figure out what to do for themselves. Our advice probably does not fit for them and often they never asked for it anyway. Children will sometimes say to adults 'I want to tell you something and you are not allowed to speak until I am finished'.

Please Listen

When I ask you to listen to me
And you start giving me advice,
You have not done what I asked.

When I ask you to listen to me
And you begin to tell me why
I shouldn't feel that way
You are trampling on my feelings.

When I ask you to listen to me
And you have to do something
To solve my problem
You have failed me,
Strange as that may seem.

Listen! All I ask is that you listen.
Don't talk or do – Just hear me.

– Anonymous

Bernie McCarthy works as a counsellor with the Kerry Rape and Sexual Abuse Centre. She lives in Killarney with her husband Tadhg and their three children: Treasa, Kevin and Niamh. She trained as a psychiatric nurse in St Finan's Hospital and worked there for nine years. She moved with her family to New York/New Jersey and lived there for three years. They moved back to Killarney in 1991. Bernie's hobbies include reading, eating out and cooking.

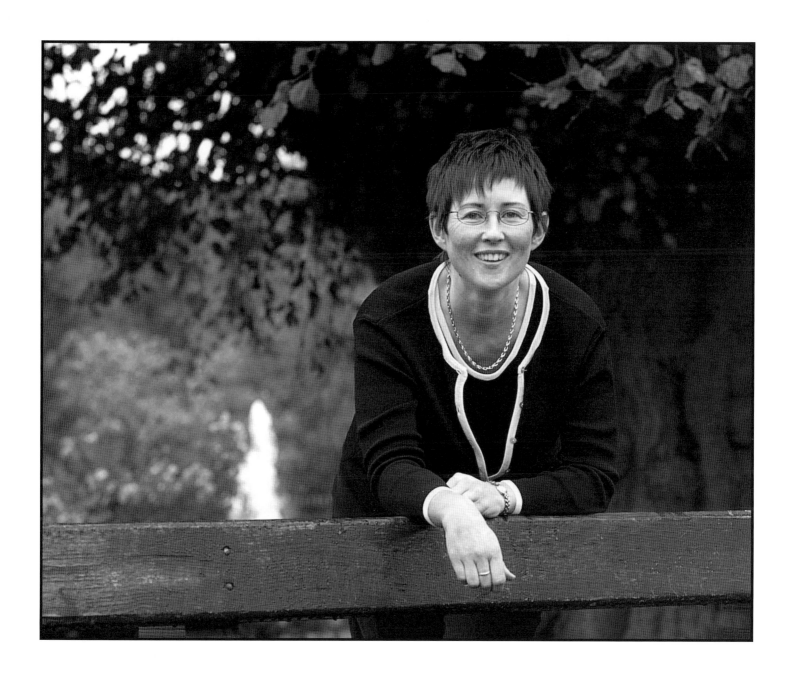

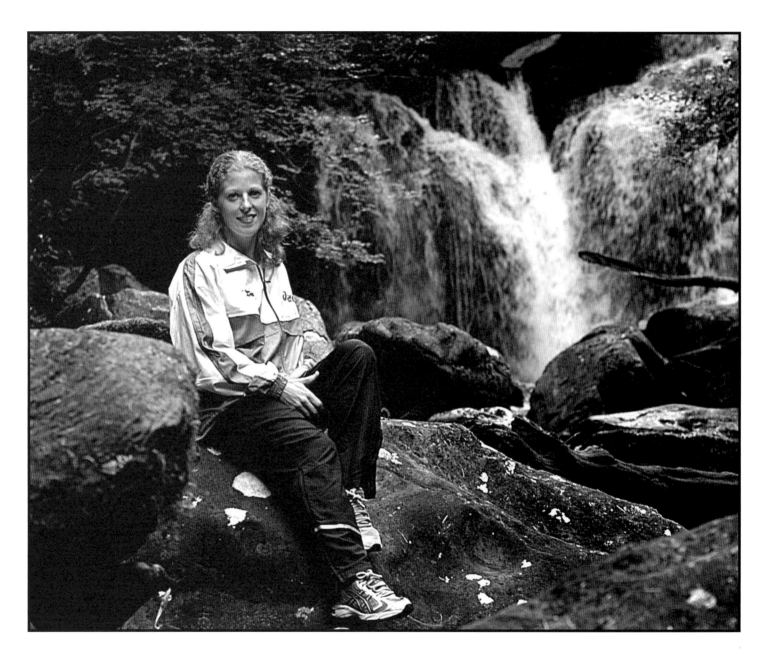

I am of

Kerry

I have been fortunate to have achieved success in athletics. While competing, I get great opportunities to travel throughout the world. I have visited countries that I would probably never have seen only for athletics. The journey I most enjoy, however, is returning to my family and friends who have continued to give me support and with whom I can celebrate my success.

Gillian O'Sullivan is a full-time athlete, based in Cork. She is originally from Minish, outside Killarney. The daughter of Pat and Alice O'Sullivan, she has three brothers and one sister: Thomas, Michael, Paul and Maria. Gillian holds the five kilometre world record in walking which she won in 2002 in Santry, Dublin. She came fourth in the twenty kilometre race at the European Championships in Munich in 2002 and tenth at the Sydney Olympic Games over the same distance. She broke the world record again in the 3000m event at he Odyssey Arena Belfast, 2003 At the moment she is training for the World and European Championships and the Olympic Games in Athens in 2004. Gillian enjoys reading, socialising, travelling, Irish music and dancing.

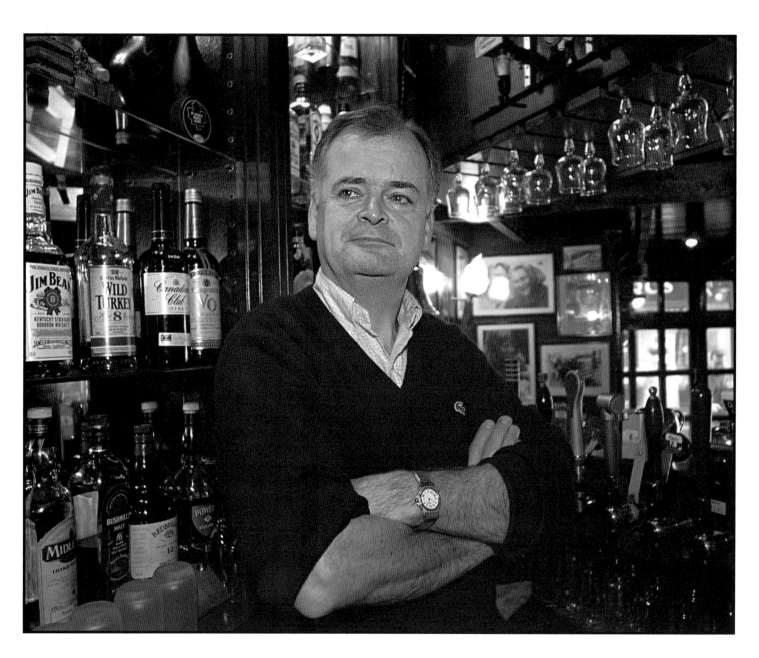

I am of

Follow your head…

It's YOUR LIFE
be happy…

Travel is education.

Gary O'Donnell was born and educated in Tralee. After studying hotel management, he worked in the Towers Hotel, Glenbeigh, then owned by the famous Ernie Evans. Gary also worked in London, South Africa and the Middle East, before returning to Tralee where he now owns and runs The Baily's Corner Pub. Gary has two sisters and three brothers and is a member of Castlegregory Golf Links.

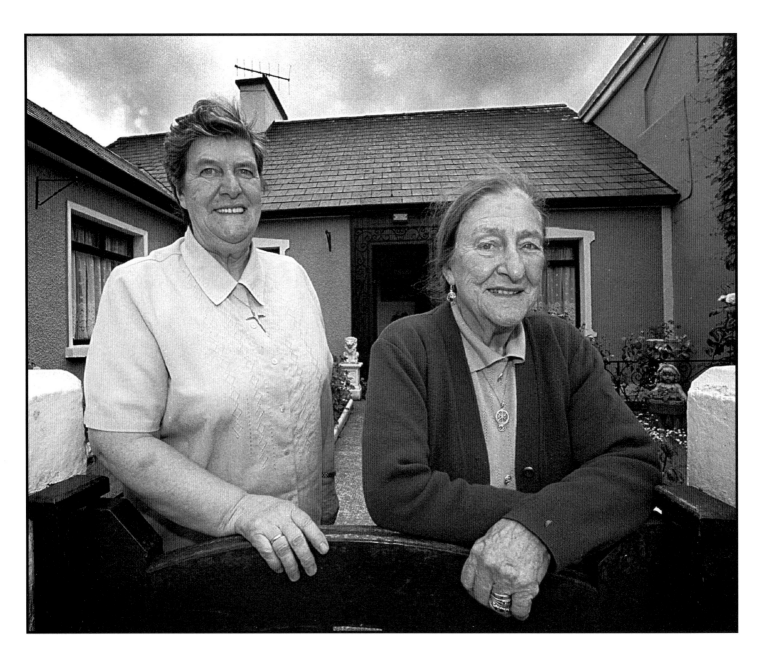

I am of

Tess & Eileen Kiely

Tess Kiely

Whether I am visiting my family at home or abroad or working in the garden, I have received great strength and hope from a prayer, that sees Mary as a tender loving, caring mother. All of my family have been taught it from on early age. I have said with them every day since I got married in 1935.

The prayer finishes with the words 'O Mary, most sweet Mother, we pray to you, knowing that Jesus will hear your prayers.'

Tessie Kiely, 'Mom Kiely', is a native of Dunmanway, Co Cork, but has lived in Kerry since 1936. After four years in Listowel, Tarbert has been home since 1940. Her husband Daniel Kiely from Kiskeam, was a member of the Gárda Síochána and died in 1983. A retired post mistress, Tessie takes great pride in her fourteen children: Mary, Peter, Kathy, Dan, Phil, Margaret, Aggie, Denis, Imelda, Gabrielle and Michael. Eight girls and six boys. She has fifty-two grandchildren, and forty-four great grand-children. Tess lives life to the full and enjoys her family and friends.

Eileen Kiely

As a Columban sister working in a hospice in a very poor part of Santiago, people ask me if the work is depressing, when we are always dealing with death. It isn't for me, when I realised what hospice care is. We want to add life to days when days cannot be added to life. To do that we must listen, accompany, be present, often feeling helpless, while at other times our expertise in pain and symptom control really help the patient to have a 'good death'. We learn a lot from our patients for they are our best teachers.

As a Columban sister I feel the stream of God's love and power flowing in and through the poor, especially women. It beckons us religious sisters to go beyond ourselves to embrace our own poverty as we relate with peoples' cultures and all creations as missionary religious women.

Eileen Kiely is a Columban sister, who has worked in Korea, the United States, Ireland and is currently working in Chile. The oldest daughter of Tess and Daniel Kiely, she draws inspiration from these words of Oscar Romero: 'We are prophets of a future not our own'.

John O'Mahony

Funny, isn't it, how the wheel of life can spin full circle in a relatively short space of time and how childhood infatuations can return to play an active role during adult life. Growing up – and growing out – in Killarney, I didn't have to travel very far to experience all the enchantment that the great Kerry outdoors has to offer.

In my boyhood years, Killarney National Park at Knockreer was an almost daily port of call during the long days of summer. And now, with time progressing, the place that held me captive in my youth has once again taken on great significance. Reluctant though I am to admit it, excursions into 'The Demesne' were scratched off my personal itinerary for many years, due to a combination of work commitments and a wholehearted determination not to neglect my social obligations.

But the entry into this world of my daughter, Molly, who arrived with a healthy bawl and a mischievous grin in October 1998, has brought me back to the future, so to speak. Suddenly Knockreer and all of its natural charm was put back on the agenda as regular adventures were activated with mum and dad consigned to tour guide duties as a buggy and, more recently, a Barbie bicycle scorched their way along the spectacular tree-lined river walk. I have quickly learned that there is no such luxury as personal time, during daylight hours at least, when there's a four-year-old to be kept amused. And, to be honest, I wouldn't want it any other way as our little dad/daughter mini adventures have helped me to re-visit, re-live and re-capture all the places and many of the things that were close to my heart in my own childhood.

Places like the engaging village of Sneem, the birthplace of my mother, where the elegance of the surroundings is matched only by the warm embrace of the locals. Places like the beach at Rossbeigh or Inch on a warm July morning or a chilly September evening when sun worshippers are in short supply and the attractions are there to be savoured in an uninterrupted fashion. Magical places like Bird's Amusements on a long summer's night offering a kaleidoscope of colour and the proverbial fun of the fair. And places like Killarney Library that can help carve out an opening into a whole new world and introduce new experiences that, otherwise, would never be encountered.

In my youth the library was located in a cramped but extraordinary room in the town hall where the late Kitty O'Connor held court and I remember, with great fondness, the great sense of dread experienced if a book had passed its return-by date. Kitty's glare was so much more effective that a three-penny fine – and I'm sure she knew it too! Today the library is housed in an ultra-modern building and it remains a virtual treasure throve although I'd swear that some of the books in stock are emblazoned with stamp marks that can be traced back to the hand of the late Kitty O'Connor.

But, still, it is 'The Demesne' that I believe personifies all that is good about Kerry, a spectacularly beautiful and tranquil wonderland, with unrivalled scenic walks and a truly magnificent sense of calm. It's a place that offers an unique opportunity to get in touch with nature, just a stone's throw away from the snarling traffic and the frenetic hustle and bustle of commercial life in downtown Killarney. It has always been my contention that the National Park at Knockreer, virtually untouched and unspoilt by the callous modern hand, has so much more to offer than the more recognisable version at Muckross which has long since succumbed to almost inevitable commercial considerations. 'The Demesne', as it will always be known to locals, perfectly sums up the scenic Kerry that I know and love and long may that continue.

If I am not there myself to oblige, I can only hope that, in years to come, Molly O'Mahony will take her children by the hand and lead them to a magic place that was much admired and greatly appreciated by their grandfather.

John O'Mahony was born in Killarney. He is a son of Sheila and the late Patrick O'Mahony. His brother, Brian, was chosen as the Kerry Person of the Year in 2002 and Irish Person of the Year by *The Irish Times* in 2001 for his work with the Irish Haemophilia Society. John pursued a career in journalism – a trade he has now been involved with for twenty-one years, and is editor of *The Kingdom* newspaper. He is married to Geraldine O'Shea from Pallas, Beaufort, Killarney and they have one daughter, Molly. They live at Lackabane Village in Fossa. John is an avid reader and sports fan. He is a keen observer of Irish political life and enjoys the company of a wide circle of friends.

I am of
Kerry

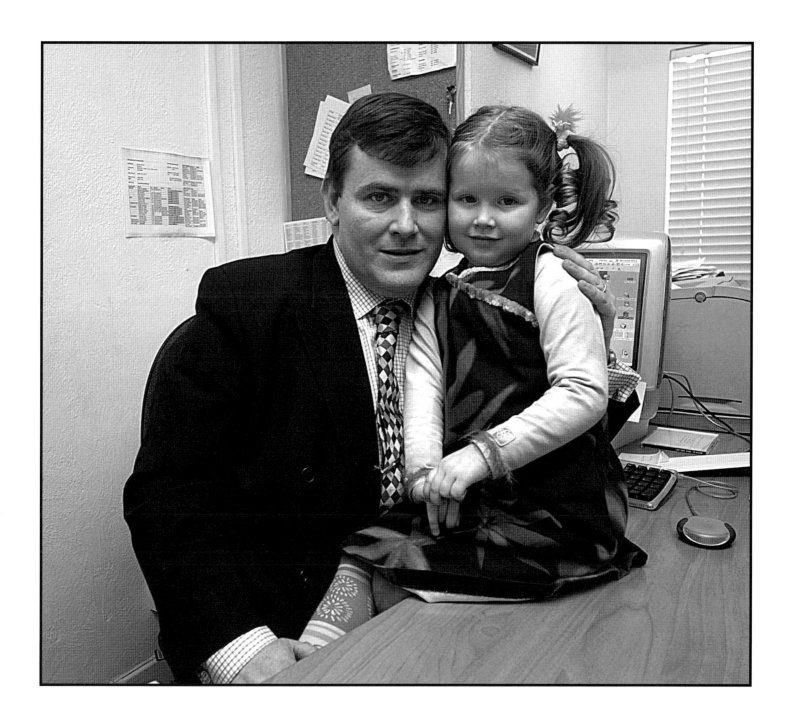

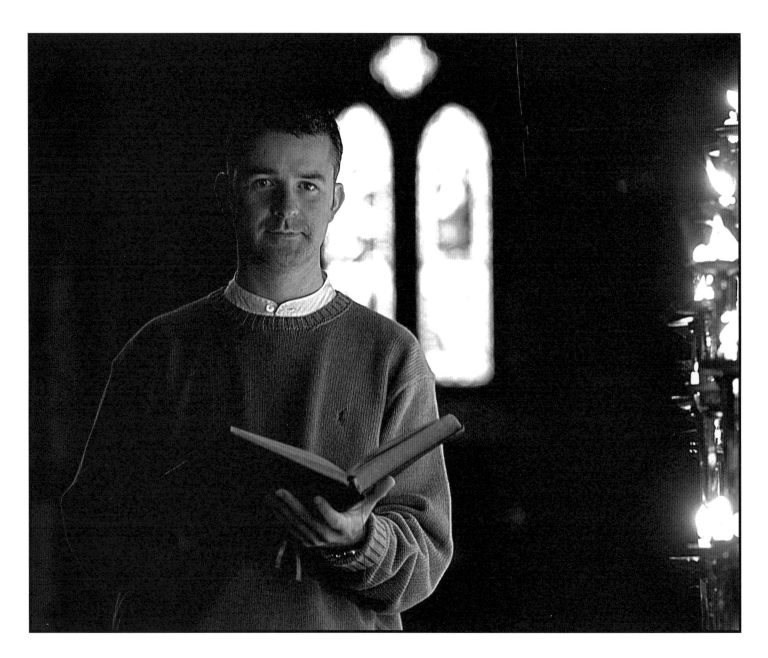

I am of
Kerry

Diary entry

Requiem
22 April, 2002
St Mary's Cathedral
Killarney

… Through the lancet windows high on the south facing nave, soft golden light in diagonal shafts cut the sombre air… The delicate strains of '*Lux aeterna*' still resound… Incense wafts from a glistening thurible, ascending gently, softening the light's razor edge… 'In peace let us take…' Words fade… Foot-fall in perfect meter embodies the farewell… Safe, away in the distance of the organ loft the vision is almost illusory…

But I'm always wrenched back. Back to that sun drenched morning from whence life could never be the same again. Memories like driving rain, still flood my mind and saturate my being. Every word, smell, colour and gesture are real. 'The just man though he die before his time,' the aroma of the incense, the clanging of the chains, the music '*Dona nobis pacem*' , the sea of blue, the incessant reverberation of the slow march drum. As real for me today, as for those who now grapple with their loss.

Yet the memories, the memorial, are of themselves cathartic and in some strange way, life giving. Presence is almost as real as absence, and tears and laughter spring from each other.

'… We recall Your life-giving death and…'

Pádraig McIntyre is the Diocesan Director of Music and Director of Music at St Mary's Cathedral Killarney. A native of Kenmare, he is the Son of P. J. and Mamie; and the brother of Geraldine and the late Séamus McIntyre. 'Music was always my hobby and is now my work. Other than church music, theatre and musical theatre is a love, having treaded many a board and "broken" many a leg. I clear my head in Gleninchaquin, Inch Strand and Muckross Abbey. I love a G&T, a rich red Bordeaux , roast duck, but just as happy with a McDonalds on the run.'

Maurice Fitzgerald

My friend and confidant, St Mary's team manager, Gerdie. Don't be fooled by this soft-looking exterior, inside is a ball of steel and as Gerdie shouts the instructions his team jumps to attention. We have worked and trained together for many years for the blue and white of St Mary's.

St Patrick's Day in Croke Park is the only thing that will satisfy this man's ambitions. Here's hoping.

Maurice Fitzgerald is regarded as one of the most stylish players of Gaelic football, on a par with the great Mick O'Connell. He is a holder of two All-Ireland medals playing with the Kerry senior team. He has been a member of St Mary's senior football team since 1985, which has won six South Kerry senior championships in that time. Maurice is a native of Cahirciveen and works in the family auctioneering business. He is married to Sharon and they have three children: Clíodhna, Muiris and Aoibhinn. Apart from playing football, Maurice enjoys hill walking, boating and all sports.

I am of
Kerry

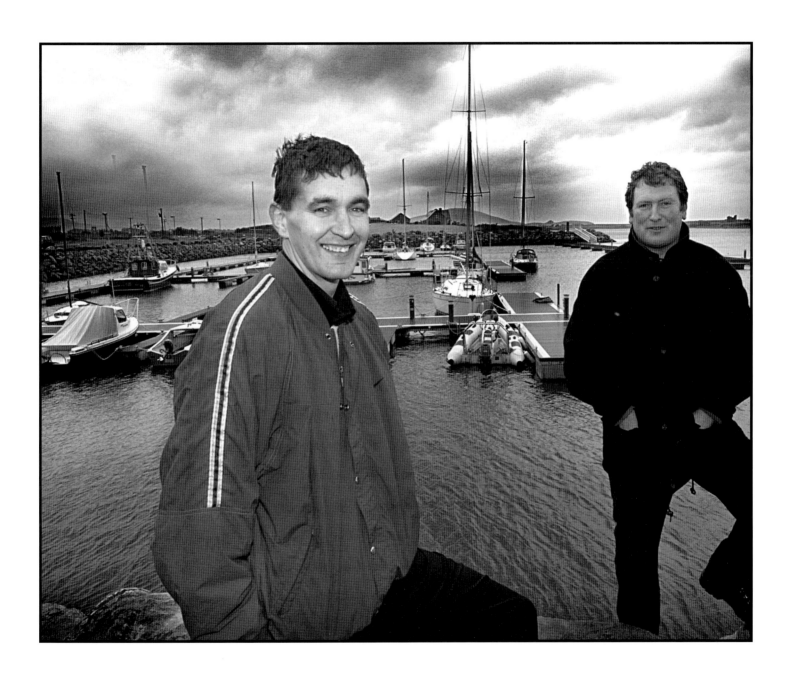

Lora Gordon

Recently I saw a friend planting a tree. She carefully put the young tree in the ground and placed a wooden stake by its side, leaving a space between. She tied them together so the stake could support the growing plant. The wooden stake looked strong next to the little tree. The image remained with me. It conveyed a sense of unconditional support. The stake does not tell the tree how to be a tree. It simply stands by the growing tree through buffeting winds, rain, hail, snow and the occasional badly aimed ball, until the little tree grows strong enough to stand alone. In my personal life and in my work support without conditions is a priceless gift.

In 1994 I returned home to live in Kerry with my family. I had lived in America, London and Australia and happily called each place 'home'. Now in my home place I felt a bit out of step. I had missed many of the big events. Celebrating Mary Robinson's presidency was a surreal moment when experienced under the high blue sky of Perth in Western Australia. My homeland had changed almost beyond recognition while I was busy else where.

Through all the journeying Ireland was always at the next turn and I knew some things would never change. The beautiful view of the Feale from the bridge in Listowel. St John's Church seen against mountains capped with snow as I drive into Tralee. These were images I took with me and they now assure me that I am home even in the times when I find myself surprised to be living here.

Lora Gordan has worked as a nurse, midwife and health visitor. She has a post graduate diploma in counselling and joined the Kerry Rape and Sexual Abuse Centre in 1995, which she describes as 'one of the most important and satisfying decisions of my working life'. Lora is married to Gary and they have three children: Sarah, Christopher and Richard, and one grandson, Jack.

I am of
Kerry

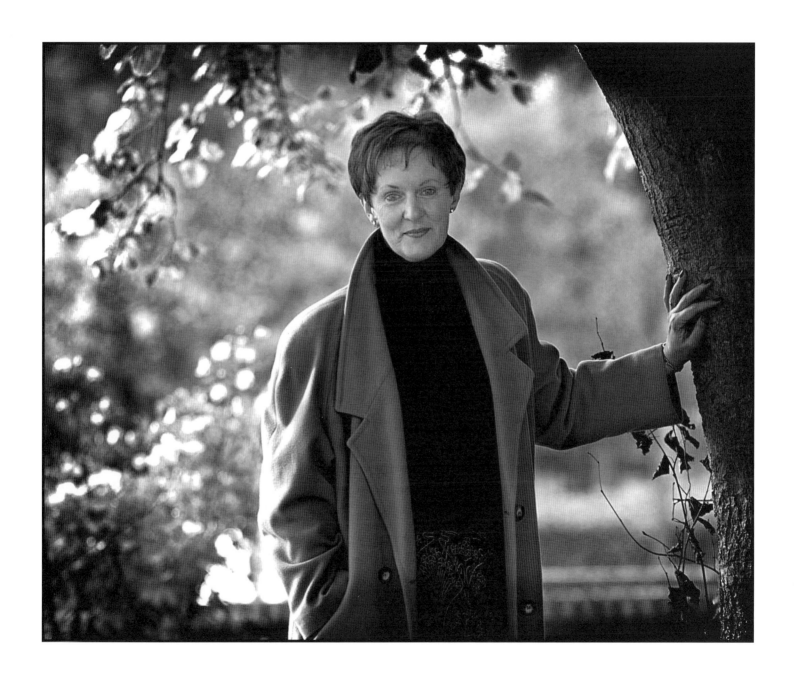

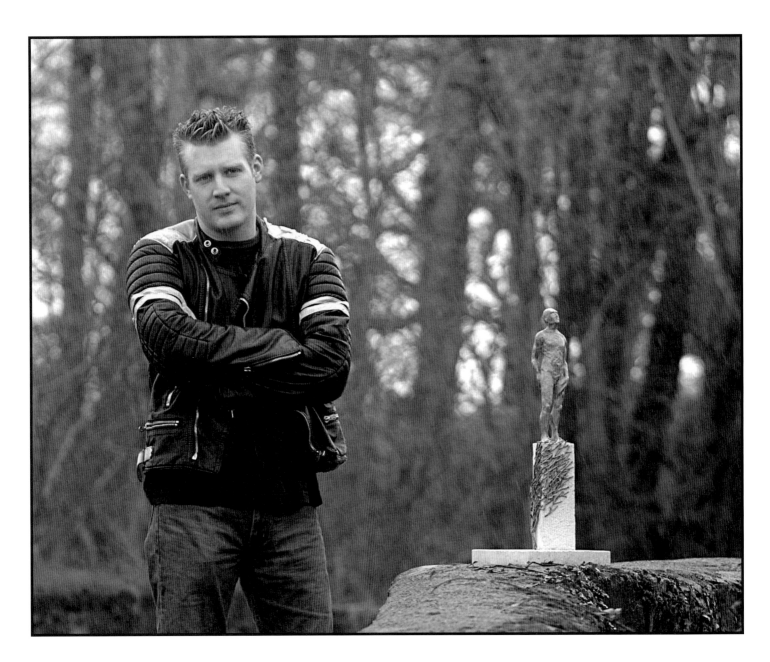

I am of

Kerry

Sunday 26 January 2003

This morning I woke to a beautiful day.

I looked to the south and found Mangerton and Torc, majestic and proud, as clear and precise in the sunlight as I had ever seen them. I could imagine the lakes.

There are many reasons why I choose to live and work in Cork. There are many more reasons why Kerry is still home.

Joe Neeson is a sculptor based in Cork, working mainly with bronze. He specialises in public art and his commissions include work for Dúchas, Shannon Development, the Department of Agriculture, and the Legal Aid Board in Cahirciveen. His piece 'Flight' was unveiled in Shannon by President McAleese in 2000. Orginally from Killarney, Joe is the son of Frank and Frances Neeson. His family include his brother Gerard and sisters Lorraine, Mary, Veronica and Frances. He enjoys cycling and is a member of Cork Printmakers.

Patrick Curran

Valentia Island

'Magical Valentia Island.' How often have I heard that expression from tourist and locals alike. When one asks 'how come?' a deluge of reasons come to mind. This seven mile island is home to one the greatest footballers of all time, Mick O'Connell! He and 635 inhabitants live very happily on the Island. So what else? Knightstown was one of the first planned villages in Ireland when the knight of Kerry, Peter Fitzgerald, called on Scotsman Alexander Nimmo to design the village. In this tiny village they built the Western Union cable station, the lifeboat station, a slate processing yard, a Mason's lodge, a fisherman's hall, a jail, a police barracks, hospital, hotel, two churches, accommodation for coastguards, a lightkeeper and radio staff house. There is a second village on the western side of the Island called Chapeltown where the river Coal flows peacefully along, stocked with trout. This village has a hostel, post office, primary school, and resource and child care centre.

More amazing was the disovery on my land of the oldest footprints in Europe and the second oldest in the world. The Tetrapod Trackway was discovered in 1992 by a Swiss geologist. The footprints date back 350 million years.

Another great feature on the island is the Altazamth Stone, where the final experiment took place confirming the lines of longtitude for seafarers. The spectacular slate quarry, Our Lady's Grotto, is once again in production.

Other places I love to visit on the Island include the Ceiliúniachs or early burial grounds, scattered around the Island; Valentia radio station, now Valentia Coastguard; the Cable Stone marking the exact spot where the transatlantic cable came ashore; Cromwell Lighthouse at the entrance to Valentia Harbour; Bray Tower which was a look-out during the War; the megalithic tomb at Feighmane; a druidic burial ground at Upper Tennies; and the Ogham Stones on the western side of the Island.

The famous Tetrapod Track on Patrick Curran's land

P atrick Curran has been a Valentia Islander all his life. He is a farmer and is involved with the daily ferry from Renard pier to the island. He is married to Marie and they have two children, Miriam and Desmond. The famous Tetropod track was discovered on his land in 1992, giving geologists a valuable insight into the earliest phase of the conquest of land by vertebrates. Patrick enjoys farming, fishing and was involved with Valentia Rowing Club for many years.

I am of *Kerry*

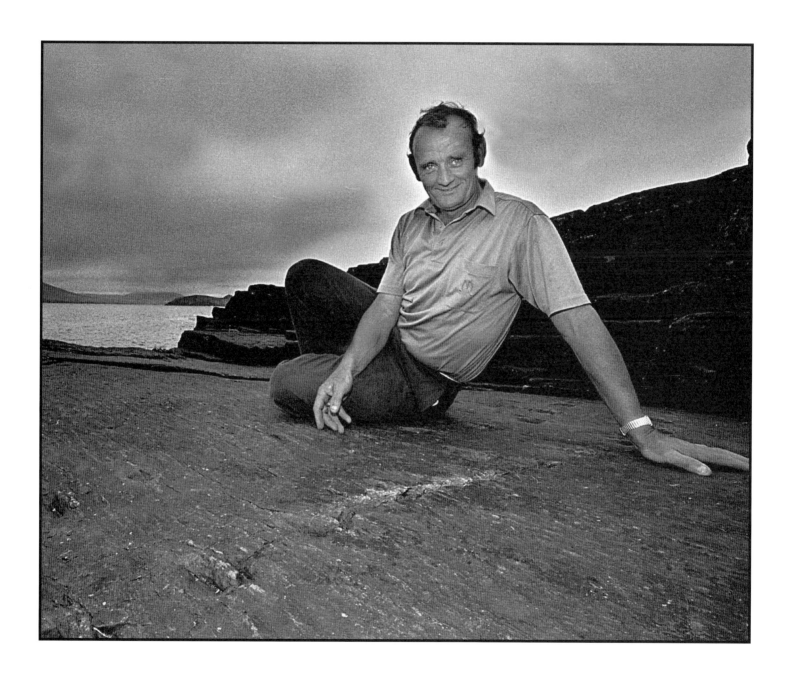

Eamonn Fitzgerald

Kerry is my home and I am at home in its kingdom.

God was good to us when He gave us the Reeks, the Atlantic, the Ring, the Dingle Peninsula and countless other jewels. I have been impressed on my travels by the Great Wall of China, Hong Kong, Athens' Acropolis, downtown Manhattan and 'Frisco's Golden Gate Bridge, but my favourite view in the world is the unsurpassable scene from the Scariff Inn, as you drop down from Coom-a-Ciste to Caherdaniel.

'Earth has not anything to show more fair, dull would he be of soul, who could pass by a sight so touching in its majesty.'

Thus Wordsworth described Westminster Bridge, echoing my own thoughts on Coom-a-Ciste.

There is another world I love thanks to one loyal companion, Cara, my dog. He has led me to the untrodden places, unknown to other men. For Pearse it was 'little rabbits on a field at evening lit by a slanting sun'. The rabbits outwit Cara as I value the moments of unexpected joy, a virgin carpet of bluebells under an oak tree, the first blackberry, the sycamore tree at the 'Corner of the Park' in all its autumnal glory, the winter torrents cascading down the mountains around Sneem – my native village, my spiritual home – and the brave crocus shoving its head above the frozen earth. That's a vote of confidence in the mystery of life's seasonal cycles, the God-given faith inherited from my late great parents, a haven of refuge for me especially on days of unhappiness. Sharing it with Maura, Niamh, Ciara and Roisín is really special.

The language of the Kerry people is music to my ears, especially Brendan Kennelly, John B. Keane, Bryan McMahon, Eamonn Kelly, Peig Sayers and countless ordinary people; what they say and what they are really saying. To know the Kerry code is to enter a world of slagging, roguery, the wink, body and elbow language. I am also indebted to those people who inspired me to learn and love the 'Gaolainn'.

Sport is central to my life, all sports but especially the GAA, the century-plus traditions of Kerry's green and gold and Dr Crokes. So too is education. Much done, but so much more to do. Life is an education in itself and I am one of its lifelong learners, sometimes master by name but always a student at heart.

Kerry made me, shaped me and is constantly recreating me.

Briseann an dúchas…

Eamonn Fitzgerald is from Killarney. He is married to Maura and they have three daughters. Niamh – married to Donal Dwyer – Ciara and Roisín, and one grandchild, Aéabha. Eamonn is Education Officer with Kerry Education Service. He started teaching in Dublin and taught in Killarney Community College from 1972-2000, where he was principal for eleven years. He won two Munster senior football titles and two National League medals as Kerry senior goalkeeper from 1970-1973. He also won several titles with East Kerry and various medals at all levels with his club, Dr Crokes. He writes the sports column 'On The Ball' in the *Killarney Advertiser* each week. His interests are in people, reading, writing, golf, and outdoor activities. Religion is central to his life.

I am of *Kerry*

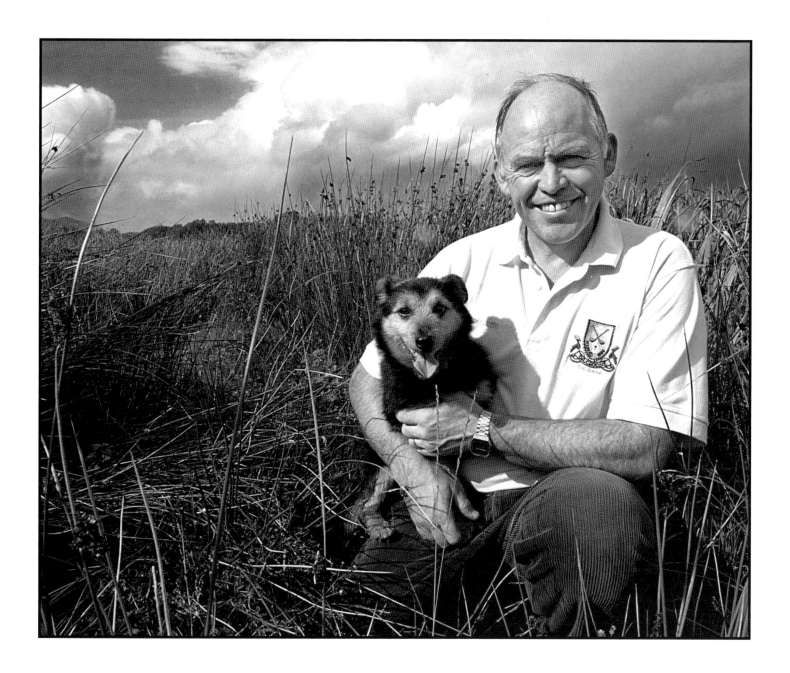

John Moriarty

My Mother crossing the yard, holding turf and eggs, fire and life, in her upturned, cross-over apron, and cows coming up the road, my father's eleven cows, and my father walking behind them, walking slowly, because cows in calf, old short-horn cows that are heavy in calf, that's how they walk, to watch them walking you'd think 'twas the Dingle mountains they were carrying inside them.

That's how my father learned womb-waiting. That's where the dangerous wildness that used to be in him left him. Sitting on a three-legged stool against the stall wall behind his cows sitting there at night, listening to them chewing the hay or chewing the cud, that's where my father came to dh'end a thinkin'. That's where his wisdom came to him.

Walking up Fitz's Hill in the dark I couldn't help but say it, pray it:

Walk on Mary, walk on Jimmy.

And something else there was that I had to say and pray:

It was Good Friday and, looking down into Adam's empty skull, the Son of Man had seen that, inwardly also, he had no where to lay his head.

– Taken from *Turtle was Gone a Long Time: Volume One*

Mystic, philosopher and writer, John Moriarty lives in the mountains in Coolies, Muckross. Originally from Moyvane in North Kerry, he studied at University College Dublin, was then tutor at Leeds University and he lectured in English Literature at the University of Manitoba in Canada for six years. He lived and worked as a gardener in Connemara for twenty years, three of which were spent in solitude. His many books and volumes include *Dreamtime, Turtle was Gone a Long Time* (three volumes), and his autobiography, *Nostos*. John's family includes his brother Chris and sisters Madeline, Babs, Brenda and Phyllis. He is passionate about nature and enjoys the company of his neighbours and friends.

I am of
Kerry

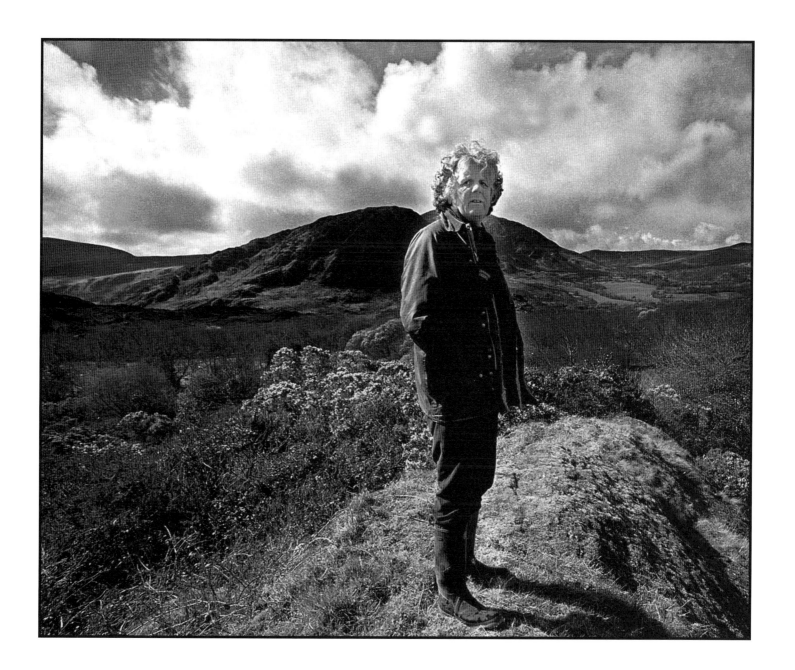

Aoife O'Donoghue

I live in Cahirciveen in Kerry. I have two silly brothers and three kittens that are my favourites. Shakira is my best kitten, the other kittens are Simba and Samba and my brothers' names are Pádraic and Michael. Michael has really curly hair. My school is Aghatubrid, my teacher is Mrs O'Neill. I used to have a dog called Shannon. She was killed by a car and went up to heaven. My friend Nina went to Germany for three weeks.

I go to Morocco on my holidays. I go there on an aeroplane. There is a swimming pool. I go to Seamus' for dinner and for the desserts. I have chocolate mousse. I like the roses, the man always gives them to us. Most days I see a tortoise.

In summer I go to Granny's in Achill. I make things out of pottery and do water sports and samba soccer. I go fishing with Daddy. I caught two fish and I had to throw one back. I like to watch James Bond and Pokemon.

At my Christmas play I was a tree fairy. Last Hallowe'en I was a purple furry alien. Next year I'll be a fairy. I like nice dresses. I'm good at drawing.

When I grow up I'll be a doctor.

Aoife O'Donoghue is six years of age. She lives in Gurranearragh, just outside Cahirciveen, with her parents Patrick and Caitríona O'Donoghue. She attends Aghatubrid National School. Aoife has two brothers Pádraic (9) and Michael (4). She loves all her kittens, eating chocolate mouse, drawing, belly dancing, swimming, going on holidays to Morocco. When it comes to music, she is a big fan of Shakira and 'The Kethchup Song'.

I am of
Kerry

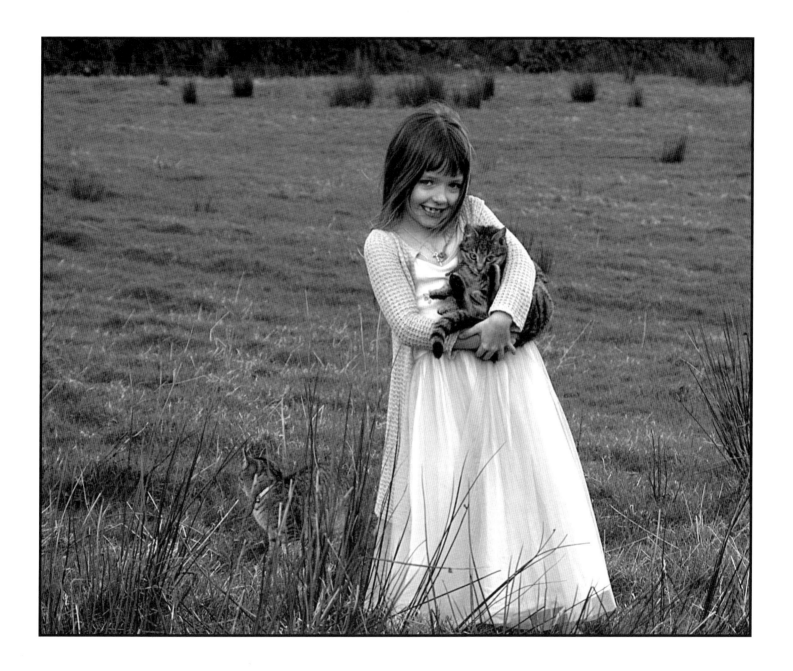

Alice Kavanagh

Originally a Kilkenny Cat, I came to live in Kerry in the mid '80s. As I drove along the road from Killarney to Kenmare with the mountains on one side and the lakes on the other, I felt I had come home.

Having lived here now for sixteen years my sense of belonging has increased. Working and living among a rich mixture of locals and blow-ins, gives Kerry a kind of bohemian atmosphere which reflects my personality.

When you choose a way of life, you invest your heart.
Choice becomes an invitation to commitment.
When you commit, you deepen your presence.

– Taken from *Eternal Echoes* by John O'Donoghue

Alice Kavanagh lives in Killarney with her two sons, Stjohn and Christopher. Having studied in the Tivoli Counselling Centre and at Magee University in Derry, she qualified as a counsellor in May 2000. During her time in Derry, Alice worked at the Well Woman Centre in Queen Street. She now works as a counsellor in the Rape and Sexual Abuse Centre, Tralee. She also works for Headway Ireland, counselling people who have acquired a brain injury, and their families.

I am of
Kerry

I am of
Kerry

When I leave Dingle for my beloved Árd a' Bhóthair and at Baile Mór get the whiff of the Atlantic breeze and gradually see the harbour open its arms in welcome, I realise that I am the luckiest bloody man in the world. I suppose the sea has a comforting, inspiring and challenging effect on me. I like the comfort, I long for the inspiration and I love the challenge. It may be the challenge aspect that has the effect of giving me a certain toughness and at times roughness that I cannot readily explain.

I live in Árd a' Bhóthair with my wife Máire and family Neasa, Siún and Páidí Óg. People often say to me that I have the best pitch in Ireland or the world, with the pub, the church and the shop, all complementing one another. My neighbours call for provisions, bread, milk and butter in the shop; for spiritual uplift in the church and for a social drink in the pub. The parish priest thinks that nobody comes to Árd a' Bhóthair without leaving a little contribution in at least two of these focal points! In the summer, when not away on football duties, I am at home to visitors and tourists, young and old, from places near and far. Nobody seems in a hurry and the welcome smile is always returned. Across the road in Paddy Fitz's house lives my mother, Beatrice, and left and right of her live the remainder of the family: Tom and Roseanna, Joan and the lads: Fergal, Dara, Tomás and Mark. In 2002 we lost Mícheál, my eldest brother.

Bar and grocery is my living with selling porter – adding a good top to it! I enjoy the evening company of locals, some blessed with the wisdom and serenity of years. Others, of sparkling wit who will be their worthy successors: seanchaís in Gaelainn as well as in the colourful Ventry dialect of Hiberno-English. Strangers at times take this to be a variety of Norse that survived near Swerwick.

I love visiting Dublin, the banter and anecdote and repartee can be sharp and enjoyable, but after two days, I want to get back home, away from traffic jams, speeding, push and rush.

Football or *caid* as it is called here, is second nature to me. Ventry had its team in the nineteenth century and folklore tells of a famous match between Fionn Trá and Dún Urlann. The opposing team had the benefit of a well-trained dog which snatched the ball and was heading home therewith when a Fionn Trá defender managed to get his boot to the ball and foil the invaders. The late Bartley Garvey, of Polo Grounds fame, led the Ventry team in the '40s and later encouraged my young efforts. Paddy Bawn Brosnan, who was as famous as a fisherman as he was a footballer, and was another of my heroes and mentors.

I have had my joys and trials and victories as a player and manager. The GAA is a model of voluntary effort. An excellent coach of team spirit. In these changing times it is striving to care for its players more than in the past and I trust it will succeed without losing its ethos of love and pride of local community, rather than financial gain.

Páidí Ó Sé has been the *bainisteoir* of the Kerry senior football team since 1995. A native of Ceann Trá, he is married to Máire and they have three children: Neasa, Siún and Pádraig Óg. Páidí won eight All-Ireland senior championships playing for Kerry in the glorious era of Kerry football. He has played in all positions including goalie. His most memorable goal was scored in Sydney against a Sydney Select in 1981. Apart from his passion for the Kerry team, he enjoys traditional music, and handball. The famous 'Comórtas Peile Pháidí Uí Shé' takes place in Febuary each year.

I am of

Kerry

I was born in Dublin of Kerry parents. My father came from Renard (Cahirciveen), my mother from Kilcummin (near Killarney). Each year we set off for Kerry in early July and returned to Dublin, sad and lonely, at the end of August. Initially we stayed with our respective grandparents, dividing the holiday between Kilcummin and Renard. In Kilcummin we spent memorable days in the meadow, in the bog or helping with the day-to-day work of the farm, and in Renard we enjoyed swimming, boating and fishing.

When the family grew to four, my parents decided that it was time we moved on and we rented a house in Spunkane, near Waterville for two happy years. In our second year there my father took my brother and I to Kells for a visit. I remember that July afternoon as if it was yesterday. Mrs Murphy of An Grianán House welcomed us so warmly. She advised my father to rent a house close by for the following year and we stayed in that house each summer until we purchased it in the early '70s. At that time, Kells was a small community with an equally small but loyal group of holidaymakers who returned every year, welcomed and accepted. Strong friendships were forged. Many of the families who came in the early '50s have, like us, acquired properties and the next generation now come with their children. My desire to live in Kerry was always very strong. I never regarded Dublin as my home. Living there was a means to an end. I was appointed Superintendent Physiotherapist at the Central Remedial Clinic in 1970 and was happy there, but spent my holidays and many weekends in Kerry.

I was resigned to retiring from Dublin at the age of sixty-five and starting a life in Kerry. However, fate intervened in 1991. A friend, on hearing that I had turned fifty the previous year, advised me strongly to decide where I wanted to be when I was sixty and to make my move. Then in September that year, Joseph Crowley of Mulvihill's Pharmacy asked if I would like to set up a physiotherapy practice in a new medical centre that he was building in Killorglin. I accepted his offer, sold my house in Dublin and moved to Kerry the following year.

I spent eight years in practice. I enjoyed my patients and the many interesting chats that I had with them but the highlight of those eight years was 17 March 1996, when along with the entire town of Killorglin, I travelled to Croke Park to watch with pride as Gerard Murphy was presented with the All-Ireland club championship trophy. I was privileged to be the physiotherapist to the Laune Rangers team and to work with a superb trainer, John Evans and a team of talented footballers, each one a unique character.

For me, to live in Kerry is to feel secure and calm, a feeling of belonging and serenity. To live with wonderful people is a privilege and to be surrounded by the most magnificent scenery in the world is an added bonus.

Kay Keating is a retired physiotherapist living in Kells, Co Kerry. She was born and reared in Dublin, and now lives with her mother Maureen, who is 93 years. Kay is a member of Dooks and Killarney Golf Clubs. As a rules official she has refereed all the major women's amateur golfing events in Great Britain and Ireland, including the Curtis Cup in Killarney in 1996 and at Ganton in 2000. She has served on the Rules Committee of the Royal and Ancient Golf Club for two years and refereed at the Open Championship at Birkdale in 1998 and in Carnoustie in 1999.

Mary Corr

Here since the beginning.

I have been with the Rape and Sexual Abuse Centre since it's inception. I was moved to take action by the number of people who confided in me about the problems they were having due to past experiences. It became apparent that there was a need for a centre in Kerry where victims of sexual abuse could receive the services they so desperately needed and deserved. A group of committed people got together to set up a Rape Crisis Centre. Many willing people came forward to help.

Funding was a problem for years but the increasing support from the Health Board has contributed greatly to the running and expansion of the services. Demand for the services has increased as society has become more open about the prevalence and consequences of abuse. Media coverage has also increased peoples' awareness. Locally, the existence and excellence of the Centre has been made known through word of mouth and outreach programmes. People have come to realise too that sexual abuse occurs in all strata of society and pain knows no boundaries.

Although, I came to the Centre with considerable expertise and experience, I have continued my professional and personal development through regular courses and seminars. Like all staff, my work is constantly supervised and appraised and I believe this has been instrumental in the maintenance of the highest professional standards.

While sexual abuse is obviously by no means a solely Irish problem, I am in no doubt that our culture of secrecy and tendency to 'sweep things under the carpet' has contributed to the reluctance of victims to come forward. This, however, like so much of Irish society, is changing. A further change that is needed is that sentencing of offenders needs to reflect the seriousness of the crime. A strong message needs to be sent that rape and sexual abuse will result in lengthy sentences for those convicted.

Through the hard times and challenges of the past decade, I have been buoyed by the support and good humour of my colleagues. I would do it all again if I had too.

I can sum up the experiences of the last ten years in one word: Hope.

Mary Corr is a native of Dungannon, Co Tyrone. Married to John from Armagh, they have three children: Kieran, Cormac and Sinéad. As well as being an accredited counsellor, Mary has also trained as a general midwifery and public health nurse. One of her main interests is in womens' health, and she was involved in the setting up of the Kerry Family Planning and Womens' Health clinic in 1980. She works fulltime as the college nurse in the Institute of Technology, Tralee, running the student health centre. Her interests include travelling and bridge.

I am of
Kerry

Johneen Lyons

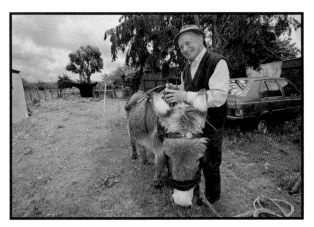

Before, you never kept any animal you couldn't take care of. Where once there was a cow per acre, now there are six cows to the acre. There is a limit we have passed and bad weather shows us that. I'm an old timer, maybe the way I have thought my life's experience through is all wrong but now that I'm moving into 87 I keep moving, keep the mind occupied and even if its raining cats and dogs keep smiling.

Are you listening to the lark? That's my time piece!

Johneen Lyons lives in Bealkilla, Finuge, Co Kerry. A retired mechanic, he still draws his own turf from his land nearby. Now a widower, (his late wife was Lizzie Mary O'Connor) his family includes Johnny, Noel, Joe and one daughter Mary. Johneen is described by friends as a great handy man and one who enjoys gardening and the odd pint in McCarthy's pub in Finuge village.

I am of
Kerry

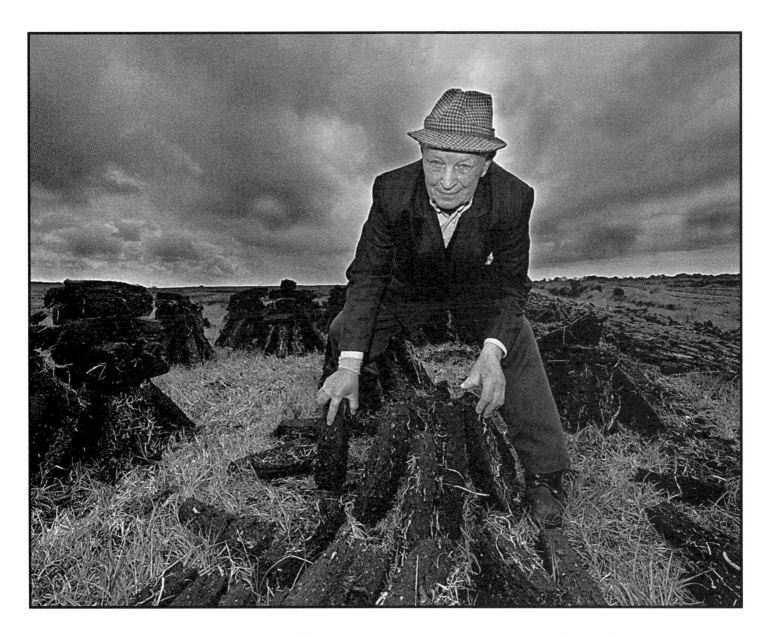

The cause of a lot of our ills is that the social part of life is gone from us. We rush too much and we are not talking to each other. No doctor could give you a tablet that would help you the way a good conversion can. Meeting people gives you a great feeling, you relax and you get value from it.

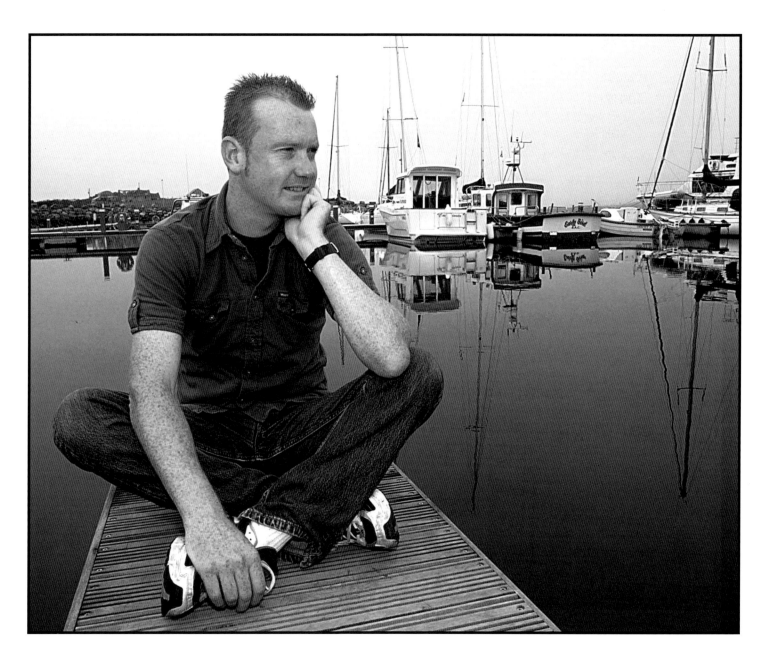

I am of

To me, Kerry is a very unique place. It's a place of beauty, of character, of magical music and most of all, a place full of the craic.

Kerry is a place where you can find so many different walks of life. People that care, that don't care, sane people, insane people, but most of the time all happy people. Who couldn't but be content, surrounded by such beauty as we are?

A place open to the sea – I count myself one of the lucky ones, living so close to it. I will never understand how anyone can live away from the sea, but I suppose, those who grew up on the shore can't imagine life without it.

'The sea is the great consoler. She may beguile us. She may challenge us, she may destroy us, but she never refuses us.'
– Tristan Jones

Shane O'Driscoll is a native of Cahirciveen. The son of William and Áine O'Driscoll, he is engaged to Louise and they have one son, Graham. He manages the family's drink distribution company. His love of music led him to be one of the main creators of the Cahersiveen Celtic Festival of Music and the Arts. Shane also works as a booking agent for Ireland's National Events Centre at the Gleneagle Hotel, Killarney. He is fanatical about the sea, and enjoys boating and scuba diving.

Eileen Sheehan

What The Old Woman Said

I will tell you this. There was a garden by the pump. Fallow land given me.
My father built flowerbeds. Offshoots of paths. Geometric patterns.
Cuttings. bulbs from my mother. The texture of earth.
Stone. The smell of water. I could grow anything.

I will tell you this. There was a pond. Wrinkles of mud. Pups that were drowned there.
Dragged to the bank. Sackfuls slit open. Way beyond saving.
Names that I give them. Returned to the water. Each small splash.
Spirals expanding. My own face ripling.

I will tell you this. There was a heron. Constant. Returning.
Stilt-leg. Growing above water. Curtains of willows.
Everything still. A crowning of feathers.
Inflections of music. Nothing was moving.

I will tell you this. There were meadows. Light. Nector from clover.
More flowers than I could name. Armfuls I carried.
Sterms that I split. Smelling of summer.
Chains on my neck. Ankles. The bones of my wrists. Knowing nothing.

I will tell you this. There was a boy. Eyes like the sky.
Eyes like my father's. Children imagined. Rooms that were borrowed.
Rooms that were painted. Stories invented.
Histories. Futures. We knew everything.

I will tell you this. There was a man. Veins under his skin.
Bones. Barely there. His stuttered breathing.
Green light on a screen. Intermittent beeping.
False light. False music. Someone was dying.

I will tell you this. I had seen his face on the shroud.
Running and bleeding. Wounds on his hands.
Pictures on glass. Coloured and leaded.
Faces on statues. A cross through his heart. Light always fading.

I will tell you this. There was a room. White. A white plate on the table.
A man at the table. Notes in his voice. A tune that I knew.
Beauty in the movements of his face. His arms. Frisson of wings.
Touch. Touch me. But he already had. I had forgotten everything.

I will tell you this. Some days are unbearable. Horizontal planes.
Moment to moment. Each long tick. I have been lonely.
Last night; a dream of a heron. The span of his wings.
Sounding through air. Listen listen I am disappearing

Eileen Sheehan writes poetry. She is originally from Scartaglin, Co Kerry and now in Killarney with her husband Mike. They have three children: Alan, Caelainn, and Bryan. Eileen's work has been published in various journals including *The Cork Literary Review, The Stinging Fly, Poetry Ireland Review, The Shop, The Rialto, Cum* and *The Kerry Anthology*.

I am of
Kerry

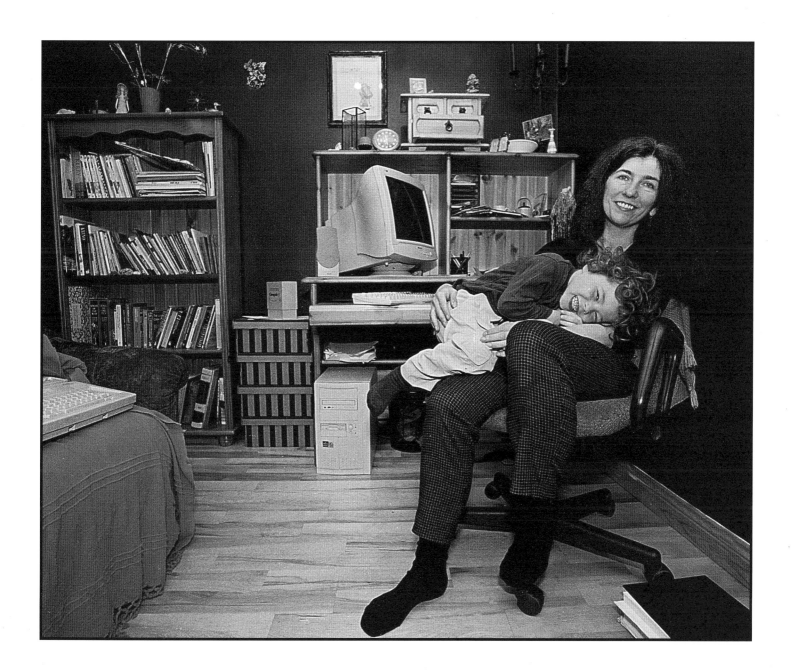

Jonathon Kelliher

Dance has always been a part of my life, from my early dancing classes in Dromclough N.S. and training under Fr Pat Ahern and Jimmy Smith in the Teach Siamsa in Finuge, right up to present day working with some of the top dancers and choreographers in the country.

Little did I think as a young boy in Finuge that the student would become the teacher. I believe that this tradition of passing on what we know from generation to generation is very important, after all if the dance masters of the past – Jerry Munnix, Jack Lyons, Liam Tarrant and many more like these – had not passed on their knowledge of dance, where would our Irish traditions and culture be today?

'The dancer plays a game of immortality.
He defies gravity and plays a mocking game with the ground…
Which is forever pulling him down.
So it is that the dancer is caught forever in our minds
Between time and eternity.'
– Bryan McMahon

Jonathan Kelliher was born in Banemore in North Kerry. He trained in Teach Siamsa in Finuge for three years and then became a member of the Siamsa Tíre performing company. In 1989 he joined the professional company and has since moved on to become dance master of the company. Jonathan also lectures at the Institute of Technology, Tralee. He is married to Jean Walsh from Ballybunion. His interests include golf and gardening.

I am of
Kerry

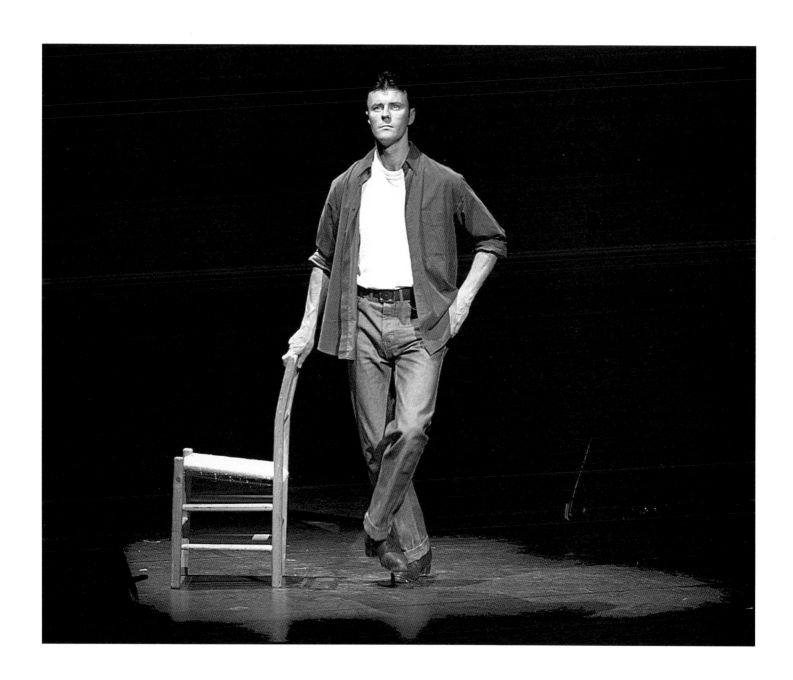

Jim McCarthy

The happiest day of my life and also for Carmel, was 18 March 2001 at 2.14 am when Gavin Joseph Mc Carthy arrived into the world, eyes wide open and one hand in the air, as if to say 'I am here now everything changes', and it did but in a wonderful way, this miracle of life we were now responsible for.

I recently read a tragic account of a young man who was remanded in custody charged with the murder of his father. Without even knowing the details of this case, no doubt a desperately sad affair for all involved, it struck a chord deep inside me as to how one of life's greatest bonds of love and friendship, so full of wonderful expectations and emotion, similar to my own experience, could go so terribly wrong.

Being a parent is one of the most important jobs anyone will do in their lifetime. My good friend Mickey Ned O'Sullivan, who has one of the best father-son relationships with his two sons, says communication is the key. Gavin and I have a good start. Carmel is an adoring mother and loving wife. We live in a beautiful home in the picturesque village of Annascaul. Because of the nature of my work I get to spend lots of time with him during the day, some days we go for walks on Inch beach and at the moment we go picking blackberries. He usually ends up in our bed in the morning with his bottle after Carmel goes to work, his tiny toes always cold searching for warmth under the covers. I look into his beautiful blue eyes and tell him I love him every day, and I know he loves me. I love everything about this beautiful boy but what I love most of all is, he calls me DADDY.

Jim McCarthy is originally from Abbeyfeale in Co Limerick, and now lives in Annascaul, Co Kerry. He worked in the hotel industry in Ireland and in Boston for many years before opening The Chart House Restaurant in Dingle in May 1997. Jim is married to Carmel Flynn, who is sales and marketing manager at Sheen Falls in Kenmare. They have one son Gavin, 18 months.

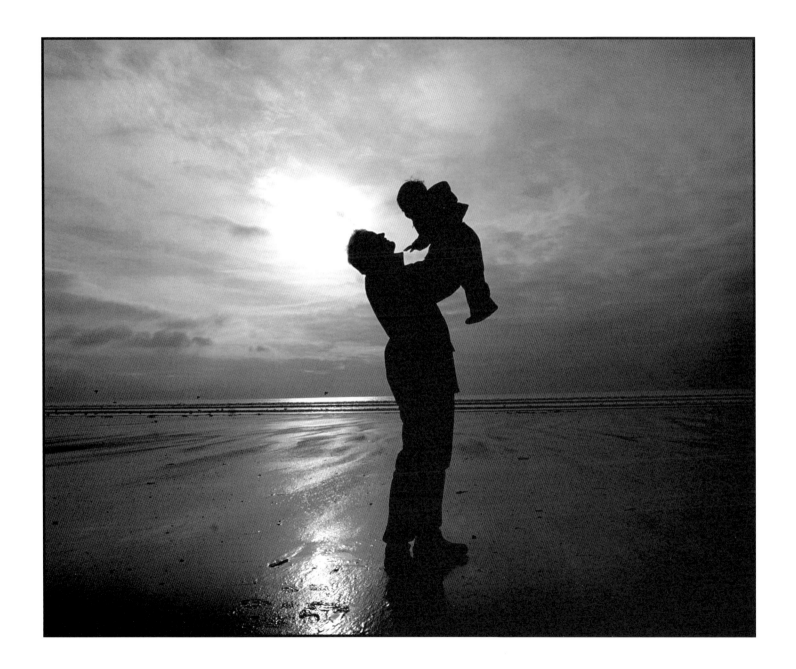

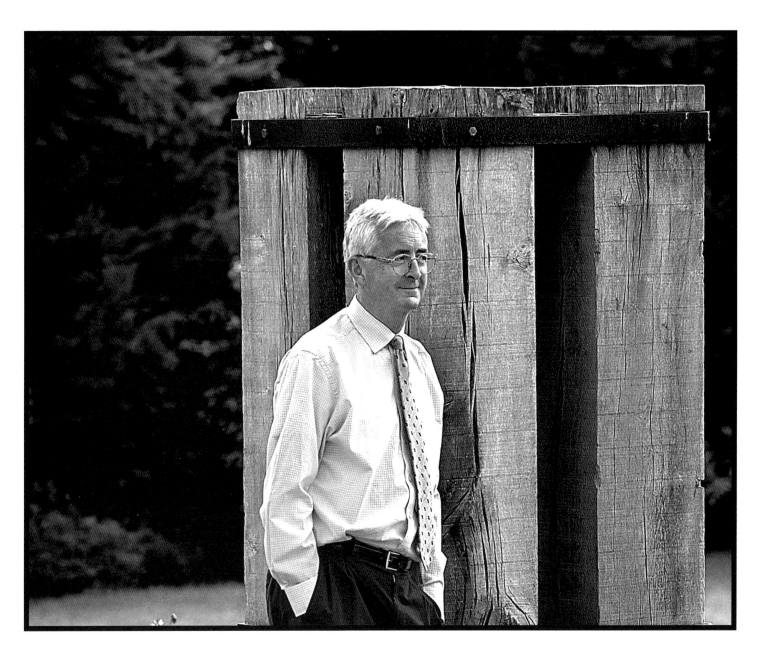

I am of

Jack and Camellias

After we laid my father
In the ground
The hailstones spat out of
A black bright sky,
And the wind
Blew out of tundras
I had never touched.
I planted two camellias
On his grave.
They turned yellow
And ignored the spring,
Mimicking the low
November sun.
But then Jack died
And when we buried him
He whispered to their roots
Of sparks that flew
From stallions' hooves,
Of headlands in the rain
Whose gorse defied
The grey and grumpy sky.

He told them why
The mountains sing
And how the rip inside run,
He teased them for their lethargy
Eight minutes from the Sun.
Then, one by one,
The leaves turned green,
And soon cascades of damascene
Lit up the graveyard. When
The equinoctal breeze
Soft dropped the blossoms on
The barren ground
The dead beneath
Stirred to the sound,
And my own father,
Death-plated now
And twelve years gone,
Winked at me again.

Paddy Fitzgibbon was born in Listowel, Co Kerry and was educated at Listowel Boys' School and at University College Dublin. His company Pierce and Fitgibbon is situated in Market Street, Listowel. He is married to Carmel and they have two sons: Billy and Mike. 'Jack and Camellias' is from his first book of memos and poems, *A Memo to Ringelblum* published in 2001. His play *Estuary* was premiered in St John's Theatre, Listowel by the Lartigue Company in 1993 and has been performed widely since.

Bríd McElligott

My likes
My dislikes

The colors of autumn
The dark of night

Someone who just says thank you
A person who just always looks for more

People who are sincere
People who play two sides

The happiness of parents when children achieve
Their sense of disappointment when all not augurs well

My husband, family and friends
The critics, most normally who do little but criticise well

Walking by the sea
Rubbish by the road

The innocence of children
The denial of that innocence

Lying in bed
Alarms ringing

Winter evenings by the fire
Famine, war and hatred

Chocolate
Calories

Handbags, shoes and coats
Food shopping

People who share achievement
People who abuse their position

White roses
Red roses

Those people who work for the benefit of others – paid and unpaid
The knockers, chancers and cheaters of whom there are many.

Bríd McElligott is a volunteer with the Kerry Rape and Sexual Abuse Centre, Tralee. She and her family are from Tralee town and she is married to Rob. Bríd is a lecturer at the Institute of Technology, Tralee and was recently appointed to the position of Head of Department of Hotel, Catering and Tourism. She works extensively with a number of voluntary, community-based organisations throughout North Kerry, and she is also an elected council member of Tralee Town Council.

I am of
Kerry

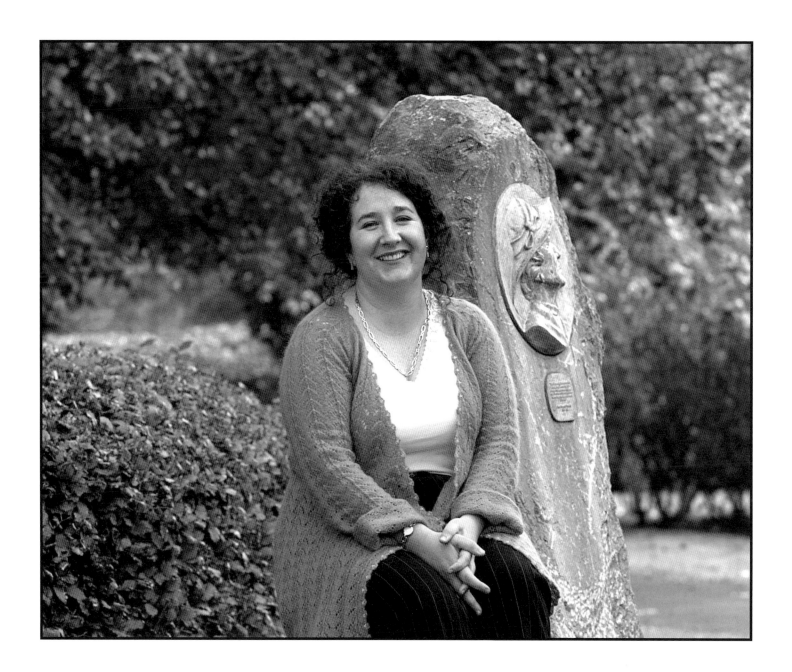

Deirdre Walsh

Sunday in September

You say it to yourself every year: if only I didn't care so much! But when you're passionate about Kerry football, it takes over your life in a way that non-believers will never quite be able to comprehend.

It starts in January, long before the draw for the championship takes place. The diary for holidays is passed around the office, and you tentatively mark yourself down for the last two weeks in September, silently praying that no one else gets the same bright idea. There's no point in being at work during this forthnight, because if Kerry are in the All-Ireland final, you wouldn't be able to concentrate on anything. For weeks on end, you talk about little else. Who is injured? What is the atmosphere like in the training camp? Who'll be playing?

Then of course, there's the scramble for tickets, an ordeal in itself. Every thirty-third cousin twice-removed who ever had even the slightest connection with a GAA club is canvassed. You start off with high hopes of side-by-side Hogans, but as the all-important Sunday approaches and desperation sets in, you find yourself willing to thumb to Donegal if necessary, for the faintest whiff of a terrace ticket. The jersey is ironed and folded a week in advance. By Friday, you're only sleeping in fits and starts, waking up in the middle of the night having nightmares about another last-minute goal like in 1982.

When the day comes, you can't eat, you're so nervous. You walk up the tunnel to that unbelievable combination of noise and colour that can only be Croke Park on final day. The team come out and you scream yourself silly. They line up to march behind the Artane Boys Band. A lump the size of a golf ball appears in your throat when the stadium falls to a hush for Amhráin na bhFiann. And then the ball is thrown in and for the next eighty minutes or so, you're totally powerless, knowing that everything turns on those fifteen lads out there in green and gold jerseys, representing you, representing your county.

And again you say to yourself, if only I didn't care so much…

Deirdre Walsh is news editor of *The Kerryman* newspaper. A native of Ballybunion, she is the daughter of the late Sean Walsh, the well-known former secretary/manager of Ballybunion Golf Club, from whom she says she inherited 'my love of Manchester United, Cork Dry Gin and all things GAA!' She has been working full-time in journalism since 1988, when she first joined *The Kerryman* as a junior reporter. She is a graduate of the Rathmines School of Journalism and a graduate of the University of London. Deirdre lives in Ardfert with her husband, Dermot Crean.

I am of
Kerry

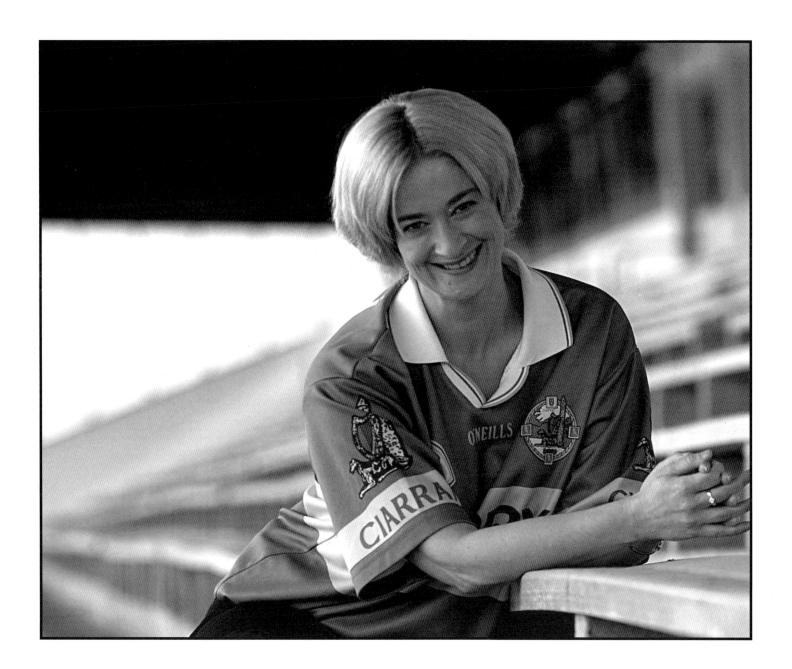

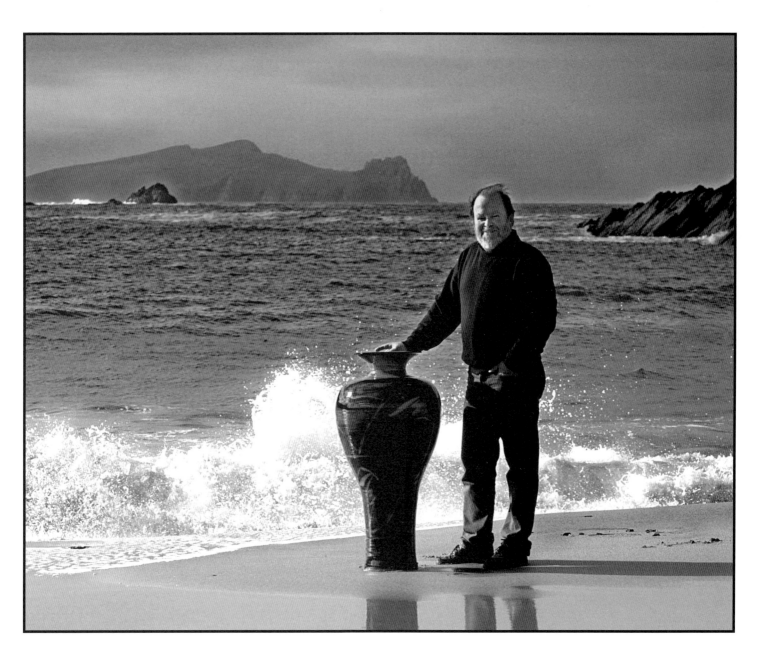

I am of
Kerry

Chaos

Yes for the common good: for peace in Europe.

Were we right?

Will we be generous?
Will we extend friendship and welcome?
Will we encourage diversity and difference?
Will we celebrate the small person, the small enterprise?
Will we encourage equality and fraternity?

Will strong values endure?

Or

Will we improve the lot of the allied at the expense of the alien?
Will we wield strength recklessly?
Will we cultivate xenophobia?
Will we destroy the small farmer, tradesman and entrepreneur?
Will we, through untrammelled enterprise, cause social and ecological disaster?
Will we magnify inequalities to bring continents, instead of nations, to war?

Will strong values endure?

See the wings of the butterfly.

Louis Mulcahy is a potter. He is married to Lisbeth, a tapestry weaver. In 1975 Louis and Lisbeth moved to Dingle, to establish the now famous Potadóireacht na Caolóige. They live on the coast, ten miles west of Dingle town. They have three children: Jette, Lasse, Sally and three grand-children: Esben and Jakob in Copenhagen and Liobhán in Dingle. Louis' passions in life include classical singing, and writing.

Catherine Casey

Diesel and Roses

The view from the window looks down on a field
and through the trees I can see the harbour lights
and I hear the welcome hum of the engines returning.
The bedroom smells of Dingle
Empty ashtrays and musty books.

Mischevious nights where hearts are poured out over pints
A town missing a life.
Where manhood is tested on a bar stool
on an ocean wave or a game of pool

A splash in the river, the colour red
The smell of diesel goes straight to my head.
This town is a drug and I feed my need
Small doses June to September

I remember you, your walk and your smile,
The Dingle Curehead who danced to Vanilla Ice
And you made me laugh with your stupid grin
The way you flicked your hair, I took it all in,

Kind words spoken on a dark night
And I wonder sometimes if you really knew
That the end was near…

Three roses on a wall
One for blood, one for beauty and one for love
A fisherman returns to the sea
And with him took a piece of me.

– In memory of Mark Vaughan

Catherine Casey grew up in Cork City, the youngest of three children. She is administrator at the Kerry Rape and Sexual Abuse Centre, Tralee. She first moved to Tralee in 1996 for two years and returned last year and now live in West Kerry. She is getting married to Diarmuid this summer.

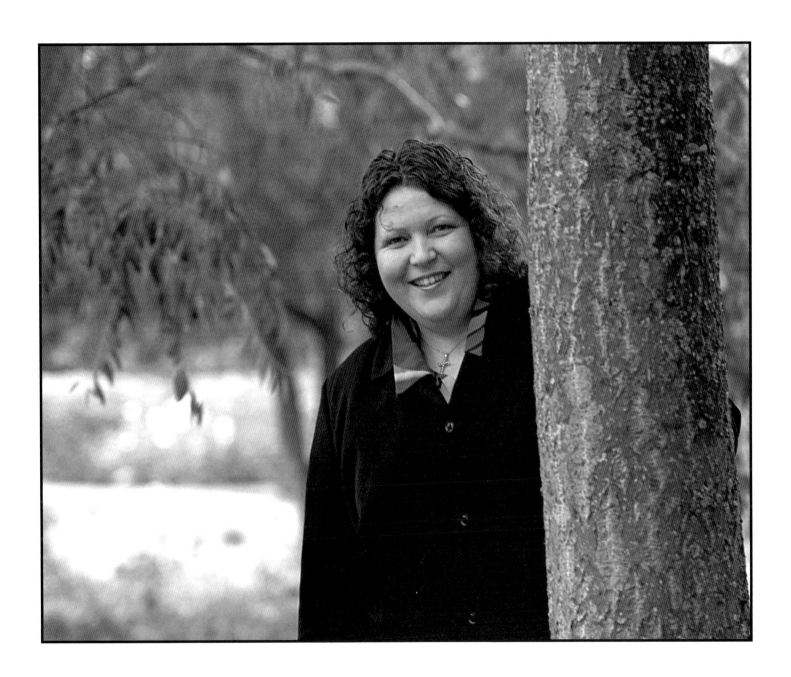

Marie Simonds-Gooding

The Late-Fee Post

After spending my first six years in India, Dooks, Co Kerry, became my home, until some twenty years later I moved to the Dingle peninsula. My parents, older brother, younger sister and my six hens took up residence in the lovely rambling house of Buncar, enclosed at the back by a cobbled stone courtyard and derelict stables. That was in the late 1940s. To the front of the house a marshy creek stretched into the front field and beyond the Glenbeigh mountains in good visibility, stood the MacGillicuddy Reeks.

Apart from the shrills of the herons nesting high in an old tree top and the wind whistling through the front door, there was the high-pitched whistle of the train coming from Caherciveen. It could be heard from a long way off before it reached Glenbeigh station or Dooks' Halt. The train rattled over the viaducts through the mountain tunnels, puffing steam and smoke and endlessly blowing its whistle. It travelled at about fifteen miles an hour, pulling one or at most three separate carriages on a single-gauge track.

My sister and I would help our mother to harness our little pony and trap, and off we would go to catch the train at Dooks' Halt for the late-fee post. Here the train stopped briefly, by a small wooden platform on the side of the road. We would tie up the pony, and my mother would greet the engine driver with her cards and letters, and sometimes ask him for his pen to finish her writing. The charge was an extra ha'pence per letter or card, and then the mail was guaranteed to catch the post that day.

The engine driver and stoker would then continue their journey, with big smiles, waving and blowing the whistle loudly. On they went to Farranfore, where the train stopped. Passengers and mail had to transfer to a train coming from Tralee, travelling on a double-gauge track, Dublin-bound.

Maria Simonds-Gooding was born in India in 1939 and has lived in Kerry since 1947. She studied at Dublin's National College of Art , Le Centre de Peinture in Brussells and the Bath Academy of Art, Corsham. In 1981 she became an elected member of Aosdána. Her work has been featured in many major group and solo exhibitions throughout Europe and the United States, and is held in several major public collections around the world including The Albuquerque Museum, New Mexico; the Department of Foreign Affairs, Dublin; The Hirshorn Museum, Washington, DC; The Irish Museum of Modern Art, Dublin; the Israel Museum, Jerusalem; the National Gallery of Modern Art, New Delhi; the Saatchi Collection, London; and The Metropolitan Museum of Art, New York.

I am of
Kerry

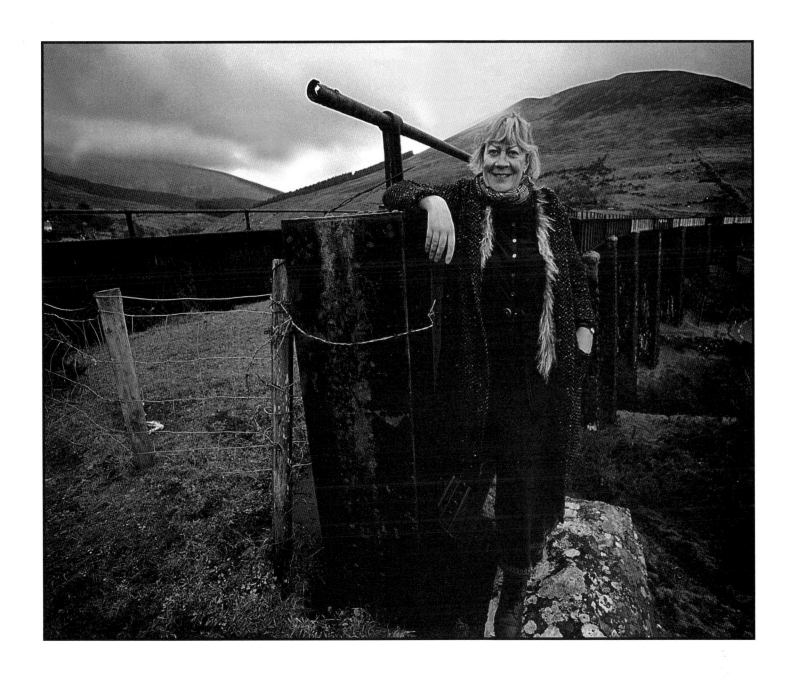

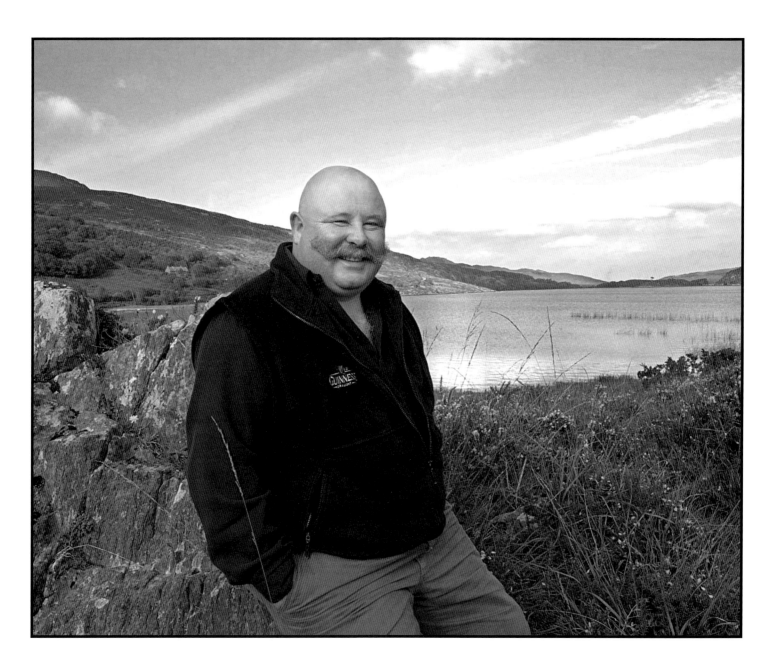

I am of

When asked where I would like this photograph to be taken, I knew it had to be Caragh Lake.

A native of Ballingeary in west Cork with its beautiful lakes, Guagán Barra and Loch Allua on the River Lee, it was only natural that I would have such a *grá* for Caragh Lake. Indeed since coming to mid-Kerry and indeed South Kerry in 1978, I have been active in motor sport, being a member of Killarney District Motor Club since that time. Caragh Lake is of course one of the best known rally stages in Ireland, second only to Molls Gap in the eyes of many people.

Every time I go there, I recall friends from motor sport who have passed away: Bertie Fisher who claimed it was his favourite stage and Frank Meagher who also rated it in his top four or five favourites. Since this photo was taken my own Dad passed away and is buried on the shores of Guagán Barra. He often came to visit me and we would drive around Caragh Lake and he would marvel at its beauty. Caragh Lake will always hold good memories for me even if a little sad for these reasons.

A lake is a living thing and will hopefully be there for the pleasure of many generations to come but sadly, some people have no respect for such beautiful places. Large amounts of rubbish are dumped over the wall on the western side of the lake, rotting and polluting lake and country-side. Is this the type of legacy we want to leave to our children and grandchildren?

Pat Healy is a gárda stationed in Killorglin since 1986. Before that he served in Cahirciveen and Ballinascelligs. A native Irish speaker from Ballingeary, he is married to Christine and they have two children: Laura and Rodi. Pat is a passionate member of Killarney and District Motor Club. He is also involved with Friends of the Children of Chernobyl, the CYMS Committee, and he participates in the annual Killorglin pantomine.

Mickey Joe Burns and Mary Moynihan

We have been involved in rowing and boats on the lakes, rivers and seas since the mid '70s and it has consumed hours and hours of our leisure time. The magical beauty of the scenery around us coupled with the peace and quiet is a real stress-release not to mention the exercise we get from rowing. It is a real possessive sport which you either love it or hate. We found it made us addicted to watching out for the weather, water currents and all types of equipment.

When we visit different places we always end up checking out boat clubs in areas and spending hours chatting with the people involved in the sport in that area. We have formed many friendships through this. We are drawn to water wherever we go. We take every opportunity to encourage people to become involved in the sport and to try it out for themselves. It is great having an involvement in rowing especially with The Workmens' Rowing Club through this we met each other and have made many lasting friendships.

Mary Moynihan is married to Mickey Joe Burns from Sneem, a self employed crafts man. Mary is depot manager at Coca Cola Bottlers, Killarney. They live in Lissivigeen, outside Killarney, and have three children: Aodán, Micheál and Siobháin. Mary is a prize-winning Irish dancer and she enjoys listening to music. She was a member of the Workmen's ladies sixes crew, and has successfully represented Ireland at international rowing regattas.

Mickey Joe won two county minor football championships with South Kerry and one senior south Kerry championship with Sneem. He was trainer and cox of the senior men's four-oar All Ireland coastal rowing crew for three years, and cox of the Workmens' mens senior-six winning crew for five years. Mickey Joe is also a champion weightlifter.

I am of
Kerry

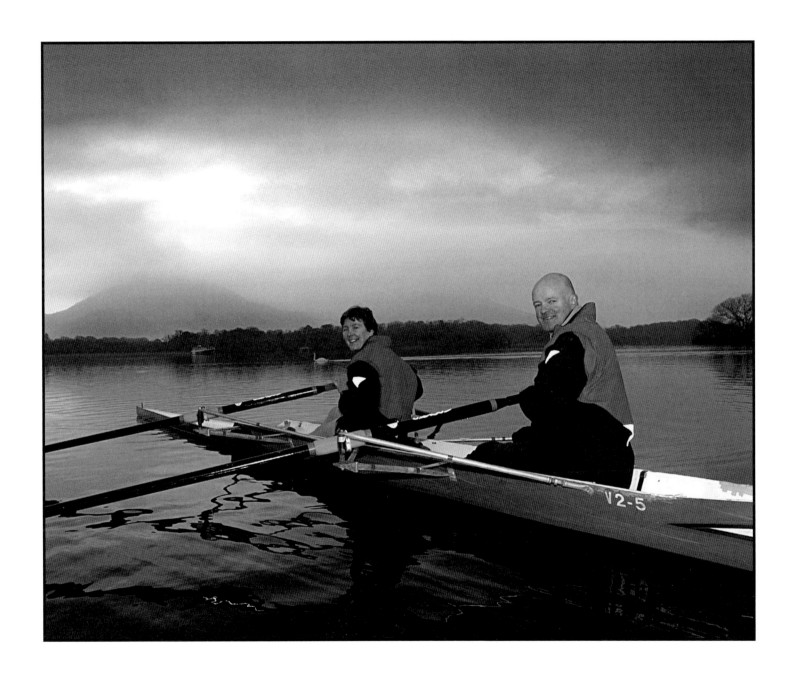

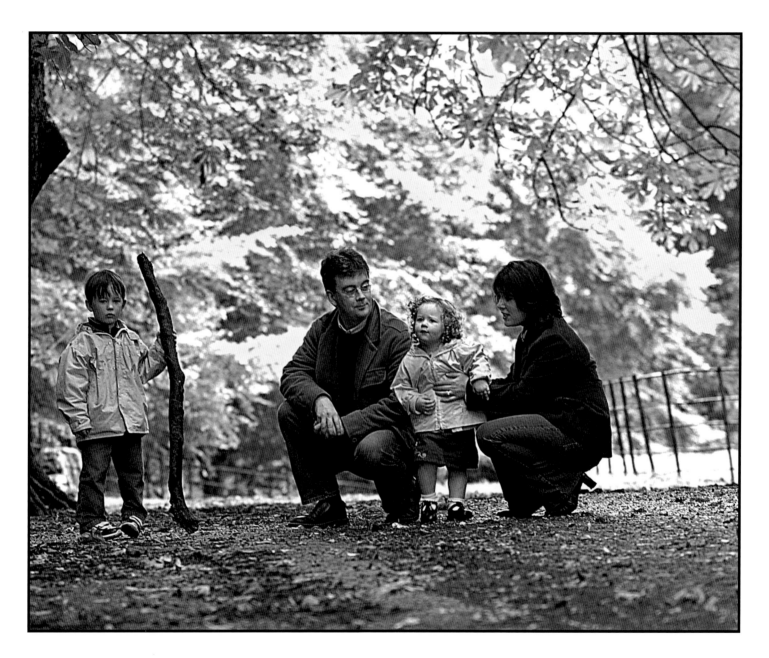

I am of

Patrick O'Donoghue

I believe that Kerry is a place where the people have a keen sense of family and opportunity. It is a place where the words family and business sit comfortably together. I have been fortunate to have been taught the value of both from my parents and grandparents. Here, as much as anywhere, there are opportunities to succeed in business as well as in other aspects of life. I apsire to follow in this tradition and hope that I have the ability and vision to take advantage of the opportunities presented to me for the benefit of future generations.

'Ability is nothing without opportunity.' – Napoleon Bonaparte.

Patrick O'Donoghue is the managing director of the Gleneagle Hotel, Killarney. He is married to Eileen and has two children: Peter who is four and Eve who is two. He is a director of Bord Fáilte and is a member of the Killarney Urban Disrict Council. He likes to read history and biographies and his business is both work and a hobby to him. His two small children keep him busy when he is not at the hotel.

Helen Higgins

I would love to live
like a river flows
carried by the surprise
of its own unfolding.

I love these lines from John O'Donohue's *Conamara Blues*. The river Garfiney flows near our home and separates the parishes of Lispole and Dingle. It symbolises for me life's journey, where within and through all our experiences, be they joyful or sad, we learn to let go and go with the flow. Where we allow life to carry us along in trust rather than clinging to its banks in fear.

Helen Higgins is a native of Ballineetig, near Dingle. The youngest of nine, she grew up in a house where Irish was spoken. Football, politics and farming were discussed and argued over but Helen was drawn to spirituality and nature. She has trained as a counsellor and in colour healing and currently works as a holistic massage therapist. Her hobbies include walking in the outdoors, acting, reading and meeting with friends.

I am of *Kerry*

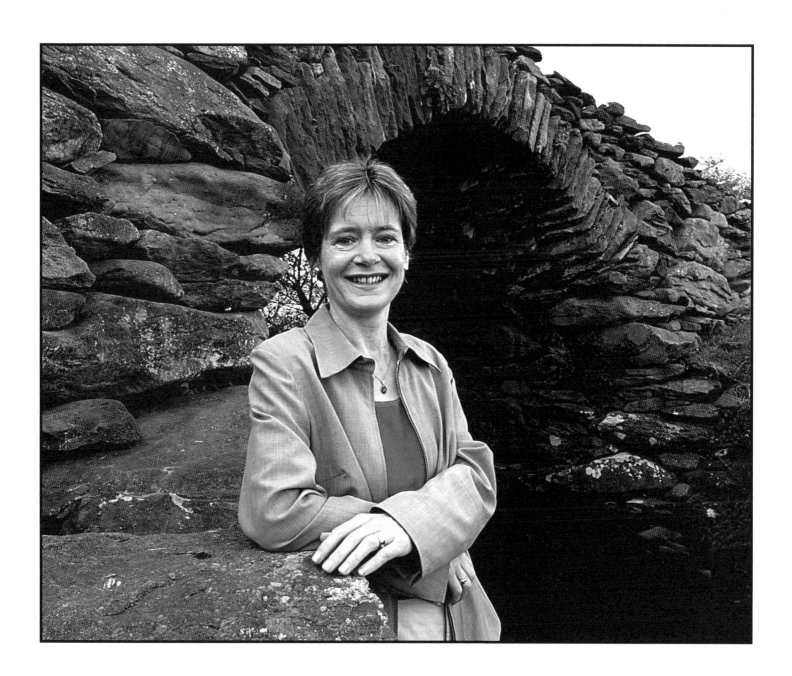

Cian Ó Siochrú

I can remember two bookshelves standing in our sitting room. One held childrens' books of all sorts and varieties: *The Famous Five*, *Huckleberry Finn*, and story books for boys, to mention but a few. As children, we were encouraged to read, and the aforementioned delights helped fuel our fertile, childish imaginations. It wasn't 'till much later that I became interested in the contents of the other bookshelf.

One night as my mind wondered during the *Cróin Mhuire* (rosary), my gaze was averted towards a large coloured book on the bottom row. Subsequent investigation revealed stories from exotic and faraway places, full of colour photography and packed with information about these regions and the people who lived in them. Other volumes that captured my attention related to World War I warships and famous battles involving them. Such wonderful ships as the 'Invincible' and the 'Inflexible' became part of our bedtime stories, and my brothers and I were regaled by tales about Admiral Von Spee and the Battle of Jutland.

This bookshelf was also home to the *Encyclopaedia Britannica*, dictionaries by de Bhaldraithe and Dineen, myriads of books about saints and their lives, but most especially books either written, or edited by 'An Seabhac' Pádraig Ó Siochrú, my granduncle.

These were real treasures. Placed strategically five or six rows up they were well beyond the reach of clumsy boyish fingers. Many of these manuscripts were first editions containing script penned by An Seabhac himself. Needless to say, they were prized possessions never to be harmed or loaned for fear of non-return.

Like many a student, it wasn't until the senior classes in Minard National School that I became better acquainted with some of An Seabhac's books. *Jimín, An Baile Seo S'Gainne*, were the appetisers before the morning main course of *Tuiseal Ginideach* and *Reamh Fhocail Comhshuite*. The simple stories and humorous style of the author endeared them to their readers. Though we now live in a time when it's fashionable to ridicule some of the texts which formed part of our old school syllabus, I can't but feel that in some instances the new syllabus is diminished without them. An Seabhac's stories hold a truth that we could all relate to, and some of his characters' shenanigans weren't far removed from our own. This element one could argue is perhaps the spark missing from some of our present helpings.

Unfortunately, I never had the privilege of meeting An Seabhac as he had passed away two years before my arrival. However he was ever present in our house, especially because of *Seanachaí Muimhneach*, *Seanfhocail na Mumhan, Beatha Wolfe Tone, Seainín, Leabhar Mhóirín, Laoithe na Féinne* agus *Tríocha Céad Corcha Dhuibhne*. These I would love to have on our new bookshelves. My wife Chris and I still have only a small collection of books. Since our boys Daragh and Tadhg arrived on the scene, the number has swollen dramatically. Pride of place now falls to *Bob the Builder* and *The Pokemon Leagues*. However I'd gladly reserve valuable space for some of An Seabhac's publications should they ever fall into our hands!

Finally, I've reserved some room on the top shelf of our new bookcase for my father's writing, should he decide to put pen to paper. For as long as I can remember, he has been editing, translating, or penning an article on some topic or other, but to date has not yet written his first book. As his influence on me has been beyond measure, both as a person and teacher, I've decided to hold pride of place on my bookshelf for his writings.

Cian Ó Siochrú is principal at Scoil Réalt na Mara in Tousist, Co Kerry. Originally from Baile an Ghóilín, Daingean, he came to Tousist in September 1987. Cian is married to Chris O'Sullivan-Morgan, from Bonane. They have two sons, Daragh (5) and Tadhg (3). Cian is chairman of Éigse Sheáin Uí Shuilleabháin, which celebrated the 100th anniversary of the great folklorist at Easter 2003. He also plays and is involved with Inter soccer club in Kenmare, the GAA club in Tousist, the Tousist Youth and Community Group, Scór na nÓg, and he plays golf in his spare time.

I am of
Kerry

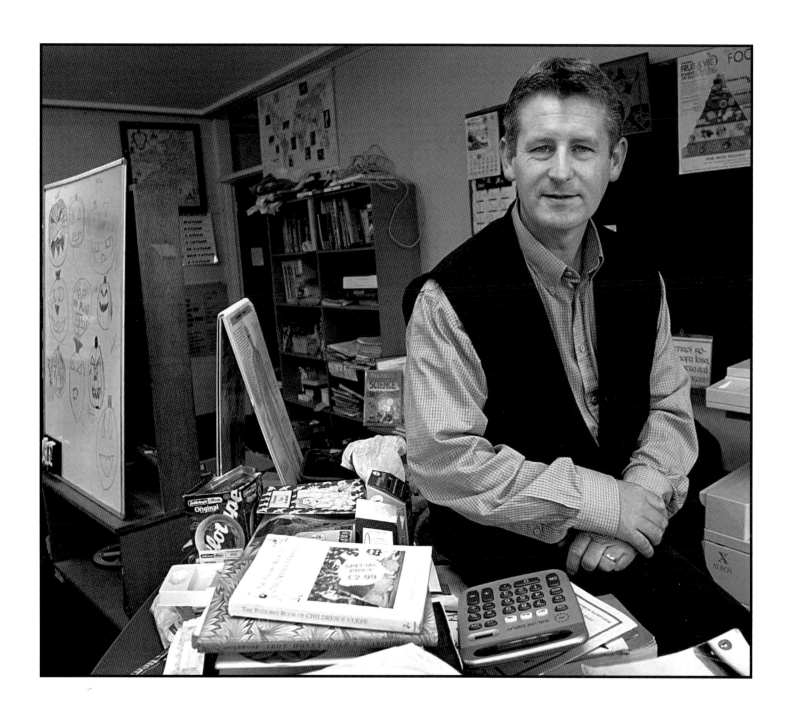

Helen O'Sullivan

As I returned to painting after spending some time rearing my family, I discovered that I was unable to express on canvas, the world around me as I had done before. Turning within, I discovered a whole new world full of myth, emotion and fantasy. Not only is this internal journey fascinating but also infinite.

It is only when we listen to the voice within that we give expression to the different aspects of ourselves. Then and only then, can we move forward, grow and be at peace.

There are no boundaries in my work. It is a trawl of the measure of emotions which can be found in the soul of every living being, a search for images which freely express that moment of stillness which is all that is needed to tap into one's own source – to be connected.

Helen O'Sullivan is an artist. Orginally from Miltown, she now lives in Beaufort, Co Kerry. She is married to Joe O'Sullivan and they have four children: Hazel, Jessica, Eleanor and Siobhan. Helen has had many group exhitition around the county as well as solo exhibitions in Deenach Lodge and Siamsa Tíre. She enjoys hillwalking, gardening and above all painting.

I am of
Kerry

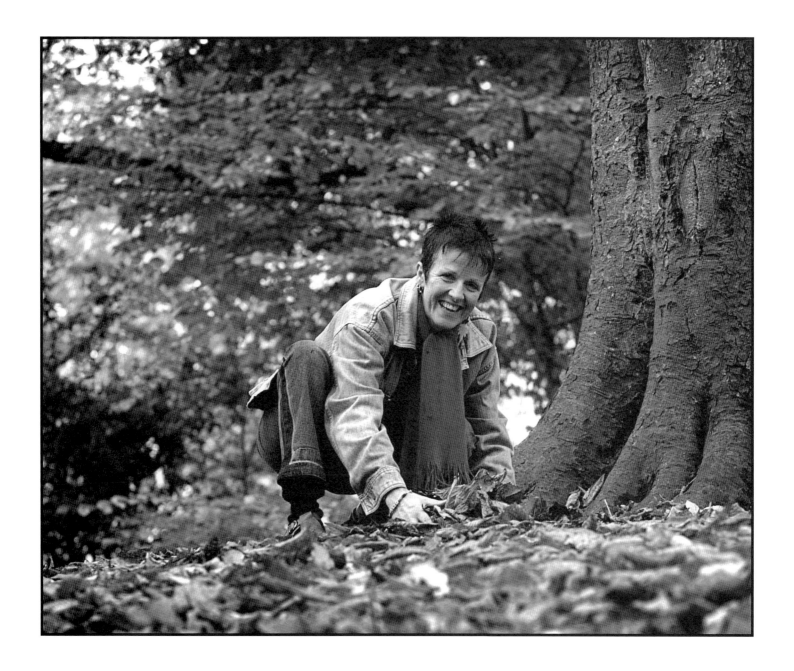

Breda Joy

Delicate as a bird, Eily perched at the edge of our childhood with a presence we never thought to question. She slipped into the pattern of the evenings as naturally as corned beef sandwiches, Czecheslovakian cartoons and the chimes of the tv Angelus. Her coat, the brown of caramel toffee and shaggy as a long-haired terrier, was only taken off on the rarest of occasions. Wisps of her long, silver grey hair fell from under the peach-coloured chiffon scarf knotted under her chin. Little, black felt bootees with zips up the front clad her feet. The drag of arthritis had gnarled her long fingers, though she never once mentioned pain. Her cheeks had the russet tinge of apples and her eyes were a lovely, lovely brown. She must have been beautiful when she was young.

My very first memory of Eily is that of her asking me to come down the street to see Mrs O'Donoghue. She led me into the back room of a tiny pub where an old lady with a shock of white hair smiled at me from her chair by the fire. Mrs O'Donoghue seemed ancient. But Eily seemed old then to a child of five or six. What age was she? Probably only fifty or even less. Over the rise and fall of the humours of the brood of us seven children, her's was a feisty voice demanding manners and delivering lectures with all the authority of the aunt or grandmother she never was.

We were 'the house of laughs and horrors'. When the cartoons finished and the noise levels rose, we were the product of 'the curse of the crows'. 'You'll never miss your mother 'til she's gone,' we were admonished. I silently disagreed but never dared say so. Neither did I think to ask about her own mother, father, her childhood. To a child, she was Eily as she was in the present and there was no thought of the past. Eily spoke with a tone and called my mother 'gurl' when she was joking. At home, she listened to the BBC on the radio which probably accounted for the refined accent. Once, she waltzed with the sweeping brush and sang to the sound of a radio tune while

we visited her. Once, in our house, she lost her temper with one of us, and grabbed the nearest thing to hand to throw at him. A sheet of cinnamon-coloured tissue paper used for wrapping bread in the family shop, it floated ineffectually in the air between them.

When Eily refused to leave her house, we found it strange and, for a long time, we tried to coax her out again. But she wasn't to be persuaded and her absence became as natural a progression as her presence in the evenings had been though it brought a new burden. Now, we had to visit her. She had two shopping lists – one for our shop and the other for Reidys of Main Street. On them were the small brown Thoma loaves from Thompsons of Cork, Barry's tea, Dettol, firelighters and matches, a tiny bottle of whiskey on occasion and, always, packets of paper tissues. The kitchen was dark. It smelled of Dettol and baby Powers. She picked at her food – the cats got the most benefit of the meals on wheels. But she had good neighbours. She rapped on the wall separating her from the terraced house next door whenever she needed anything. When she got less able, the neighbours lit the range.

When she went to hospital, we thought she wouldn't be able to wait to get out but she basked in the care of the nurses. She didn't want to leave her nest of soft pillows and the reassurance of constant company. Eily grew afraid of dying. She slept in her chair beside the range in the kitchen. She thought that if she didn't lie in bed, she wouldn't die. When my mother visited one night, she didn't want her to leave. My mother spoke of the look in her eyes that night. Her tone was something I never forgot.

Eily's unmarked grave is to the left of the gate at the cemetery in Aghadoe, just inside the wall. Her spirit is off out there somewhere swirling to the sound of music on the BBC, and she's calling my mother, 'gurl'. We miss them both.

Breda Joy is a staff journalist with *Kerry's Eye* newspaper. She lives in Killarney with her son, Brendan, aged eleven. A member of Killarney Mountaineering Club, she enjoys 'the Kerry outdoors, being a mother, dabbling in creative writing and sinking a few peaceful pints in Hussey's Bar!' She is also a member of Amnesty International and of a John Main meditation group.

I am of
Kerry

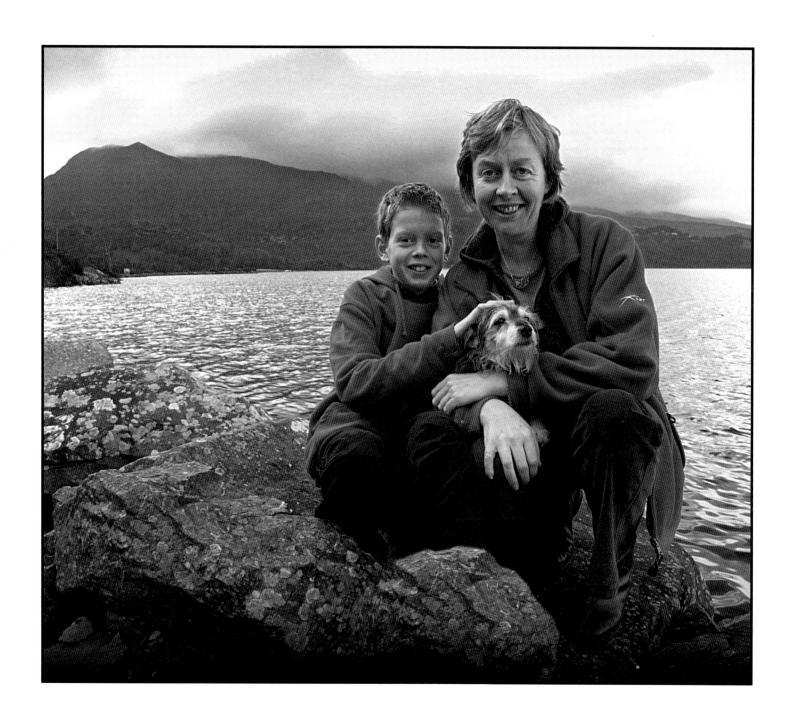

Mary Fagan

An Eye for Talent

It all started when I was ten years old, in fifth class in primary school in Moynalvey, Co Meath. A Salesian brother, Hugh Boyle, later to become a Salesian priest, visited our school. He was based with a team of young brothers in Maynooth College just nine miles from my home. He formed 'The Talent', made up of all us talented, and not so talented, would-be stars. Well I suppose that wasn't really the beginning, I always had notions when it came to drama and stuff like that. I blame my father really, because it's one of the things for which I remember him praising me wholeheartedly. Of course, he died when I was twelve, so my opportunities for both lavish praise and severe criticism were cut a bit short.

Getting back to The Talent. I lived for it. My best friend Catherine Weldon, a truly gifted artist and fine singer, and myself were dedicated to this group. We designed and painted props as well as singing, dancing and acting. I suppose the girls got an extra kick out of it as we were crazy about all the brothers who came to our small parish with instruments from guitars to saxophones, having hailed from places as far away as South Africa and Italy.

Our early performances were a mixed bag of singing, dancing and even some gymnastics on Hugh Boyle's head! Oh, we toured the local halls and engaged in that great killer of fun and creativity: competitions. Our troupe of musicians grew and we got more ambitious, tackling the musicals of the times, *Joseph and His Amazing Technicoloured Dreamcoat* one year and *Oliver Twist* the next. We won the Fr. Michael Cleary Cup and the likelihood is we would have won it the second year, but the brothers were on retreat

for the Final and the great, twinkle-eyed diplomat himself, Hugh, was in Swaziland, fulfilling his personal vocation and mission. As the Artful Dodger, the adjudicator pronounced that this boy, meaning me, would go places. I'm still waiting and I'm sure this sexual misidentification did me no good either.

Down through the years I have participated in and enjoyed drama. My most memorable (memorable for me) performance was in Synge's *Well of the Saints*, with the UCC Drama Society. I have found this interest has also enriched my work with the KDYS (Kerry Diocesan Youth Service). Drama is a wonderful medium for work with young people, whether it is in street pageants or on radio.

A very pleasant journey for our family began this year when Paddy, my partner, undertook the dramatisation of Brendan Kennelly's *Moloney Up and At It* poems, for the Kennelly Summer Festival in Ballylongford. *Glimpses*, another Kennelly book of poems, was also used in the dialogue that pulls the story together.

Bawdy and Soul was born, featuring poems, music and dancing, and a far-fetched story line. Two weeks before the performance we recruited the cast. A motley and enthusiastic crew was pulled together, made up of our friends who had, and hopefully still have, an interest in performance. It worked on the night and we have given a number of performances since, fundraising for various worthy causes. Our motivation is the enjoyment we get from it. The positive response from audiences demonstrates the constant need we all have for fun and laughter.

Mary Fagan is manager of the Kerry Diocesan Youth Service in North Kerry. She is married to Paddy McElligott and they have two children, Tallann, eight years and Evaun five years. They live in Listowel and 'the whole family engages in creative activities as often as possible and, in the words of singer songwriter, John Spillane: "Will We be Brilliant or What?"'.

I am of
Kerry

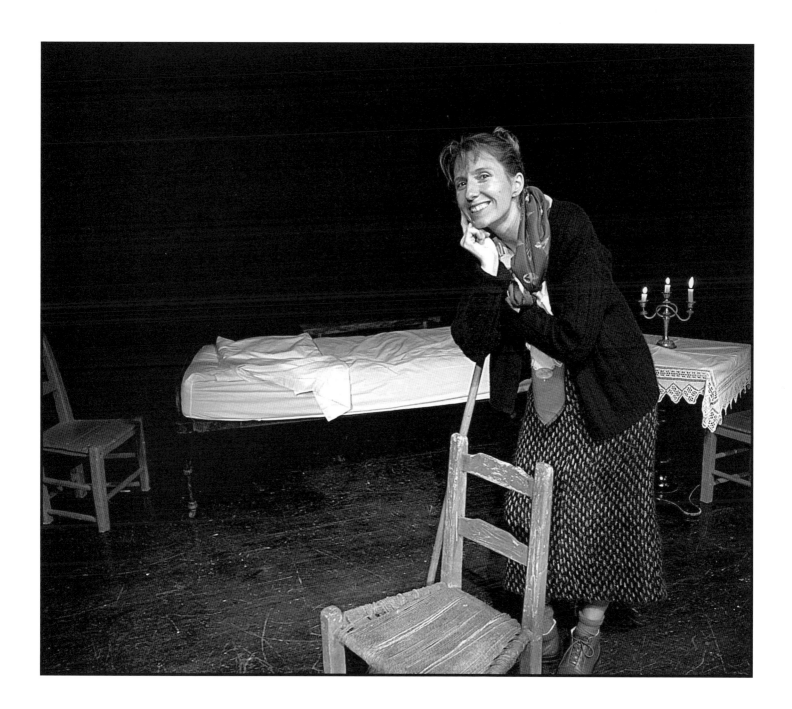

Dan Counihan

I grew up in Tralee and had a wonderful childhood. My father Jock was from Faha, Killarney. He had a garage in Princess Street, where my practice is today. It was the first business in Princess Street. My mother Agnes was from Galway. She always reckoned Kerry people were too cute (as in cute hoor). It really drove her mad when Kerry beat Galway in the All Ireland. Tralee was her home and she wouldn't have lived anywhere else.

I broke my front tooth in the school yard in Clounalour, CBS. Ned Ryan RIP treated me and sparked off a lifelong interest in dentistry. Ned was a real gentleman and a very caring dentist. As a final year dental student in UCC I was influenced by an orthodontist Bridget Dineen, who has a fine mind and I choose to pursue a career in orthodontics. I went to the UK for five years where I specialised and when I came back I worked for UCC, where I met my wife Bernice. We were married twenty years in March. Our eldest daughter Kate is now a first year dental student and we have three other wonderful children: Jock, Maeve and Sarah.

I love living in Kerry. I enjoy hill walking in the mountains with various groups of friends, lunch being the highlight. I enjoy the philosophical discussions on the meaning of life with my old friend Fergus Dillon and Tom McCormack. As a child I spent many summers in the Maharees, where my father introduced me to the sea and sailing. This has also been a lifetime passion and I love to see my children enjoy it as I do.

My son Jock is a very keen surfer and really enjoys the sea. Maeve loves to sail her optimist dinghy and we have started going to competitions around the country. Kate has a wide variety of interests and she has gone back swimming and started water polo. Sarah is light of foot and loves to do her Irish dancing.

I encourage my children to go to church and I believe we should put aside time every week to look after the spiritual side of our lives. I thank the Lord for my family, friends, neighbours, colleagues, for my good health and the breaks that life has given me. I still think my best move ever was marrying Bernice.

Dan Counihan is an orthodontist in Tralee. His wife Bernice is also a dentist with the Health Board. They have four children: Kate, Jack, Maeve and Sarah. Dan also lectures in orthodontics at Trinity College, Dublin, Liverpool University and at other universities by invitation. He is a life member of Tralee Sailing Club, and a member of Tralee Mountaineering Club. He enjoys swimming, visiting friends and teaching dinghy sailing.

I am of
Kerry

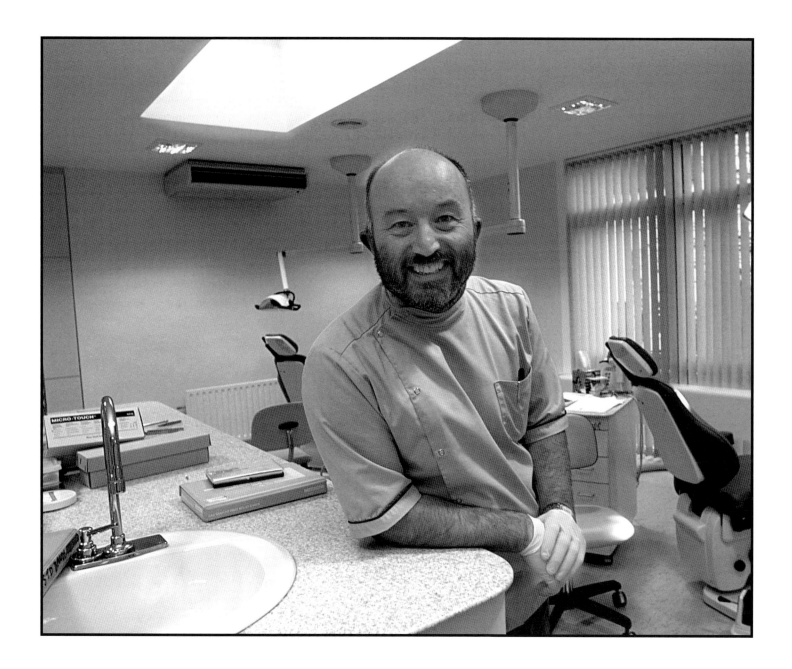

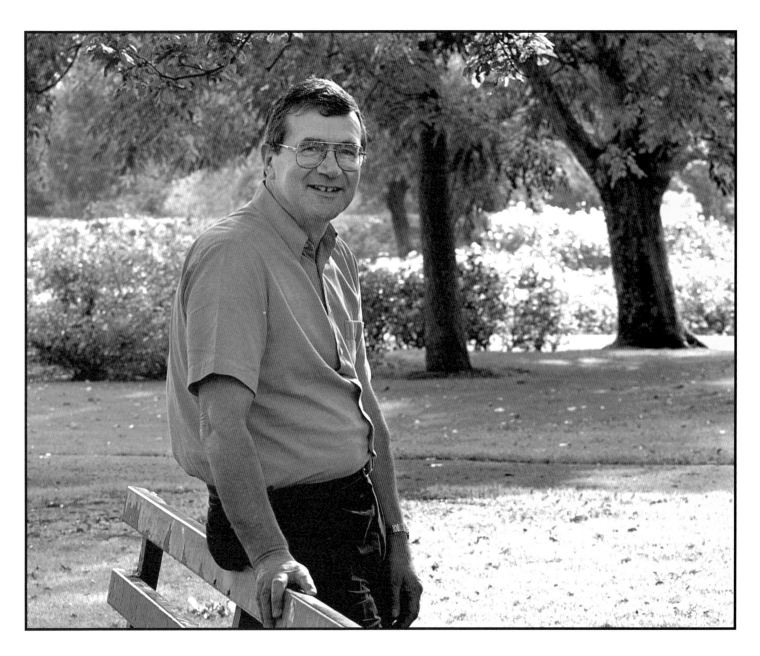

I am of

A Male Counsellor's View

It is good to be celebrating ten years of healing work by the Kerry Rape and Sexual Abuse Centre and to realise that so many people, women and men, have moved out of the shadows and shame of sexual abuse and are recovering a new sense of dignity, personal meaning and joy in their lives. As a man and as a therapist, I realise how difficult it is for men who have been sexually abused to take the first step towards recovery. There is so much shame, fear, hurt and anger hidden under the public face we show to others. And, as we live in a culture where we feel as men that we're expected to 'put a face on it', hide our pain, go for a few pints and 'keep the show going' at all costs. Deep down we know that this cost is high and it leaks out in our behaviour and in our emotional distancing of others, even those we are closest to.

As a male counsellor, I understand this and that is why we at the Centre offer a safe, welcoming and confidential space so that the healing journey can begin. We urge men who have been sexually abused to take the first step, contact us and let us help you across the threshold of fear and shame.

> I ain't looking for your prayers or pity
> I ain't coming round searching for a crutch
> I just want someone to talk to
> And a little of the human touch.
>
> – 'Human Touch' by Bruce Springsteen

Michael Joyce is a native of Mulranny, Co. Mayo, 'across the bay from Croagh Patrick'. He has lived in Inisbofin, South Mayo, Dublin and Zambia, and lives now in Ballyheigue where he says he is 'nourished by images of Brandon and Ballyheigue Bay'. He has worked for extended periods in the areas of pastoral care and human resources and now work as a counsellor and group facilitator. His hobbies include walking, music and going to the theatre.

Carol Moloney

The one constant thing in a nurse's life, every nurse's life, is sick people. That's where it begins and ends. Twelve years as a theatre nurse has taught me so much about people and the uniqueness of each individual. I'm very lucky: I have a wonderful partner in life, two of my very own real-life action men, close family and friends. I also have a meaningful job where I work beside people I admire and respect. Ironically, without patients our jobs would be irrelevant, non existent even. I wrote the following verses to let those who suffer ill-health know you're always on our minds.

Distinguished blue eyes, neat silver hair,
Wheeled through theatre doors in need of our care.
Damp tissue clutched in one frail hand,
I'm anxious, afraid nurse, you do understand?

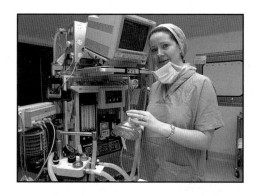

Next we are met by large saucer eyes,
Mum is agitated, baby just cries.
Cuddled, distracted, cajoled off to sleep,
In no time at all she'll be back on her feet.

I can't imagine what it must be like
To come through those theatre doors,
To put your faith and trust in those
You've never met before.

Patients remind me so much of others I know,
Someone's father, or child, concerned family members in tow.
Different personalities combine to make up theatre staff, some quiet,
Some serious, some always game for a laugh!

The bottom line is to take care for those who are ill,
Trained professionals who fit the bill.
Working diligently week after week,
None are the same, all are unique.

Carol Moloney is a theatre nurse in the Bons Secours hospital, Tralee. She lives in Farranfore and is married to Tony Moloney from Limerick. They have two children: Stephen (6) and Liam (18 months). Orginally from Mayo, Carol's family moved to Killarney in the '70s. She enjoys reading, music, and socialising.

I am of
Kerry

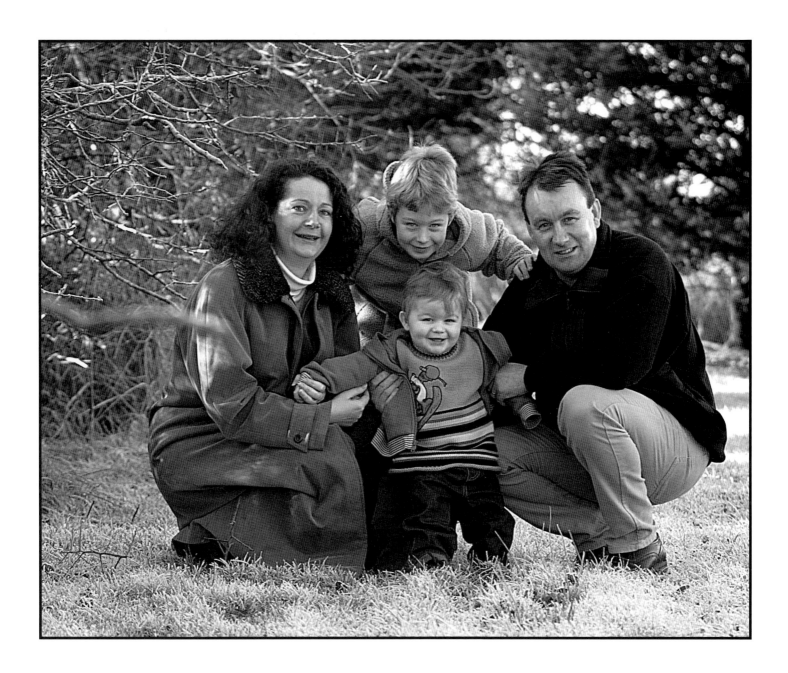

Garry McMahon

Dúchas: The Kingdom's Green and Gold

You say tradition counts for naught when two teams take the field,
I fear you are mistaken, lad, but time will make you yield,
And when your hair's as grey as mine, and the years have made you old,
Then you'll invoke, the truth I spoke, of the Kingdom's green and gold.

You cannot box or bottle it, nor grasp it in your hand
But pride of race and love of place inspire a love of land
Time honoured is our birthright, you will never break the mould,
For it's deep within the soul of us, who wear the green and gold.

Grey lakes and mountains soaring high, Mount Brandon's holy hill.
The little church at Gallerus, our language living still,
The Skellig Rock, stout football stock, that can't be bought or sold,
For our country's fame, we play the game in the Kingdom's green and gold.

And when the battle's fiercest and our backs are to the wall,
We stay alive, we can survive we stumble but won't fall,
For the spirit of our fathers and of stories yet untold,
Still ensure, we will endure, in the Kingdom's green and gold.

We savour Kerry victories, we salute a gallant foe
And when we close, there's no excuse, we pack our bags and go,
So raise your glass each lad and lass to our warriors brave and bold,
Who each year aspire to the Sam McGuire in the Kingdom's green and gold.

Garry McMahon is a native of Listowel and a son of 'The Master', the late Bryan McMahon, who enjoyed an international reputation as a writer, dramatist, folklorist and ballad maker. In his youth Garry played hurling and football for his county and won All-Ireland senior football medals in 1959 and 1962. He has the honour of scoring the fastest goal in the football final in 1962 coming thirty-four seconds after the throw-in. He has composed two Masses in Irish *Aifreann na Ríochta* and *Aifreann Ár Sinsear*. He has practised as a solicitor in Newcastle West for the past forty years, where he lives with his wife Joan. They have three children, Gearóid, Treasa and Rossa.

I am of
Kerry

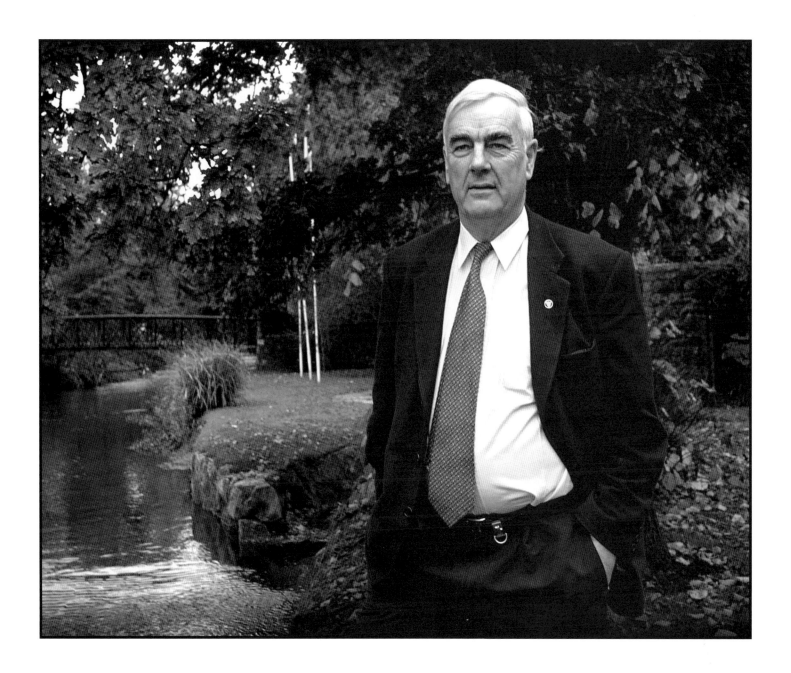

Mary O'Riordan

The village of Miltown in the heart of Kerry, nestled by the Sliabh Mish mountains, holds its organic market every Saturday morning in the old church which was built in 1819. The church opened its doors again in July 2000 to encourage the natural and organic approach to living and food. When customers enter the main hall for the first time, one can hear exclamations of surprise at the atmosphere of market hustle and bustle!

Customers travel weekly from near and far to taste the delights and socialise with the stallholders, who are the growers, producers and cooks. The core group of stalls includes the best of Irish baking, Mediterranean and Egyptian cooking suited to vegetarians and food gourmets alike. You will discover organic wine, breads, meats, and eggs. Locally grown wholesome foods. Visiting stalls offer chocolates, herbs, plants, jewellery, crafts and health products. People are welcome to come and browse and enjoy the atmosphere which is enlivened by live music. If you are brave enough you may even get your face painted!

The seeds of this venture were sown by me in January 1999 and a meeting of a dozen like-minded people supported the idea. I am encouraged by the stallholders, the quality of their goods and by the continuous feedback of contented customers, who spread the good word.

I strongly believe that if we were given the choice, we would not grant permission to contaminate our fruit and vegetables, mistreat our meat, pollute our homes and water supply. Each little step we take in our homes and communities has a ripple effect on our global community.

I hope that the small step that was taken in Miltown will encourage other communities to do likewise.

Mary O'Riordan has been co-ordinator of Miltown market since its inception in 2000. Mary is a native of Killorglin and loves gardening, walking with her dog, Guinness, in Rossbeigh beach.

I am of
Kerry

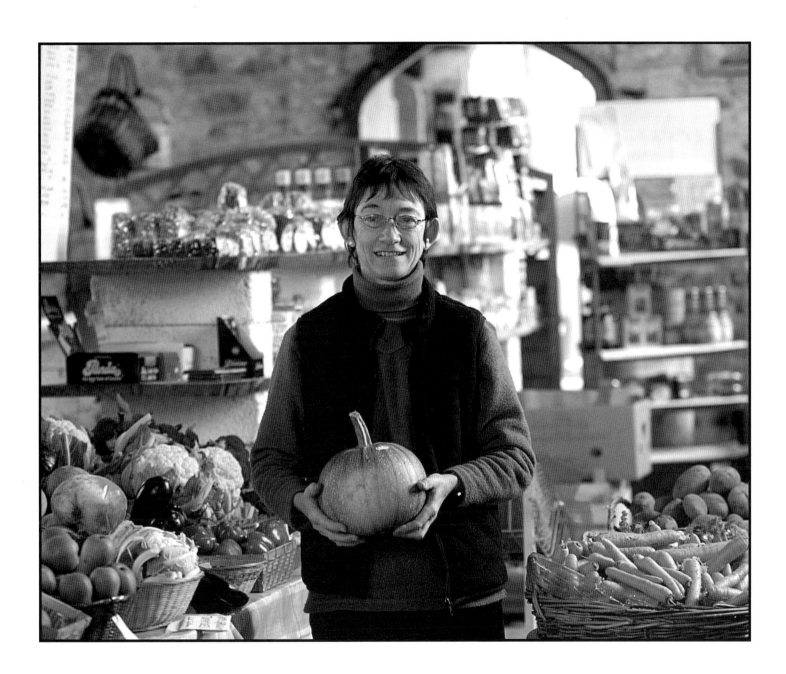

Bridget McCarthy

What I love about my job is the variety. No two days are the same. I work in Tralee and Killarney, because it is a Kerry-wide project. I spend a lot of time working with different voluntary and statutory agencies.

The other part of my job involves working with various groups. At the moment we have a women's group in Killarney studying arts and crafts and computers. One of our youth groups is doing a photographic project and they have produced a calendar for 2003, which draws awareness to Traveller culture by producing a visual record of our lifestyle. I also work with another youth group and we meet every week and this could be games or arts and crafts. The kids really enjoy meeting their friends and recently they went horse riding which was a great treat for them.

Like everyone else, when I get some spare time, I like to visit friends and family. I enjoy going on holidays and seeing different places and meeting new people.

My hope for the future is to continue the work I am doing and by doing this, to encourage other travellers to get involved in working together to build a better future for us all.

Bridget McCarthy is a member of the Travelling community. She born in Cahirciveen and was raised in Tralee, where she now lives. She is a youth and community worker with the Kerry Travellers' Development Project. Bridget has four sisters: Mary, Teresa, Jacqueline and Elaina. Prior to joining the KTDP, she worked as a market trader and as a childcare worker. Bridget enjoys reading, walking and shopping.

I am of
Kerry

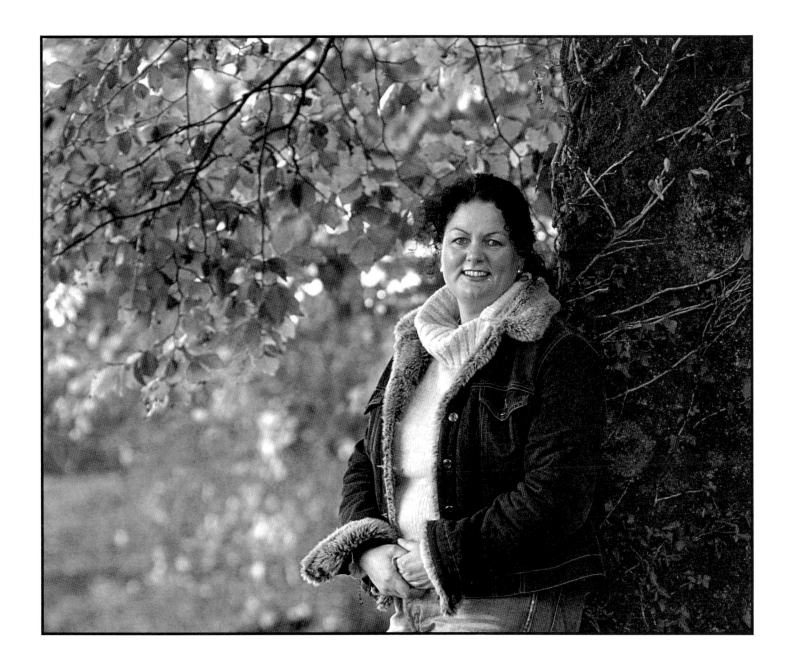

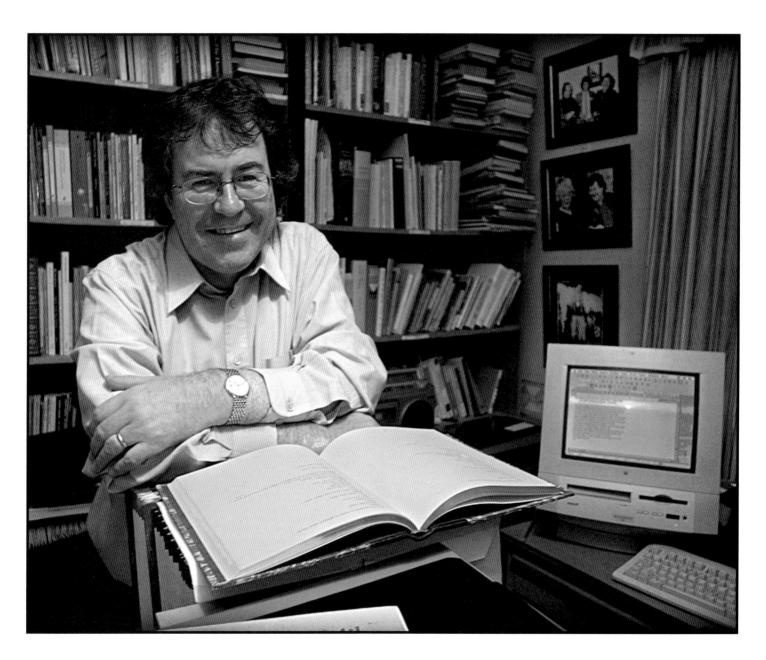

I am of

Kerry

On Being Appointed Principal of Moyvane National School

For my people who walked barefoot miles to school,
For the children in the years of hand-down dress
For the hurt who can't forget being branded 'fool',
For the ones who left this parish to success;
For the youths that died in foreign wars who fought
When adopted lands conscripted them, and those
Who lived and died for Ireland, those who wrought
A nation from a peasant's ragged clothes;
For those who perished homeless, those who took
Their lives in desperation, and for all
Who were wronged or felt diminished by the book,
For those who heard and followed its great call;
For all my predecessors have set free
From the days of the hedge school down to me,
I accept this post.

Gabriel Fitzmaurice was born in the village of Moyvane, Co. Kerry where he still lives. He has been teaching in the local national school since 1975 where he is currently principal teacher. He is author of more than thirty books, including collections of poetry in English and in Irish as well as several collections of verse for children. He has translated extensively from the Irish, and has edited a number of anthologies, including *An Crann Faoi Bláth/The Flowering Tree: Contemporary Irish Poetry with Verse Translations* (with Declan Kiberd), *Irish Poetry Now: Other Voices, Rusty Nails and Astronauts* (with Robert Dunbar), and *The Kerry Anthology*. He has published a volume of essays, *Kerry on My Mind*, and collections of songs and ballads. Gabriel's is a familiar name on radio and television. He is married to Brenda (Downey), and they have two children: John (14) and Nessa (12). He has played and sung on a number of albums of Irish traditional music and ballads.

Mary Lynch

Have you ever crossed a river stepping from one stone to another? While standing on any one stone there is a feeling of security. It is safe. Moving to the next stone is a frightening step, however. That feeling of uncertainty (amongst many others) is comparable to what I feel as I go through the grieving process. My husband Dermot died in May 2000. My safe and secure life with my partner is gone, and stepping out into a new life on my own is indeed precarious and daunting.

I have found no painless entrance into this new life. But I have found many safe stepping-stones, particularly Ballinskelligs, and the John Main Christian Meditation Centre. This centre is a place of spiritual renewal and quiet relaxation for many people from all walks of life. For this pilgrim it is a place of storm, stillness, beauty, healing and hope. It is from here that I go forward with an invisible shield of courage to mind my steps.

Mary Lynch lives in Killarney. She has been involved with the John Main meditation group for many years. She has two sons: Danny who lives in Dublin and Bobby who lives in Killaloe. She has two grandchildren: Conor and Jack. She counts herself garteful to live in Killarney and for her close circle of friends.

I am of
Kerry

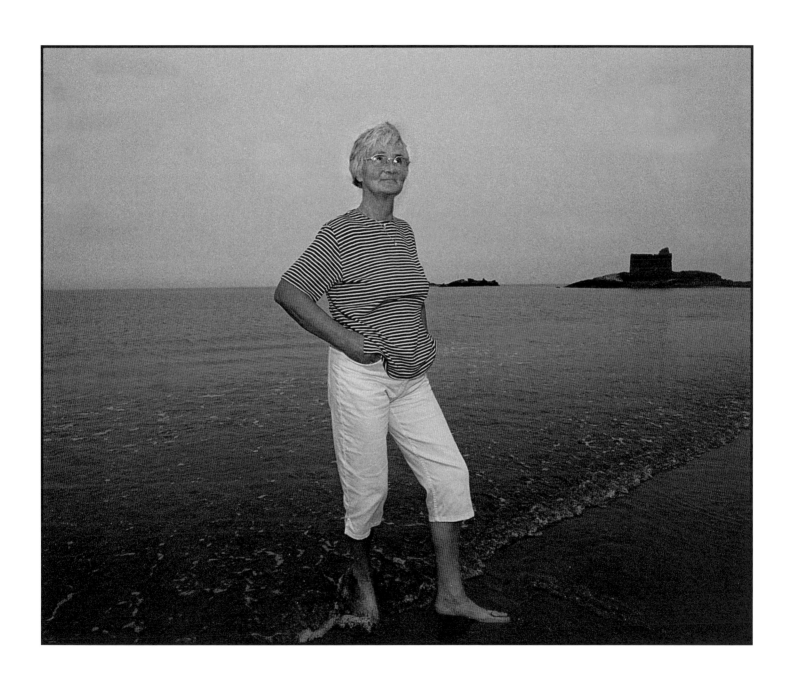

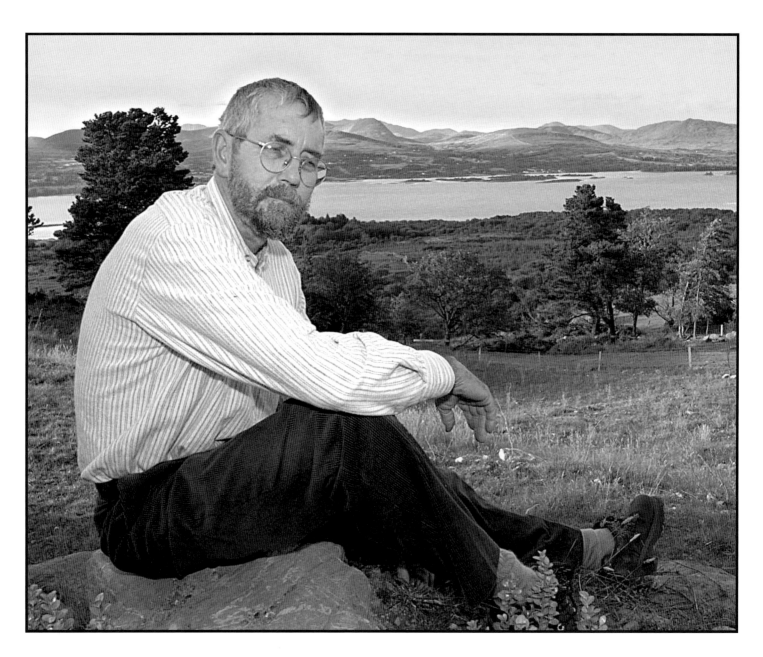

I am of

Own Space

Because we recognise our own humanity in the eyes of the people around us, we therefore need them to know we too are human. Some people like myself, need space and solitude to think and work on the edges.

This was the promise I saw when I first met Kerry. Before I met the 'temptress' I had lived in several different countries and studied in Austria.

This landscape and its people have so much to offer businesses, from the arts to agriculture to industrial products.

When I came to live here, I found a strangely cosmopolitan people connected to the world much more than many other nations. Such people are open to new ideas and willing to benefit from them.

My own home town is the size of Cork. In cities it is easy to meet a lot of people, but most you meet out of necessity, without getting to know them. It is impossible and impractical to meet such a large number of people as individuals. Rather, you create your own circle and the crowd stays as an abstract hum. In such an environment children barely have the space to develop their own personality. All that is left is an artificial world of video games and television.

I am of the impression that adults and children find themselves more in small villages and as a result are more content within themselves. It simply is a gentler way of life. And for the odd occasion we would like to go to a concert or theatre while living in the country, it is easier on our nerves to drive there if we wish to, than to be stuck in traffic jams for most of our working days.

Harm-Jan Veldhoen is a Dutch national from Eindhoven. He has been resident for twenty-three years in Muckera, Kenmare, Co Kerry. He is married to Marie-Louise and have two children: Martijn and Amber. Louise's hobbies include Irish music, languages and set dancing. Harm-Jan's own hobbies include plants and graphical art, which complements his professional interests in construction and design.

Joan Maguire

I blew in one day in May in '83

The night prior
A nun had passed away
Walking the Conor Pass
With her sisters

With over four hundred souls
I have shared time
Taking bytes and chewing bits
Under the eyes of Edmund Rice

Ventry is where I rest
With friends
Above and below the ground
Strong man, beautiful girl these I love.

Under the eyes of Sliabh Gullion stands a house
That moved in the night
Over the lane is Rosie's fort
The first milk was brought here for protection

This is my mothers milk.

A Wexford man walked from his sodden inheritance
To drain a bog in Rathfarnham
He built a wooden house
Filled with laughter drained by death.

My father's people.

I am the fruit of Gullion and Loch Garman
Born on a Dublin Monday morning
Reared with plenty of women and few men
With the key of life fresh and shiny in my hand

I took the iron road to Kerry.

Joan Maguire is an IT consultant. Originally from Dublin, she now lives with her daughter Aoife in Dingle. She has provided computer training and IT services in Kerry since 1983. Joan is Chairperson of the Dingle Information Age Town Committee, co-founder of Oifig an Cheoil, and a founder member of Dingle Credit Union. Her main interest, however, is the sea. She has rowed naomhógs for eighteen years picking up quite a few trophies along the way.

I am of
Kerry

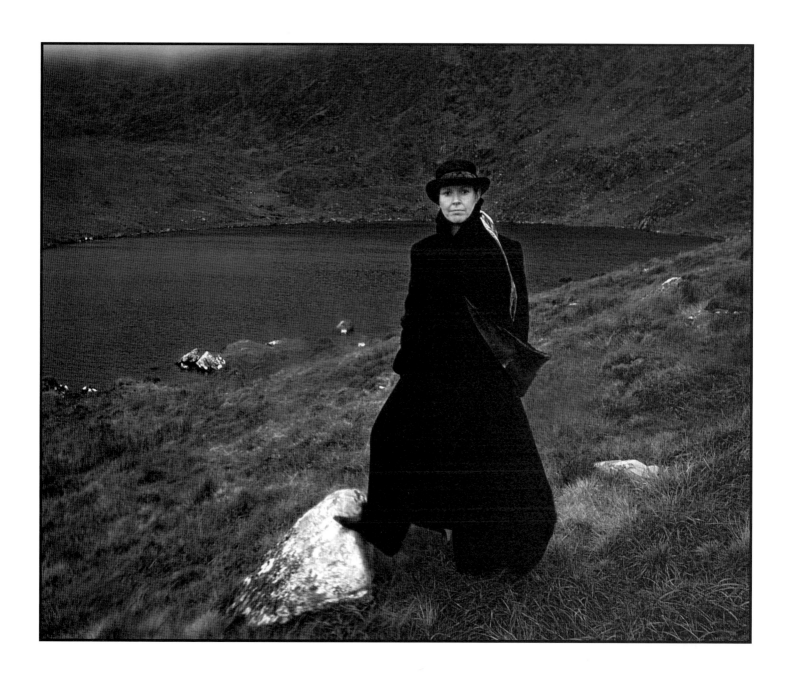

Alan Ryan

When I was growing up in Kerry I was always confused by the idea of 'Kerryman' jokes. Why were people always making fun of us when they rushed to visit Kerry for their holidays at every chance they got?

After I first left home I worked in London for a construction company that owned and operated by Kerrymen. It was here that I first noticed the difference in attitudes and personalities with those of other counties. There was definitely a great pride in being able to say that you were from Kerry.

Later on when backpacking around Asia I met people of all nationalities who had visited Ireland and fallen in love with Kerry in particular. At one time I met a group in a village in Nepal who had visited places in Kerry that I had not only never been, but had not even heard of! This awakened in me an interest in Kerry's natural beauty as well as in its people.

The most memorable part of any trip home for me is when you are crossing the county bounds into Kerry. I feel a huge sense of relief to be home again. Then when I am leaving, be it a day, a week or a month later I leave with that sense of nature, of family and of community that is unmatched anywhere else in the world.

Alan Ryan lives with his family in the mountains outside Kobe, Japan. Orginally from Killarney, Alan has travelled and worked in Asia, Hong Kong, Thailand, Austraila, and Saigon, before opening his own pub, Ryan's Irish Pub in Kobe. He is married to Akemi, and they have two children: Conor and Luna. Alan enjoys mountain biking, hiking, paragliding, martial arts and walking his two German Shepherd dogs.

I am of
Kerry

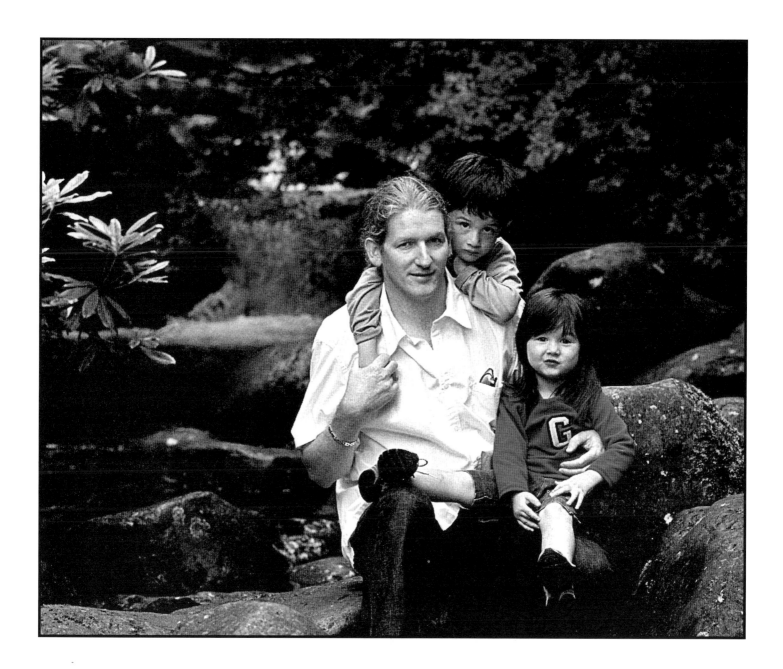

Noelle O'Connell

Is it possible to change?

What does change mean? To be different? Is my different the same as yours? No, thankfully. If we were all the same we'd be very boring!

Can I change 'me'? Or do I mean 'Can I change how I behave, or react, or even look?' When I was little I may have thrown a tantrum to get what I wanted. As an adult I find this approach is not as successful! So, I found another approach, I changed my behaviour but I still endeavour to get what I want, even if I use subtle coercion, compromise or downright flattery! As long as I respect the other person, I know my limits, I'll chance my arm to get what I want! Is this change? Have I changed?

I believe I am born as 'me'. My essence is innate. However, the environment I live in has a bearing on my development, it experiences influence my responses. I may have similar feelings as others, but express them differently. I can change my behaviour, how I react to different situations. Maybe I reacted out of fear from previous experiences but by acknowledging the fear, examining and removing it, my reaction can be different. IF THAT IS WHAT I WANT.

Often I can do this easily; sometimes I may need reassurance and support. This might mean someone to listen, just to be there for me. Their support empowers me to grow and change, but I am in charge of what is happening. This gives me the confidence to be comfortable with the 'real me'.

> Fair seedtime had my soul, and I grew up
> Fostered alike by beauty and by fear.
> – 'The Prelude' by William Wordsworth

Noelle O'Connell, from Listowel, is married to Tom and they have three children: Maura, Brendan and Eoin. Until recently Noelle worked in the financial services industry, where she had accummulated twenty-five year's experience. She has been a volunteer with the Kerry Rape and Sexual Abuse Centre since 2000. She holds a Higher Diploma in Counselling as well as certificates in listening and communication skills, couples therapy and Adlerian Play Therapy. She has also worked with bereavement support groups.

I am of
Kerry

Sheila Prenderville

I am ninety-two years of age and still working in my shop every day! This old world premises, which includes a public house and grocery business in Castleisland, dates as far back as 1798. It is a three hundred year old building, beautifully contructed in cut stone.

In 1840 Mrs Galvin (née Riordan) – a great-aunt of mine – was in business here. On Mrs Galvin's death it passed onto her niece Catherine Riordan, who married William Prenderville from Kilcusnan. It's been in the family ever since.

I love meeting people. Before I came to work here, I gave fifty year's service in Lyon's drapery shop in Tralee. I travelled to work on my bicycle. My own memories of working there are happy. It's what I wanted to do. My family wanted to send me nursing, but I got into the drapery and that was it! I came to work here in 1953 and kept the shop the way it was. Nobody objected. I never want to retire. The regulars keep me going, every day there's something. I give out to them and fight with them… but only sometimes! I enjoy it all.

Sheila Prenderville owns and runs Prenderville's Public House and Grocery, situated on Lower Main Street, Castleisland. At ninety-two years of age, she is still very active and enjoys the company of the regulars and visitors calling to the shop. Sheila is originally from Scartaglin. Her sister Brigid lives in England and her brother Billy lives nearby. There were six in total in the family: three boys and three girls. Sheila enjoys meeting and talking to people, she was a great cyclist in her day, and for entertainment in the pub, she displays her gift of divining!

I am of
Kerry

I am of
Kerry

As a young child my father often told me: *Tóg go bog é agus bogfaidh sé chughat*. The essence of my father's message was that if we say 'Yes' to life and not resist or fight it, then life will come freely, gently and fully.

My stongest memory of Kerry is of people who had a great sense of place and a sense of presence of living life fully. I was taught more by deed than word, that there is a time for everything and if we live fully in the now we will live freely, responsibly and with integrity. What happens here, now, is my responsibility. It is not a matter of doing great things: it is a mater of doing or saying small things with responsibility and courage.

That is not easy. There are, however, great spiritual comforts for us if we are all willing to become people of truth in our time, however hard it may be. To live with honesty and integrity, letting go of falsity, gives us a new sense of freedom and truth.

With freedom, truth, honesty and integrity comes self-esteem. Self-esteem is something that once truly acquired we can never lose no matter what. Longfellow's lines hold immortal value: 'Those that respect themselves are safe from others, they wear a coat of mail that none can pierce.' When we have done what must be done, what we are put here to do at this time, in this age, at this place, then we can live with heads up and hearts unbroken, whatever our losses. Then no one can best us even when we fail the fray, then we will never die before we have lived.

Sr Stanislaus Kennedy, is a native of Lispole, Dingle, Co Kerry. She joined the Irish Sisters of Charity in 1958. She has a extensive track record in social care in Ireland, being a founder member and director of the Kilkenny Social Services, a founder member of the National Association of Child Care Workers and the Campaign for the Care of the Deprived Children, amongst others. She founded Focus Ireland in 1985, helping people to find, create and maintain a home. In 1997 Sr Stan was appointed as a member of the Council of State by the President of Ireland. She is the author of several books including *Spiritual Journey, Gardening the Soul,* and the bestseller, *Now is the Time.*

Pat Moore

> I slept and dreamt
> that life was joy
> I woke and found
> That life was duty
> I acted and behold
> Life was joy.

Of late I'm finding the joy the poet Tagore spoke of. If in dreams responsibilities begin, I now find that joy in my duties. More and more for me the patterns of life I see emerging are the eternal patterns we are all caught up in. My Christian faith gives me the hope and meaning to trust the present moment I find myself in. To move beyond myself, by shrinking my own ego, allows me to feel that there is only one suffering, only one joy.

Friendship is transformative for me. It is wonderful for me to sit by the fireside in the home of my friend Sonny Egan. There I'm surprised and nourished. For the last twenty years Sonny has opened the front door of his home in Garrangore every Tuesday night from November to April. No-one is expected and everyone is welcome. There you can dance, sing, play an instrument, recite, talk or gawk. It enacts the challenge and the healing dimensions of community for us. It uncomplicates life and builds us up when we feel like reeds blowing in the wind as Jesus would say.

These days the more I try to live in God, the more prone I am towards the difficult optimism of Christian faith. For, as it has been well said, in our day pessimism is the easy option.

Pat Moore was born in Asdee on a farm where his mother Peg still lives. His two brothers are married and live with their families in Mayo and Surrey. For over twenty years he has worked as a priest in various parts of Kerry and he now lives in Irremore near Listowel. His hobbies include travel, reading, maintaining friendships. He is fascinated by the way 'story, history and identity come together in all our lives'.

I am of
Kerry

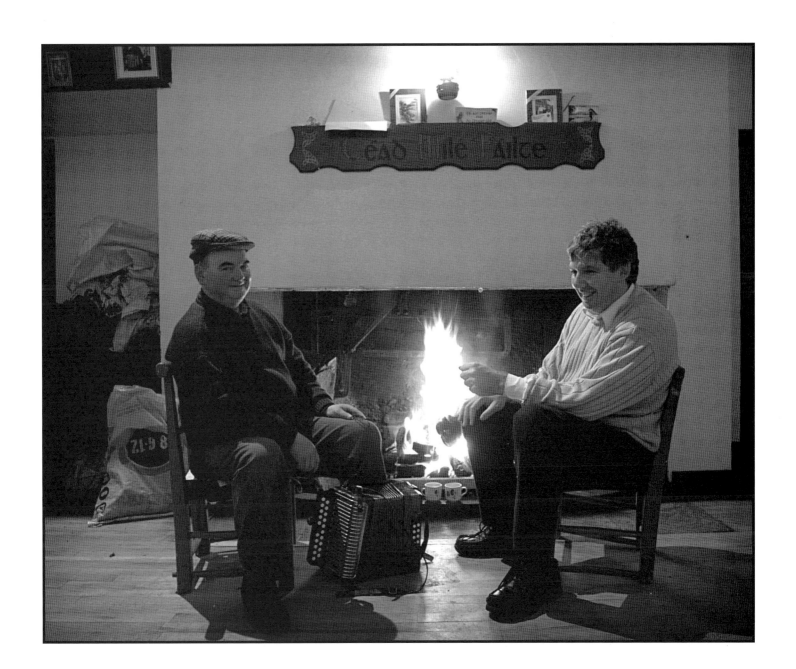

Mick C. O'Shea

The Military Funeral of Martin Cournane RIP
to Holy Cross, Sunday 24 September 1995

The remains by his comrades were borne,
From the church, the requiem bell toll'd;
With his gloves and beret on the coffin,
The drums solemn muffled beat,cold.
Drum Drum Drum Drum

The soldiers, slow marched, rifles reversed,
Whilst the fam'ly bereaved, wail'd their caoin;
And gloom cast a pall o'er Cah'rsiveen,
That never it's like ere been seen.
Drum Drum Drum Drum

A Michael Collins Milit'ry band,
The 'Flowers Of The Forest' played;
As the cortege wended to the graveyard,
Therin, tributes and last respects paid.

Three volleys rang out thro' Gurranearagh,
Their echoes returned to encore;
The 'Last Post' waft'd out o'er the Fertha,
And the drum beat resound'd once more.
Drum Drum Drum Drum

'Twas farewell, to a valued comrade,
Such a heartrending last, sad adieu;
May perpetual light shine upon him,
Martin Curnane, so willing, so true.

Young Marty, much griev'd, now reposing,
And waves roll ashore on White Strand;
Where oft' he'd list to crying seabirds,
Whilst he'd sunbathe and bask on the sand.

Requiescat in pace.

Footnote: Can be sung to 'Lament' from Beethovens *9th Symphony in Minor Mode. Tempo di Marcia Lente.*

Mick C. O'Shea who sadly died in January 2003 was a tailor, cutter and designer. He learned his craft from his late father, Daniel O'Shea. Mick C. was the youngest in his family and was introduced to the trade at an early age. He remembered Sigerson Clifford's father working in the family business. Mick C. was born in Cahirciveen town. He described himself as 'the biggest blue shirt in South Kerry. I'm a Michael Collins man! A poet, a lover of classical music especially Verdi, Bizet and Mozart. I can play any musical instrument I can get my hands on!'

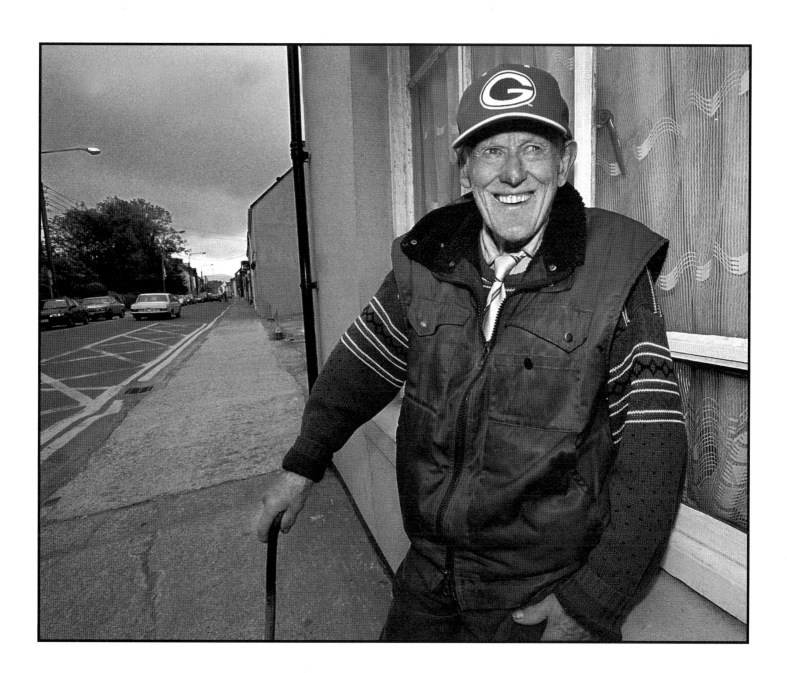

Pat Kavanagh

To live fully and work hard in one's home place, (in my own case – Kerry), for any length of time is a necessity and a privilege. I am delighted to have done so for nearly thirty years now at Kells Post Office, and on my family farm. The additional task of managing a FÁS sponsored social economy programme for the local development company IRD Foilmore - Kells Co. Ltd, has recently become part of my working day.

The natural beauty of this area, farming life, my work and the people of my community – past and present – are part of my understanding of the university of life. There are certain sacrifices a person makes when they choose to live in a rural area, but they are more than compensated for in the happiness and peace that I have found. I often think of my life as a journey. I remember early in that journey, (perhaps I was about five years old), I stood on a piece of ground that my father told me was the old railway track. At a further station in my life (perhaps I was in my twenties), my uncle told me a story of heart-breaking emigration, again based around the old railway. It is the life and I suppose the death or closure of the railway line from Farranfore through Kells to Cahersiveen in 1960 that seemed to challenge me throughout my journey of life.

When Kells Station was put on sale, the local development group purchased it. Kells railway station and buildings are now a base for community activities. In many ways since its regeneration, the station at Kells has found a new purpose.

The railway line of 1892 was a tremendous foresight by the people of the area. Today we are a much more fortunate generation, who ought to build upon the spirit of a community that overcame great difficulties. It is this same spirit that is our daily strength for the next generation. I say it's the spirit of the Kingdom.

Pat Kavanagh is manager of Kells Station, now FÁS Social Economy Program IRD Foilmore Ltd. Pat lives in Kells with his wife Tara. He also works in Kells Post Ofiice. He enjoys farming, community work, and research.

I am of *Kerry*

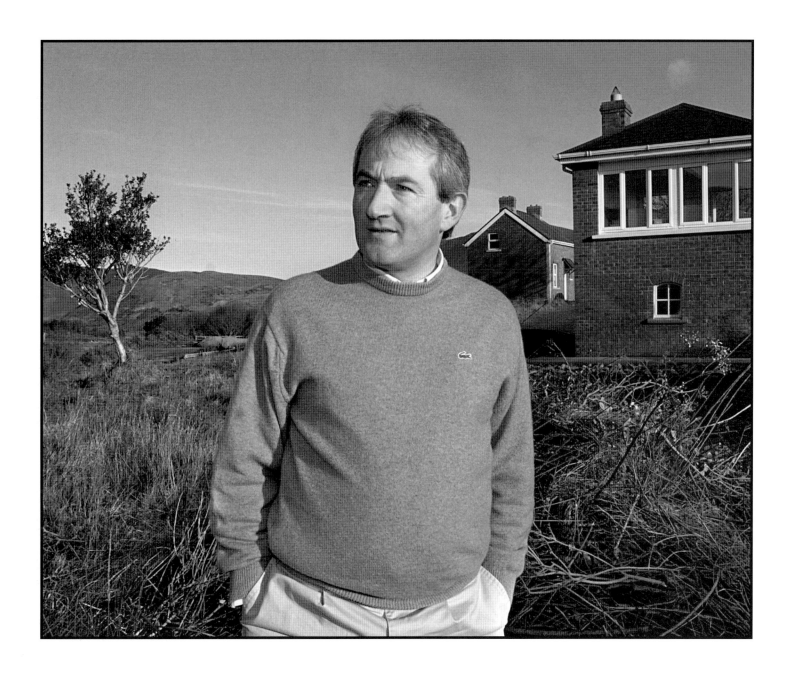

John O'Shea

I think it was John B. Keane who said that being born a Kerryman was the greatest gift that life could bestow. On that basis, my greatest disappointment came with my birth in Limerick.

It's not that I have anything against the Shannonsiders, but life would have been whole lot more interesting, and possibly rewarding, if my mother – then living in Charleville, Co Cork – had made the decision to drive to Tralee for the occasion. Facing a choice of nursing homes in Kerry, Cork and Limerick, she chose the latter. Happily, however, my father, John, was a native of Cahirciveen, Co Kerry and although most of his working life was spent in Cork, Mayo and Dublin, he never let me forget he was a Kerryman born and bred. As a result, I almost got through life pretending to be one as well.

One of the proudest moments of my life came when I was allowed to pull on the green and gold jersey. It was in the late '80s, and a challenge match had been organised between old Dublin and old Kerry in Parnell Park in Dublin to help Pat Spillane back into the game after a knee operation. Covering the game as a journalist for the Evening Press, I brought my gear along as well, just in case. And it paid off. With just minutes to go to the throw in, and short a player because of a mix-up with cars, Kerry's manager Frank King turned to me and uttered the words I had waited half a lifetime to hear. 'O'Shea,' he said, 'tog out'.

The Kerry greats playing that day – Jack O'Shea, Eoin Liston, Mikey Sheehy and of course Spillane – have probably long forgotten it all, but for John O'Shea, born in Limerick, raised in Mayo and Dublin, lining out for the Kingdom remains one of my greatest achievements.

But the bluff didn't stop there. Years after setting up GOAL, I received a phone call telling me that I had been chosen as the 'Kerryman of the Year'. For a few brief moments, I almost accepted the honour. But I knew I'd never be able to pull it off. 'Look,' I said, 'it really would be lovely to accept that award, but I've got to tell you that I'm not a Kerryman by a long way. I wasn't born there, I didn't go to school there, I didn't live there.'

Silence from the other side.

'Hang on a minute John. Didn't you go to school in Killarney, and live in Tralee for a while, and sure didn't you even play for Kerry once?' The last part was true, as I've explained. The rest, unfortunately, was pure fiction. The Kerry organiser was distraught. A vote had been taken in some meeting or other about it, and that all the arrangements were in place to crown John O'Shea as 'Kerryman of the Year'. Programmes for the event may even have been printed. If they weren't pulped shortly afterwards, they're a true collector's item. Our conversation, in retrospect, was as bizarre as you'd expect from the deepest crevices of that blessed county. The man who wanted all his life to be a Kerryman spent at least ten minutes trying to persuade a real Kerryman not to make him accept the award of 'Kerryman of the Year'. In the end, of course, common sense won out, and the award went to a real Kerryman who richly deserved it.

Born on the wrong side of the Kerry border, I missed out on life's greatest gift. But that was just an accident of geography. Whenever Kerry people gather to give thanks for their status as Ireland's chosen people, keep an eye out for John O'Shea lurking at the fringes of the crowd. The birth cert says Limerick – the heart proclaims the Kingdom.

John O'Shea is founder and chief executive of GOAL, the humanitarian organisation dedicated to helping the poorest of the poor in the developing world. John is married to Judy (née Gallagher) and they have two sons and two daughters: Stephen, Lisa, Karen and Johnny. For twenty-four years he worked as a sports reporter with the *Irish Press* Group. John's list of achievements and awards include: People of the Year 1987 and 1992, The Ballygowan Outstanding Achievement Award 1988, Publicity Club of Ireland Communications Award 1990, MIR Award 1992, Citizen of the Year – Dun Laoghaire 1992, Association of Tennis Professionals – Humanitarian of the Year 1993, Late Late Show Tribute 1995, and Texaco Outstanding Achievement Award 1995.

I am of *Kerry*

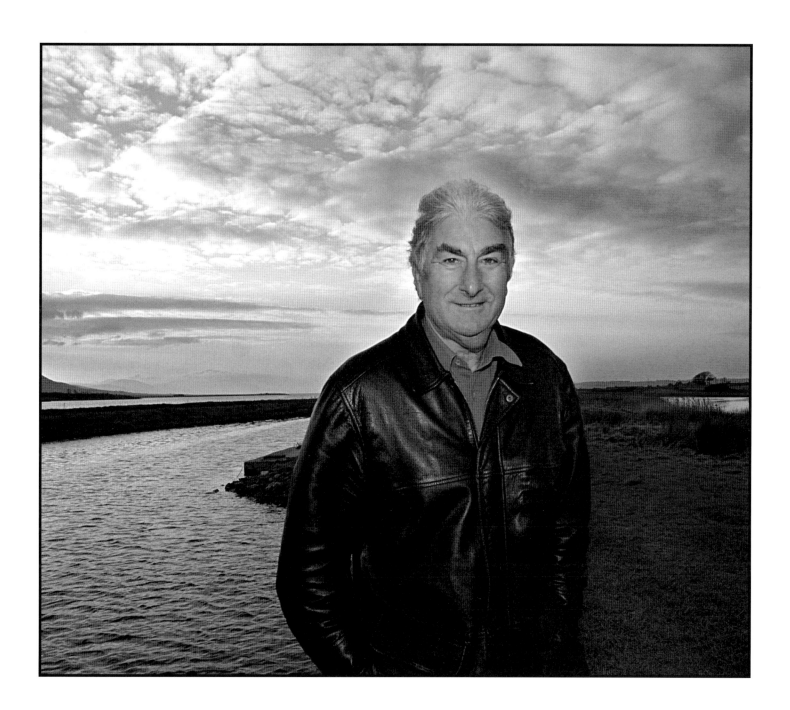

Dorothy Moynihan

What Makes me 'Tic'

I was always a dreamer from an early age and I still am today. For me it is so important to have something to aim for and my dreams or passion for creativity get me up in the morning.

I was never great at maths, science or sports but I loved art, cutting things up and creating something new. I remember as a poor student making some skirts out of pillow cases! Once I get stuck into a new project I go into a different world and the project takes on a life of its own.

I didn't get a chance to do my fashion course in Mallow until I hit thirty but getting to Taispeántais and having my designs on national television made all my hard work worthwhile, thus proving that you are never too old to start something new. In my opinion there lies the secret to a happy and successful life.

So what is next? To keep on going through the highs and lows and reach my ever-changing goals.

Doherty Moynihan is a dress designer from Killorglin, and she is married to Dermot Moynihan from Knocknagree. They lived in England, Scotland, Limerick and Mallow before returning to her native Killorglin, where they run the local photo shops in the Squares in Killorglin and Dingle. Doherty loves working with textiles, and enjoys painting. She has won awards in tailoring and recently her designs were featured in Taispeántais, the showcase for design graduates from all over Ireland.

I am of
Kerry

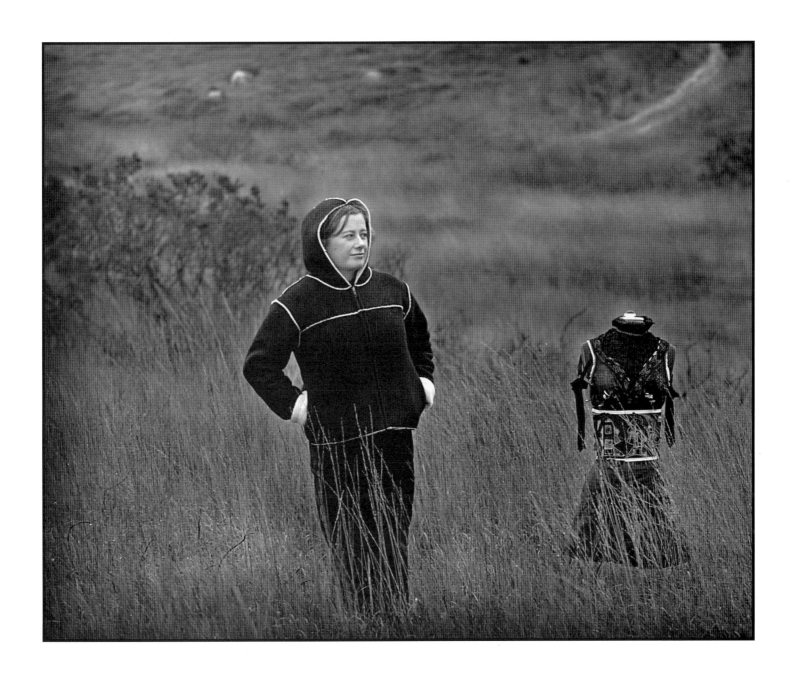

Seamus McConville

I travelled a lot of road before I took root in Kerry. I lived in Meath, Cork, Laois, Leitrim, Louth and Dublin before I arrived in the Kingdom in August, 1957. Even though I came on a one-way ticket, I hadn't planned to settle here. But marriage – to a Cork woman – and a family decided my future. And I have never had any regrets.

I love the spontaneity of the Kerry people, the colour of their language, their sense of fun, their ambition, their pioneering spirit, their sense of tribal loyalty, their pride in their own place and the achievments of their own people. And there is that place called Kerry. You may have to come from outside to fully appreciate its magic. I have been exploring that magic – north, south, east and west – for forty-five years and still get excited by it all.

If I were to choose a place which has special memories for me it would be Caherdaniel. That's where we spent our summers when our children were small: caravanning at Dan Curran's in Glenbeg. All have now left the family nest but all of us still love to go back there.

In fact my daughter Fiona and her husband, Pierce Ryan, are building a house down that way. So Caherdaniel and Derrynane are likely to see more of us in future!

I have watched Kerry grow and prosper and been happy to use my journalism and my travels to tell the world about its magic spell: the glories of the Ring and the splendours of the west beyond the Conor Pass.

Good friends have made it easy to live here, to take root. We thank God every day for their generosity! It is what binds us to the sainted soil of Kerry.

Seamus McConville was born in Navan, Co Meath. He began his career in journalism with *The Meath Chronicle* in 1952 and spent three years with the *Irish News* Agency in Dublin before joining *The Kerryman* newspaper in 1957. Seamus retired as editor in 1987 and is now a columnist with the paper. He is married to Dolores and they have four children: Denise, Sean, Fiona and Marissa and three grandchildren: Laure, Rachel and Grace Mary. His hobbies include work and living!

I am of Kerry

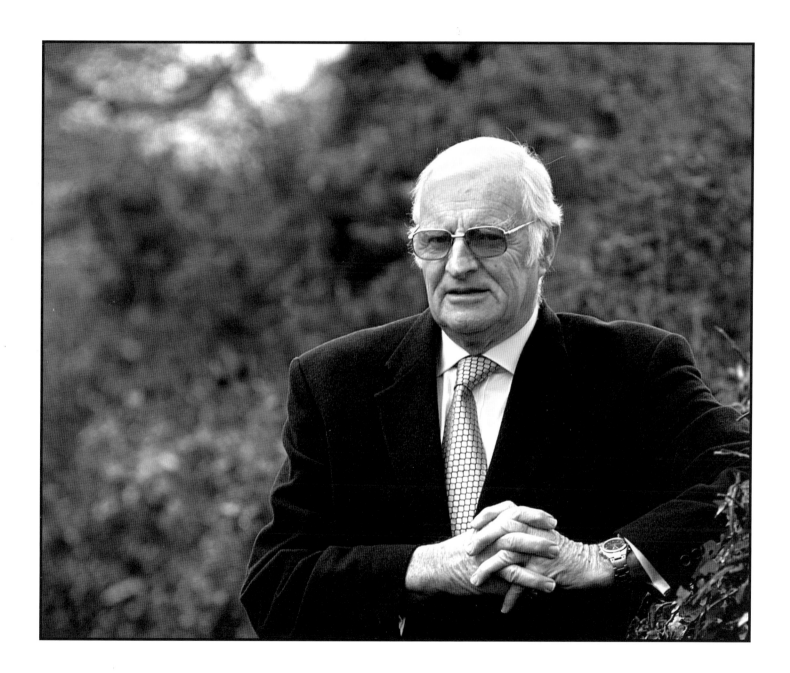

Mick Galwey

My wife Joan has been my strongest support and greatest critic: from counting the number of times I say 'at the end of the day' in interviews to giving me a much needed reality check when rugby might have been getting me down. I can always count on her. Joan has brought the children to Limerick, Cork, Dublin, Cardiff, Paris, even Boston and Toronto. People sometimes might look at Neasa and Aibhe and wonder why we bother. It would be so much easier and often more enjoyable to leave them at home. There are two reasons. We want both of them to grow up knowing they were part of this phenomenon called Munster rugby. Although Neasa will have much bigger crises in her life that the current 'who took Daddy's number four jersey' and Aibhe is still too young to understand, we hope they will grow up feeling privileged like we do to have been part of it all. Secondly, being a professional rugby player involves a lot of time away from home. If we didn't bring them to matches, our contact time with them would be very limited.

I've enjoyed many famous moments on the playing fields of Ireland and the world and I will forever carry the memories of those great times with me. However, at the end of the day (sorry Joan!), the love and support of one's family supercedes all. In this regard, Joan has been a pillar whether times were good or bad. She was there for me through thick and thin since we first met in Woody's night club in Castleisland. Her love has be unstinting. We have been blessed with two lovely girls, and God willing, there wil be a third member of the family before the end of the 2002/03 rugby season!

My mother Bridget has been to me, my number one fan. There was never a time when I deserved to be dropped and to this day, it's woe betide anybody who criticises me. That's a mother's role isn't it? Although her rugby following days have been curtailed in recent years due to her poor eyesight, she is totally in tune with the world of rugby from her kitchen in Currow. She listens to all the news reports and takes disappointments worse than I do. She raised eight children and buried two husbands. I hope I have her will to live and ability to enjoy life at her age.

Rugby has been my life. There's nothing fair about it. I have played with and against several players who deserved to be capped and never were. Lady luck and the hand of God play a huge part in all our lives. I think of my father who died at forty-eight and never saw me in a red or green jersey. I look at my family and know how much he would have adored them.

What the game gave me far, far outweighs whatever contribution I might have made. I can honestly say that I will look back in years to come and say 'I was there and I loved it.'

Currow man and Kerry Person of the Year, Mick Galwey, has had an amazing rugby career. He has won 41 international caps, made 140 Munster appearances and captained his province on 85 occasions. When playing with Shannon, he won nine Munster Senior Cups and five AIB leagues. Mick is the leading forward try-scorer in all-time AIB statistics. He lives in Kilkenny with his wife Joan and their two daughters Ailbhe and Neasa. Mike enjoys golf, Gaelic football and is devoted to his three favourite girls.

I am of *Kerry*

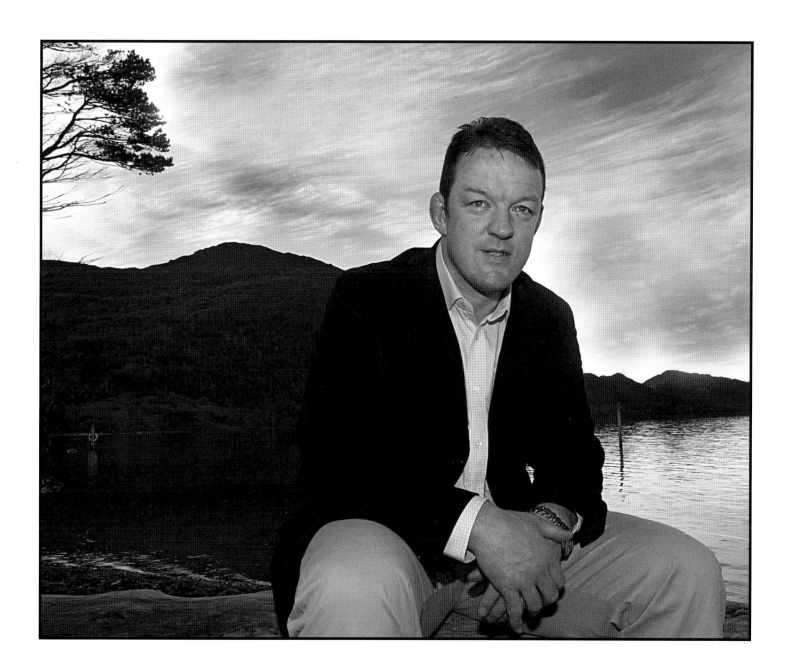

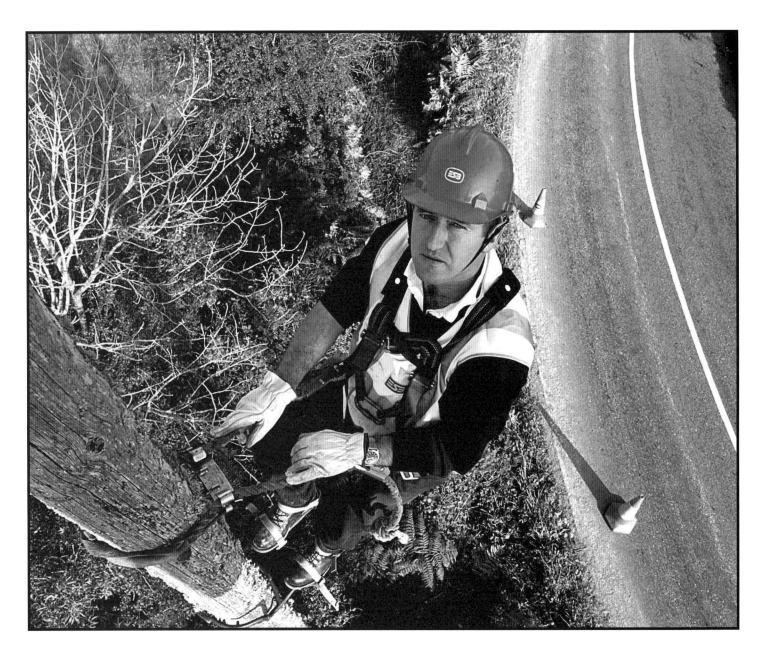

I am of
Kerry

When will I have it all? And will the 'all' bring contentment?

As a young lad, growing up on a farm I watched my father work the land. I spent a lot of my time outdoors too. That was a rich life – simplicity at its best. Like all youngsters, I lived for the moment, the fun and games, visiting the cousins, pal calling, kicking football, but I never lost my love of nature and animals.

When I started working, the ESB line work suited me, I was still outdoors, walking through the fields, and sometimes looking at beautiful scenery from a bird's eye view on top of a pole. Spending a lot of time in the midst of nature gives me the space to think and to work out what's important to me!

Whether it's a day in the meadow at home or climbing a pole, the answer is always the same: Keep it simple! There have been a few moments when I gained more insight in the meaning of life: the births of my children. They teach me how to live life simply. They have a way of expressing their views and needs in a direct and honest manner. Their innocence demands time and truth.

Another key moment of insight was the loss of my father and friend, Willie. He never sought material gain and yet his life was full. He had nature all around him, his family, good friends and his greyhounds as a pastime. The legacy he passed on to me was to live a full life, live it simply, but live it well. It's the very young and the old that have taught me the most, and all of it in the context of the cycles of nature, the seasons of life.

The world's giant media and marketing animal led me to believe in my teenage years that material objects were not only desirable, but essential to make me happy. But if I step back and remember my loved ones both young and old who are with or no longer with me, and when I see the hunger and suffering world-wide then, I appreciate how lucky I am to be able to enjoy life for itself. A simple stroll through the fields, a game of football or rugby, or a good chat and a laugh, but most of all spending time and playing with the kids. That's real life. That's gold to me.

Jack O'Rourke is a network technician with the ESB. He is from Ballymacdonnell, Farranfore, where he still lives with his wife Maureen and their sons: Ben (five), Jonathan (four), Dylan (three) and Isaac (one). Jack works on the family farm. In keeping with his father before him he keeps greyhounds: 'the great escape into sanity'. He takes an active interests in sports having played football and soccer in his youth. He follows rugby and in particular the Munster Rugby team.

Clo O'Keeffe-Lyons

To become a really whole person we must be still and face the fear and hurt inside us. Having a place which allows us to do this, to quietly sit and listen to our own depths. To know who we really are is essential, though for many not possible. I believe the Kerry Rape and Sexual Abuse Centre offers a sacred place which allows us all to learn to be still, to value a safe space and to learn to wait for growth to happen. This growth happens gradually when we learn to listen and be still.

Time allows the light to dawn out of the darkness, only with the help and support of people can we learn to be safe and come to realise that the shadows only exist because there is light.

Clo O'Keeffe-Lyons is clinical advisor at the Kerry Rape and Sexual Abuse Centre, Tralee. She was born in Dublin and is the third in a family of six. She attended secondary school in Mayo and then moved back to Dublin. She studied in UCD and completed BSc and MSc in psychology. She spent nine years in Mayo and moved to Australia with her Mayo husband Sean and their son Colin. On returning to Ireland, Clo came to work in Kerry. Nearly two years later her daughter Maeve was born. Six years later she's still in Kerry and plans 'to stay here for a while (at least!),' she says.

I am of
Kerry

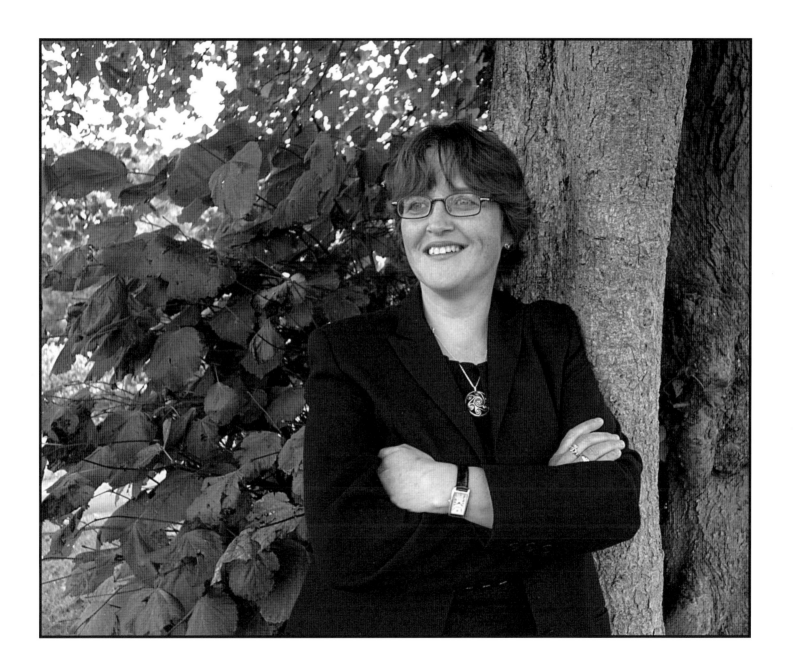

Hanna Maher

It feels like forever since my first day at school but I suppose eleven years is not that long ago. I don't remember everything about the day but my most vivid memory is of being in complete awe of the classroom's apperance: the low yellow-legged tables and chairs, the bright posters and drawings on the walls, the array of books on the shelf at the back of the room and the kind looking woman at the door.

After we had met the teacher and were allocated our seats we were given a colourless picture and a cardboard box of wax crayons. I don't think we did much else that day and before I knew it my mother had come to drive me home.

Hanna Maher is fourteen years old. She lives in Cooleanig, Beaufort, and is a student at the Intermiediate School, Killorlgin. Hanna is the daughter of Paddy Maher and Riona MacMonagle. She has one brother: Lorcan. She enjoys reading, hockey, and modern dance with Carol O'Connor. Their dance group is called Ricochet. She loves hip hop and R 'n' B.

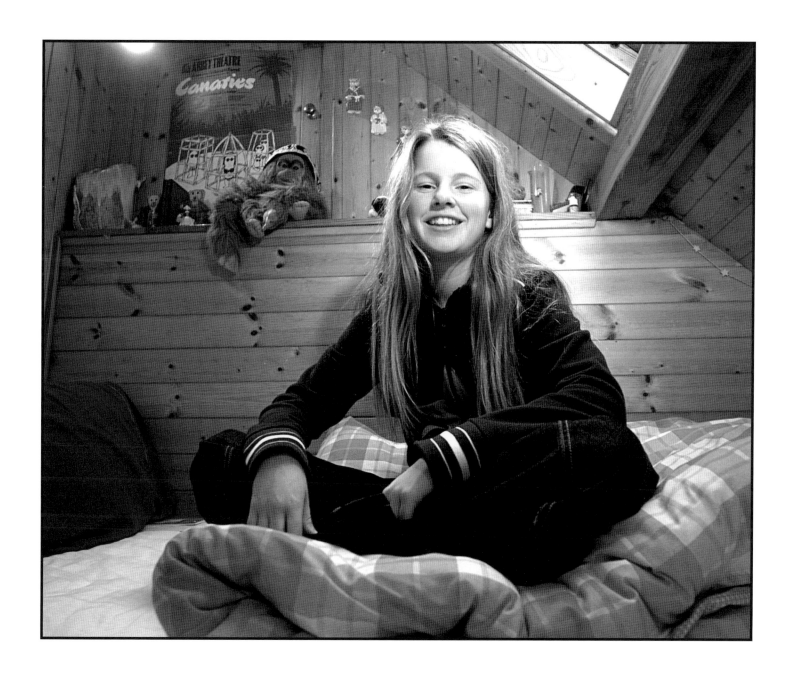

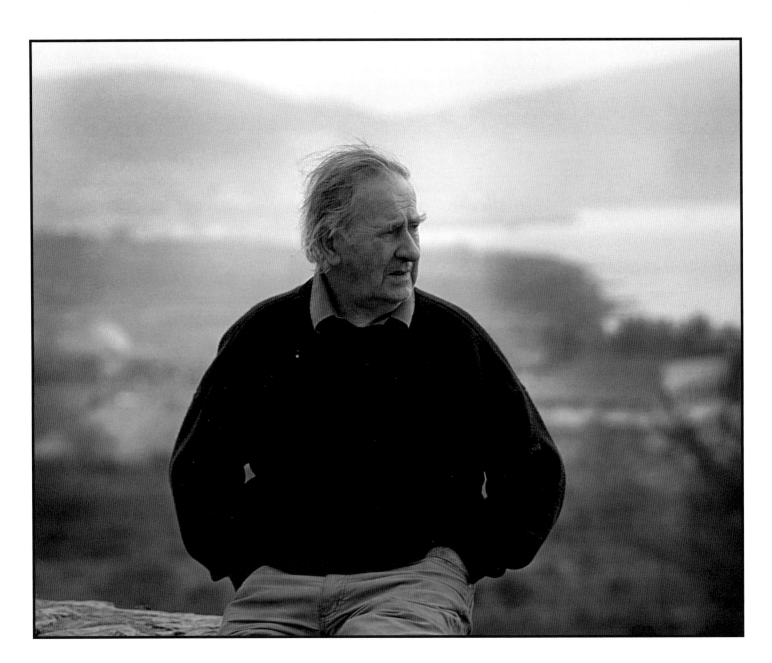

I am of
Kerry

A Humanist's Prayer

I want to live
>> to see the flowers opening lips
>> drink in the Summer's rain
>> but not the frightened eyes of war-scarred orphans
>> crazed with pain

I see the golden moon
>> rise up above a distant hill,
>> a lover's moon, but not a bomber's
>> out to kill.

To hope that man shall follow man
>> as has happened since the race began,
>> and that the line continues endless
>>>> 'til the end of time.

>> no God, or gods, I ask for help;
>> let me appeal to men,
>> 'Give us this day our daily bread, not bombs'
>> Amen Amen

This poem was first published in *Breakthru*, an English quarterly poetry magazine and subsequently included in a collection of its best poems.

Sean continues: 'For the information of the younger generations who have been born since the end of World War II, I would like to explain that the pilots of the heavy bombers coined the phrase "A Bomber's Moon" because the moonlight was a help to navigation in their deadly mission of off-loading their bombs on enemy towns and cities.'

Originally from Cahirciveen, Sean Healy worked as an instrumental technologist in England. As a child he travelled to school on the train from Kells Station where his father was station master. He is now retired and living in Cahirciveen town. Sean is married to Ruth and they have two children: Mick and Simon, and four grandchildren. Sean loves writing poetry and prose and enjoys reading.

Moira Murrell

Capturing what it is to be of Kerry is not the easiest of tasks. Certainly, it is a county renowned for its beauty and charm, rich culture and history extending back to the origins of civilisation itself. All of these things make Kerry a special place, yet none so special than the fact that Kerry is my home: the place of my past, present and most significantly my future.

It is that place where I can name on a walk of Muckross House and Gardens, the estate gardener and house cook from over a century ago, and with a nod of recognition pass the old vegetable garden, by the café, where my grand- and great grand-fathers tended to the landlord's greens. It is that most beautiful eastern part of Killarney on a rise overlooking the lakes, that I can picture in the now vacant house, the home that once was. The comings and goings of a family, the well water and the long labourous hours worked on this farm, that too the toil of my forebearers.

The past and the link through time to a place, enriches the present. A present and a place where I have the greatest privilege to live and work and constantly discover. The back-road through Ballyfinnane, the standing stones at Lispole, the Sheila na Gig at the Ratoo round tower: all my recent and prized discoveries in this Kerry.

Of course I can not complete this piece without mentioning as a Killarney native that the crowded July Streets and the green clad visitor of late summer also represent in its own way the 'Summer Kerry'. Be that experience part of the native's pain or pleasure, is one I would gladly debate (perhaps at another time). This too is an integral seasonal part of the Kerry of which I am very glad to call my home.

Moira Murrell works as a Senior Executive Officer: Finance and as European Liaison Officer with Kerry County Council. She is a native of Killarney, where her parents, Charles and Mary Murrell, still reside. Now living in Tralee, Moira has a brother John and two sisters Breda and Margaret. She was educated in St Brigid's secondary school, Killarney and University of Limerick. Moira has worked with both Killarney Town Council and Kerry County Council since 1993. She enjoys reading, hill walking, cooking, current affairs and politics and has a keen interest in local history.

I am of
Kerry

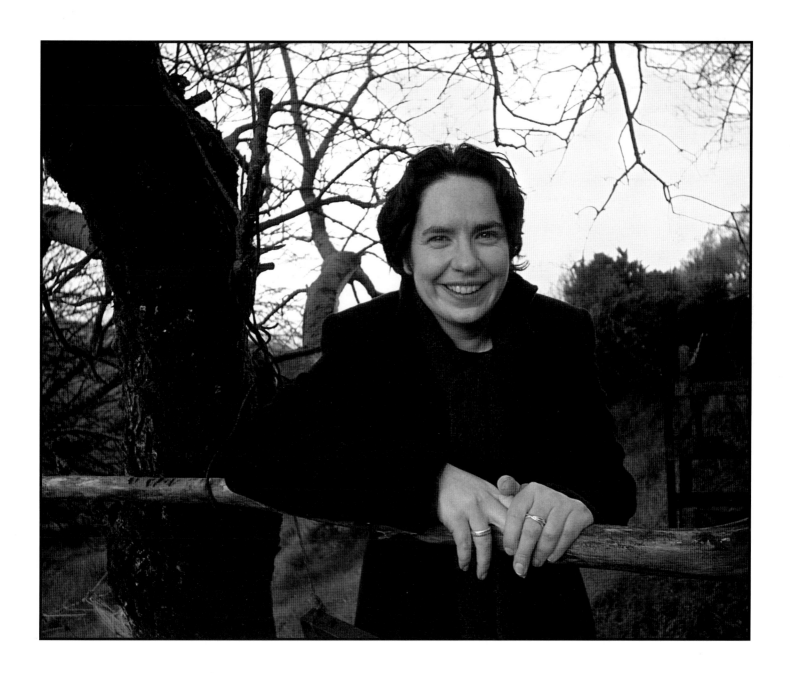

Mark Daly

John F. Kennedy, when speaking in Dáil Éireann, said, 'we need not feel the bitterness of the past to discover meaning for the present and the future.' Kerry and Kenmare like all of Ireland is steeped in a long, sometimes proud, sometimes sad, history. Reminders of this, our past, are all around us. From the stone circle up Market Street to the famine roads that stretch for miles, from the monument at the cross roads commemorating fallen volunteers to Father Breen Park where Kenmare's red and black was worn with pride by an All-Ireland winning captain.

Our past, some of which does not sit easy with the present, bitter and sad as some of it is, should remind us of the mistakes that were made, but should also make us resolute not to repeat them. As we all know the Irish forgive little and forget less, but as JFK said we should remember the past, and learn from it, but we need not live there. The sacrifices of the past, the sacrifices of those who made our community and our nation what it is and made us what we are, should not be forgotten. For the lessons that they have taught us can be learnt without the bitterness that caused them to happen.

Growing up in Kenmare you learn that you are not just an individual but you are part of a wider community. As part of a community you have a responsibility to make the world we have inherited somewhat better for those who live in it with us and those who will come after us. Thus when we go on our way to that great big football field in the sky, if it could be said of us that between the good and bad that we have done, that on balance we left this world a little better than we found it, what more could we hope for?

M ark Daly is an auctioneer and survivor of RTE's *Treasure Island*. He lives in Tubbrid, Kenmare, Co Kerry. He is the son of Sean and Eileen Daly, and he has two brothers John and Conor and a sister Elaine. Mark is chairman of the Kenmare Shamrocks hurling and Gaelic football club, as well as being a player. He enjoys history and politics and the people he most admires are his parents, Brian Crowley MEP and John F. Kennedy.

I am of
Kerry

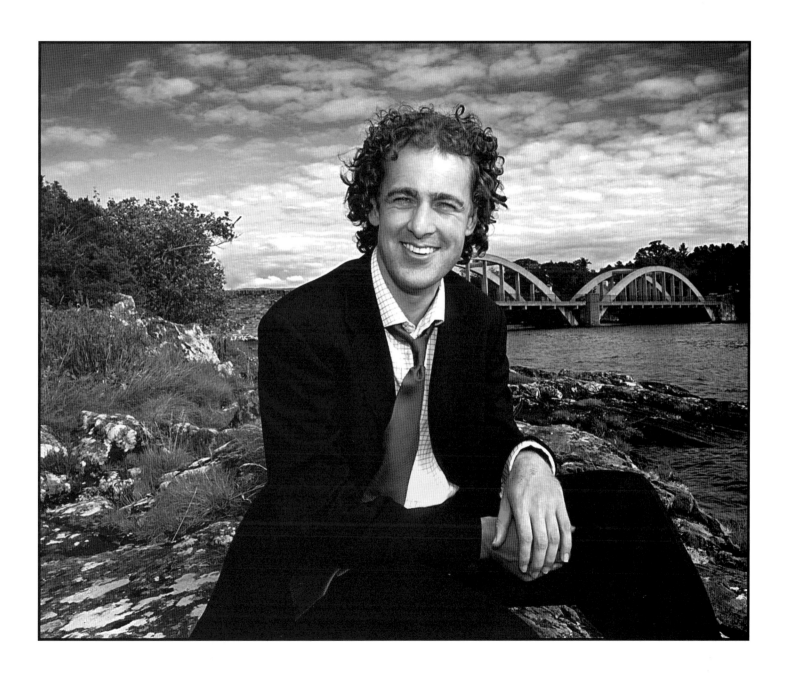

Billy Keane

Mary

Mary Maher was still soft and womany warm
But for ignorance
It was hard to beat her husband Sean.
His foreplay a gallon or more of porter,
His lovemaking a slaughter
She lay
Like a fish on a slab
Waiting for the stab.
She did it to keep him quiet
While her children slept at night
And as he wiped himself upon the sheets
She heard lovers laughing in the streets
And she wept
Silently.

Billy Keane lives in Listowel, and is married to Elaine. They have four children: Anne, Laura, Lainey and John. He runs the family pub, John B Keane's, and is a regular contributor to the *Irish Independent* where his sports columns 'gives many a chuckle'. Billy is working on his first novel, which will be published next year. The poem 'Mary' was broadcast on the RTE programme *A Darkness Echoing*. This is the first time it has appeared in print.

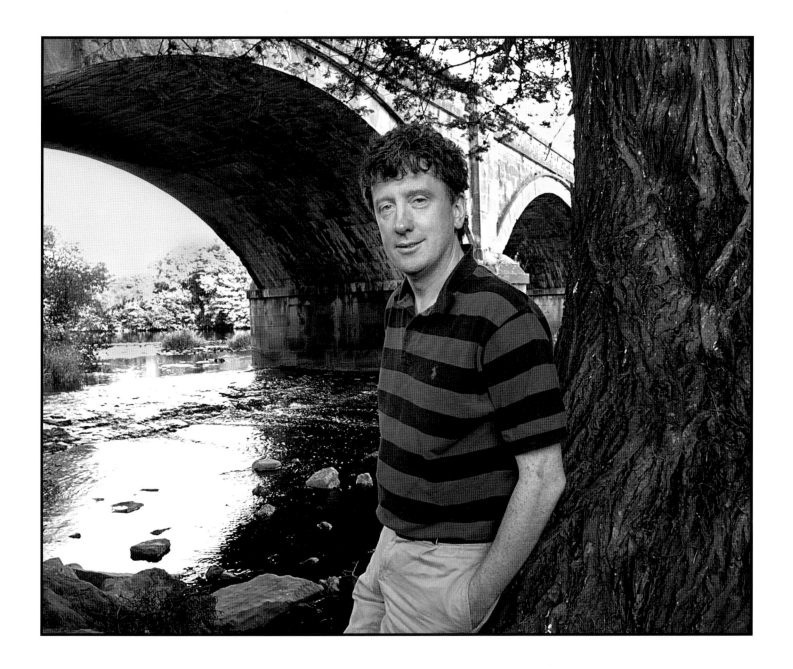

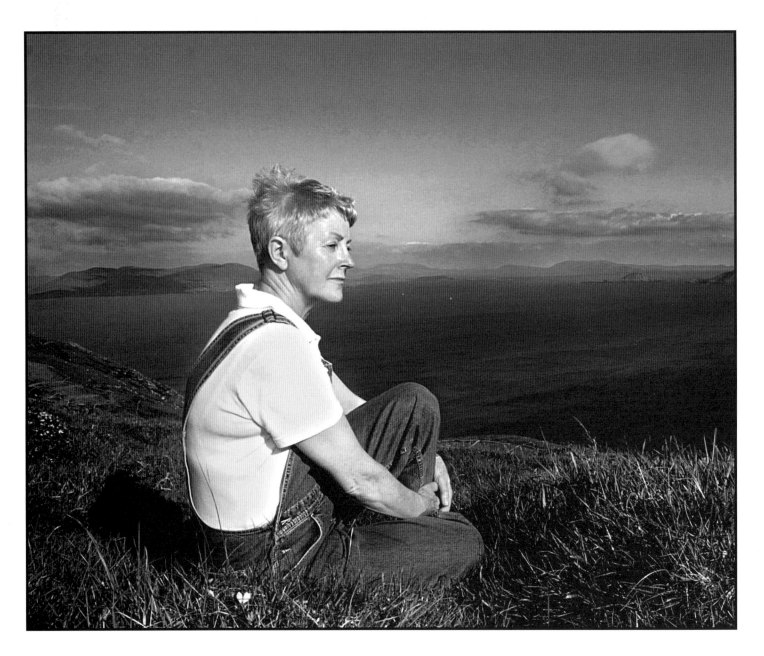

I am of

Here I am surrounded by such infinite beauty, sitting or strolling along 'the edge of Europe', where the monks from Skellig also once walked.

> What need have you to care
> For wind or water's roar

This is what has always remained constant in my life, like a photo you keep treasured, a memory locked away in your mind of something special, only it never diminishes and it never, ever looks the same from minute to minute. In my bleakest times coming here is what restores my faith in human nature.

> Being young you have not known

If the good God created such beauty for mankind to enjoy, he must love us very much. I ponder on this beauty, this expanse of openness, the multitude of changing colours, the stillness, the serenity and again, I'm reminded of W. B Yeats' poem 'To a child dancing in the wind'.

> What need had you to dread
> The Monstrous crying of wind?

Mary Casey was born in a remote part of South Kerry, a few miles from the most westerly point in the map of Ireland. She came to Killarney over forty years ago. In 1973 she established the *Killarney Advertiser*, one of the oldest free newspapers in Ireland. Mary is a mother and grandmother and devotes a lot of her time to helping children from Chernobyl.

Patrick Dunne

I've been a refuse collector for fifteen years. I always enjoy collecting the bins when the day is fine, but when it's raining, it's miserable! Apart from the weather I enjoy my job, meeting people on the rounds, I know most people on the route. Our job is made a lot easier nowadays with the new bin system, whereas before we'd be lugging bins and plastic bags.

I miss my friend Sonny Healy who retired in August. We had great crack together. When he retired all the neighbours in Marian Park threw a party for him: that's how popular he was. They thought the world of him.

I enjoy being part of the Greyhound Bar golfing society in Tralee. No matter where we go, we always finish up in the Greyhound!

Being a 'Rocky' all my life has made life great whether it's with the Greyhound golfers or following the Austin Stacks footballers or the Kerry team.

Patrick Dunne describes himself as a 'Rocky' from Stack's Villas, Tralee. A Tralee man all his life, he has two brothers: Johnny and Michael, and three sisters: Mary, Noreen and Eileen. Patrick follows Austin Stacks and is a great supporter of the Kerry team, travelling to most of the matches.

I am of
Kerry

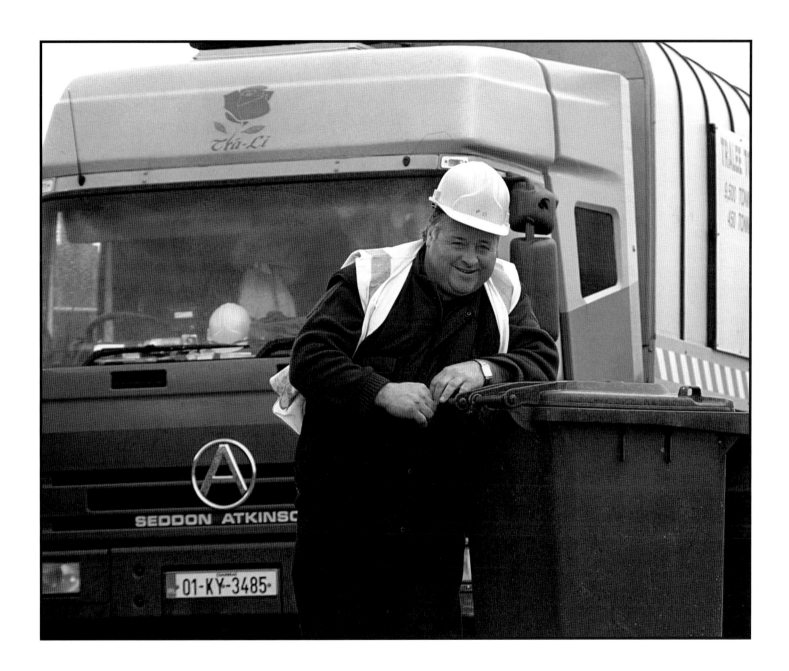

Maura Moriarty

This extract from a London newspaper, *Religious Liberty,* says it all for me about Caherdaniel: the place I have lived in and loved all my life.

A little piece of heaven

These are the changing times in our country of northern clime. The heather of the uplands has regained its sheen and bounce after being pressed by winter snows. The enchanters from Latin lands daily tempt us to come and visit them. Ably abetted by the travel companies, the siren call is wailed from mystic shores.

With all the skills of modern technology, the lily of the unknown is gilded. The colour tone of glossy magazines enhance the well dieted young men and women, scantily clad and golden, dare us to join them in their solar Utopia. The too perfect bodies, the sumptuous culinary layouts, the posing palm trees, smack of the unreal. Not for me, thank you!

My dreamland is eighty miles from my door, by car. Even the engine seems to give a soft sigh of relief as I head in its direction. As I head west, through Coolea, and over the Coom, the draíocht (magic) is already casting its spell. Reaching Kenmare, and driving on for Sneem, my mind unwinds with the road. Between there and Westcove, with the sea on my left and the mist tipped mountains on my right, my mood is positively benign. Only a few more miles to traverse and I am there.

Rounding a bend, there's the jewel of Castlecove, sparkling in its perfection. The last lap. Ahead is Derrynane Hotel, flags fluttering and in it's perfect setting. And then I'm there – Caherdaniel. As I park in the village, it seems I never left. The drowsy, friendliness of a salute tells me I'm home. In a frentic world it's nice to have a constant. On Lamb's Head, boot emptied and cares with it, I take stock. With the sound of surf easy on the mind, I look into the distance. Far out, near the islands, a fishing boat bobs in the sea. A seagull rests on the wind over Abbey Cemetery. The earthly remains of the Liberator, Daniel O'Connell rest there. To the right of the cemetery is his home, Derrynane Abbey, now part of the expansive, beautifully kept National Park. Inland, the mist rolls over the bog atop of the mountain. Caherdaniel, snuggling under it, is full of its mysticism. Daily, through my holidays, I journey to its peak.

The peppermint air and mountain streams are a bountiful reward for my climb. An unwise night in a local hostelry can be saved by a trip to this shrine of fresh air. But it's the beaches, the massive expanse of silver sand, which provide the areas crowning glory. Washed by the unspoilt purity of the Atlantic, they lie there, pristine and alone.

The long cotton wool trail of a jet forms a ribbon in the blue sky. Where it's going and who's on it I wonder. The plaintive cry of a curlew matches my thoughts. The soft blur of Gaelic in a turf incensed paradise is more gratifying to me than the whine of a jet engine. My heaven is to be found on my own shores. The soothing lap of water on a hushed evening, the tittering of sea birds before sunset, the mountains put to bed under misty flannel – this is peace in a perfect place. The lure of tropical sun can be taken up by others. The silver-winged giants will whisk them to deception. My ancient Ford transports me to my little piece of Heaven – on earth – CAHERDANIEL.

Maura Moriarty is a retired postmistress. She worked in Caherdaniel Post Office until her retirement in 1994. She has lived in Caherdaniel all her life and she was educated at Loreto Convent, Killarney. She had two brothers: the late Canon Eddie Moriarty and the late Seamus Moriarty. Maura loves the Irish language and reciting poetry. She visits the Derrynane Hotel each day and informs the guests of the local history and places to visit in the area. Her post office skills are also put to use at the hotel, every day she brings the post to Caherdaniel Post Office a job she really cherishes.

I am of *Kerry*

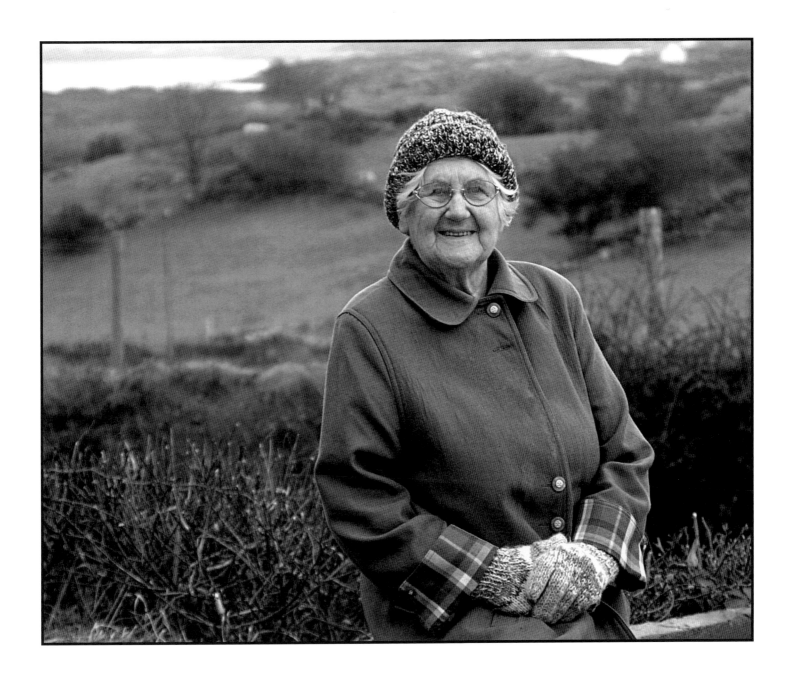

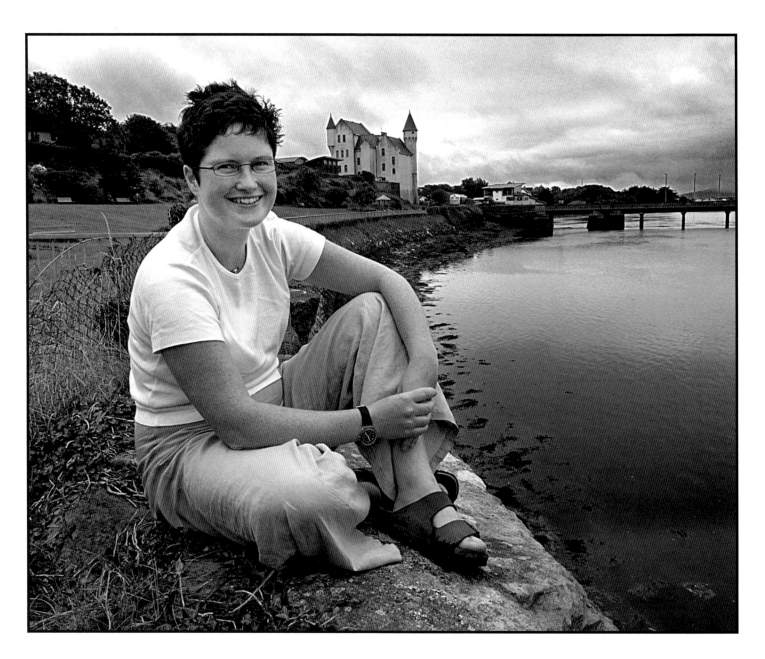

I am of
Kerry

Six-months on…

The first thing I did when I arrived in Cahersiveen was crash my car into a lamp-post! No doubt this eased my acceptance into the community as firstly, I immediately contributed €900 to the local economy in repair bills and secondly, it ensured I would never be an uppity Corkonian.

The rain poured for the first four weeks. My rite of passage. It was so bad that I sometimes drove the 100 metres to work.

Two goats perched on a gatepost greeted me on my way to work the first morning. At lunchtime I saw an elderly man taking his messages home in the bucket of his tractor. I knew I would fit in well. For the previous six years I had been living in the fast-lane of cities. Or at least I was on the hard-shoulder of hyper-markets, cinemas, theatres as well as air pollution, and anonymity. I was delighted to be given the opportunity to work and live in a small town. As I breathe in the sea air on the ferry across to work from Valentia in the morning I think of the poor souls stuck in traffic jams. I don't envy them with their shops and cinemas. The rain and goats and tractors are part of my life now.

Of course it's not all sweetness and light. More people need to have job opportunities in rural Ireland. And the blight of holiday homes must give way to affordable housing for those who want to live and work in the area all year round.

Having lived most of her life in Cork and spent the last six years in Cambridge and Aberdeen, Janet Heeran now lives in Cahirciveen, Co Kerry. She works as community and Carrefour information officer for South Kerry Development Partnership where she provide EU information to South West Ireland.

Wilma Silvius

A Kerry Woman?

Really? Legitimately? Well, I suppose I've lived here more than half my life; but I was not born here. Are you sure I fit in this book? My being different sticks out; my accent being the greatest traitor, never lost the Dutch tongue, although in Dublin they call it Kerry-Dutch. When I tell people I am from Kerry, an expecting silence descends where everybody waits for the rest of the story. Kerry people have a great ability to relate to 'blow-ins' and when these 'strangers' show a small sign of affinity they are taken up in their midst.

I found this so when I arrived in Kerry in 1975 a week before Puck (what an introduction!) to stay with Sheila and Danny Sullivan and their children Daniel and Breda in Langfordstreet. My three months stay could have been frought with homesickness if it wasn't for my immediate acceptance into their family, introductions to relations, acquaintances (amongst whom my future husband) and the 'social scene' in Killorglin. Before I realised it, I was part of the place, to such an extend that some years later I received the highest compliment from John's first cousin Kathleen Mangan, who exclaimed when we were talking about emigrating and missing people at home: 'I forgot you are not one of us'!

I never forget how my mother-in-law Wanie Mangan, opened her arms to me with a hearty 'Welcome'. We used to get on like a house on fire, and although she often must have found my ways strange, her acceptance of me was unconditional. Kerry is my home. Through the years I have built my life here with John and the kids, with my work on the farm, in school and the Killorglin community. I put down roots in Ardmoniel. Farming was an important part of the process. The closeness with the land developed through walking and working it, the animals, the view of the Macgilllycuddy Reeks and Carrauntoohil outside my front door every morning, the business we developed together. It is great to walk into a supermarket or delicatessen and see Wilma's Killorglin Farmhouse Cheese on display.

The same satisfaction hits you when a calf is born, the milk tank fills with the frothy white elixer; a smooth cheese emerges from the mould. Or when I can help a young person with their decisions about their career in school. Or when I walk down the road and exchange the time of day with people I know; and I know most of them. I came a long way from city life and anonymity. Satisfaction is so easily achieved; pleasure, delight and enchantment accompany our life in Killorglin. The interest in sustaining this type of life and community has carried John and I farther than our farm/business/community and pushing the cause of the right of small farmers and rural communities to survive, at national and international level.

If I wonder what makes me a Kerry woman, it is definitely the love of the land and landscape, and the love and welcome I received from all the fine Kerry people through the years.

Wilma Silvius was born in Eindhoven in the Netherlands, where she studied social and cultural anthropology at the University of Nijmegen. She arrived in Killorglin on a reserach programe for her Master's degree. She is a teacher and career guidance counsellor at Killorglin Community Colleges. She is married to John O'Connor, Ardmoniel and they have four children: Marieke (18), Sinead (17), Sean-Tomas (15), and Rikus (13). They run the home farm, where they make Wilma's Killorglin Farmhouse Cheese, with milk from their own cows. They sell the product all over Ireland and abroad.

I am of
Kerry

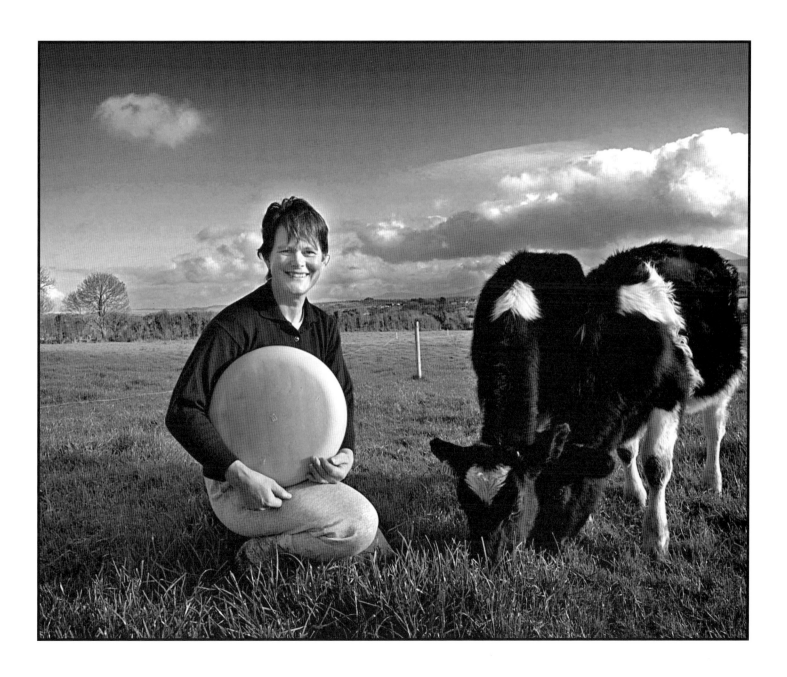

Shane Fitzpatrick

As a non-Kerry native, why did I leave the Kildare plains and the big Dublin smoke for the Kingdom and Kenmare town?

Interesting question and one not easily answered… in words anyway. It's definitely the wonderful restaurants and pubs, the inspiring scenery, and the cosmopolitian atmosphere. But most of all I think it's the people and the craic and quite literally 'living on the street where everyone knows your name'.

It's the feeling of having been accepted as 'one of their own' or 'one of the lads' and enjoying the constant buzz of laughter and good humoured banter. Having worked in Dublin and for short spells in France and Australia, there is nothing to compare with being recognised and welcomed when driving through the town and that is why I have come back time and time again!

Shane Fitzpatrick is bar manager at Mickey Ned's Bar in Kenmare Town. He is a native of Kilcullen, Co Kildare and came to Kerry seven years ago. Shane has three sisters: Karen, Louise, and Lorraine. His parents Michael and Nancy live in Kilcullen. Shane has always been involved in the catering profession. Prior to working in Mickey Ned's he worked in Sheen Falls Hotel. He represented Ireland in the Youth Skills Olympics for Catering in France, where he won a Silver Medal in the restaurant section. He is a member of Kenmare Golf Club and enjoys swimming and all outdoor activities.

I am of
Kerry

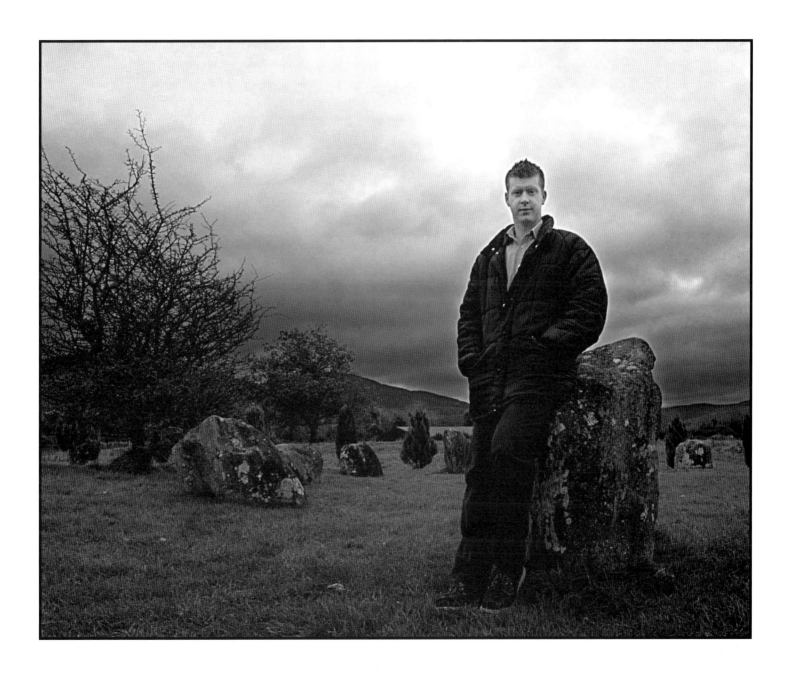

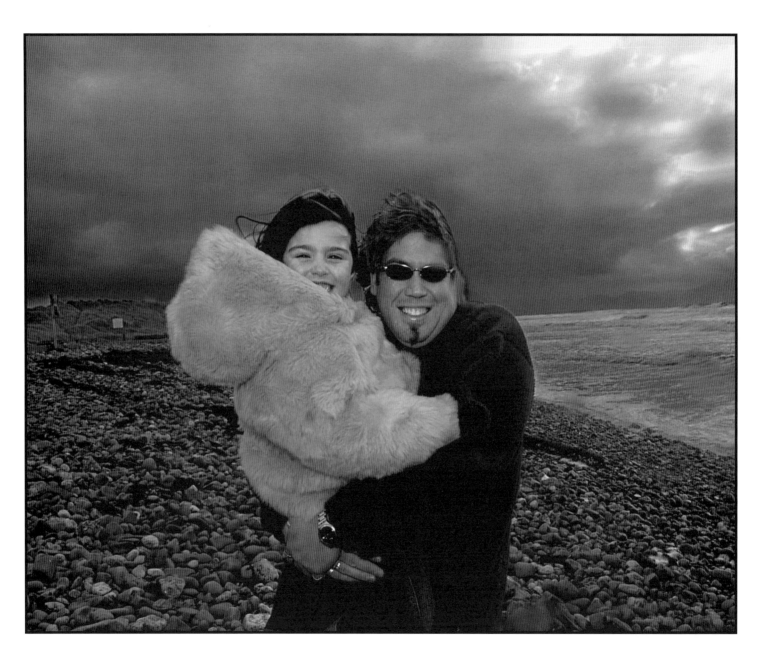

I am of

Kerry

'Over 30 years of mischief and merrymaking' is the tagline on my business card. Admittedly, I am only 33, but I feel I have been working my whole life to get to the point where I am now. The mischief I created as a child led to merrymaking as I got older. That in turn I have harnessed and focused to bring fun, entertainment, humour and creativity to other people.

There are far too many appalling events, people and attitudes in the world. We should all attempt to do something to balance these unpleasant things. If I can make at least one person a day smile it helps to maintain stability. My goal is to make everyone I meet happier in order to tip the weighing scales in favour of fun.

Children are mirrors of all of us. I try to reflect fun, creativity and understanding back to them. Adults often have misplaced their fun and humour in the day to day hustle and bustle of their daily lives. When I perform, I try to bring some of that back to them. There is magic in all of us, young and old. If I can tap into that magic and fun and then release it, people will feel better about themselves and others.

My own magic comes in the form of my daughter Rose. She is the highlight of my life. Quite a lot of what I do and what I learn comes from and through her. Joy, laughter and love all stem from who she is and what she does. She is the single most important thing in my life.

Chris Reina has been described as 'eclectic, diverse and varied'. His work and interests include street theatre, Macintosh computer support, fire-blowing, percussion, juggling, graphic design, children's entertainment, drama, film-making, a samba band, photography, magic, martial arts, games, chairperson of a school board, stage/set design, kite-flying, face/body painting, masks, costume making and puppetry. He has performed on the street, stage, screen, public and private, in venues from the US to Ireland to the UK. He lives in Inch, Co Kerry. His mother, Bonnie, is also a well known artist in the area.

Veronica Shanahan-Whitehead

I love this county.

I had to come full circle to know this. Anyone who has had to leave the country will know the feeling. During the years away you begin to appreciate what home means. I love the sight of Kerry; its vibrant colours, its heart-stoppingly beautiful countryside, its rocks and bogs, its ugliness on a wet, grey day, its madness during a storm.

Kerry has a touch all of its own, from the cold stone of its ruins to the warmth of its waters, the coolness of its mossy trees to the weight of a friend's hand on your shoulder. The taste of Kerry has become more intense over the years. It is simple, natural and is being infused with the many wonderful influences enhancing this county. How I love the smells of Kerry! Its woods, fields, seashores, its towns, villages and markets, and yes, its people. It is full of life and unique.

What has always affected me most is the sound of Kerry. It is never silent but always magnificent. I love the sound of the people, their speech and the music they make. But I most especially love the sound of my home, where my heart is.

I have great hope for the future of this wonderful place. I am awestruck by its past and I am glad to be part of its present, for I am of Kerry and I wish for it only the very best.

Veronica Shanahan-Whitehead was born in Killarney and reared with her four brothers and three sisters in Farranfore. Her influences are her parents, whom she describes as 'the most amazing and extraordinary people'. She has a degree in music and a HDip in Education from UCC. Now living in Kenmare, she is married to Adrian, a golf professional from Coventry. They have two children: Sara-Jane and David, who are her 'saving graces' and the centre of her world. Veronica's main interests are music and the arts, eating out, sports, people, the world we live in and its care.

I am of
Kerry

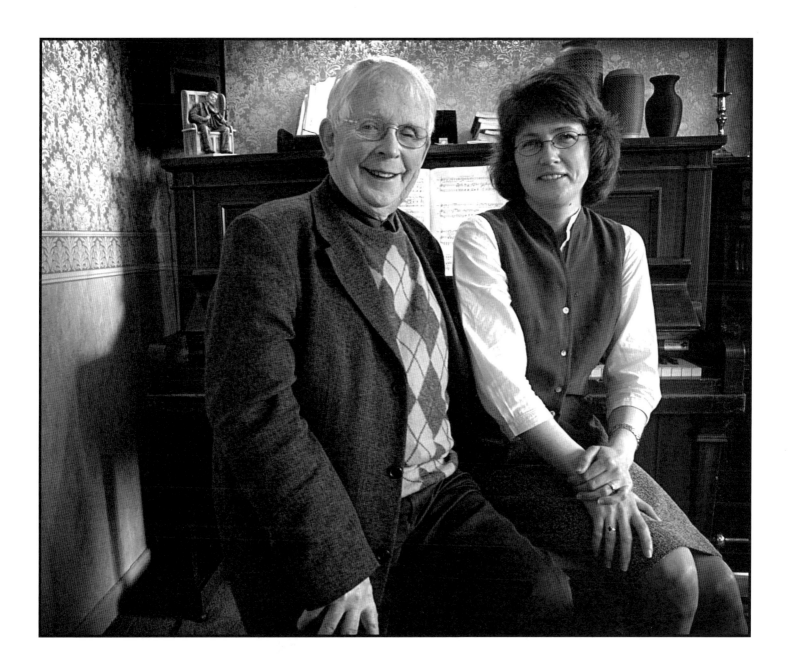

Anne Lucey

It would be nice to wax lyrical about Kerry and about being from Kerry. To catch from an office stool the wasp yellow fields where the kelp streamers lie, like Sigerson Clifford.

I do this sometimes with the moon shining down the side of Mangerton and the house quiet except for the low murmur of a sheep, or a fox or the rustling of a squirrel up a pine or the growl of a deer through the conservatory walls, I catch up that poem and I belt it out catching my breath at the first line or so where it talks about being from Kerry like 'my mother before me and my mother's mother and her man.' For this is true. I am Kerry. Yet it strikes me too, at full throttle and the moon shining, there is something askew, ever so slightly askew about the rhythm in that poem. There is a beat missing somewhere. The more often I read it, the more I see this missing beat. This is true too of Kerry. The longer I live here, the less in some respects I like it. Something grates. It is I think because the dream has been sold, or worse, not realised, when all the while it could have been.

When I was leaving Cork for Kerry having spent too many years in the bowels of the library at UCC with the Egyptian mummy dusting through old papers, the poet, my professor, John Montague said to me in a small pub off the Model Farm Road where we would go sometimes to have a medium of Guinness 'Don't let them get you.' At the time I wondered what he meant, half knowing too.

For all its beauty, this is a county of men. It is a county that favours male games, male committees, mostly male juries, where football is a religion'. Even being called an animal is less insulting than the latter, I think. It is a county where you could imagine a second run at The Kerry Babies, a county where to lie and to deceive are far more acceptable than in most. And it's not all codding.

It is a county which has begun believing its own tourism marketing 'myths' – not alas the ones of Deirdre keening Naoise in the cave near Rossbeigh, but newer, emptier ones of perfection, and which reacts with fury once those myths are challenged.

Anne Lucey is a journalist working mainly with *The Irish Times* and *Independent* Newspapers, concentrating on news and feature stories. Prior to working as a journalist, Anne worked in the arts and has an MA in Old and Middle English. She is married to Haulie and they have two children: Robert (11) and Edith (7). They live in Lorien, at the foothills of Mangerton mountain, Killarney. Originally from Fossa, Anne enjoys gardening, reading, music and radio, 'cinema, great paintings in great galleries; London which I adore, the interior of churches especially English, and French and Spanish doors.'

I am of
Kerry

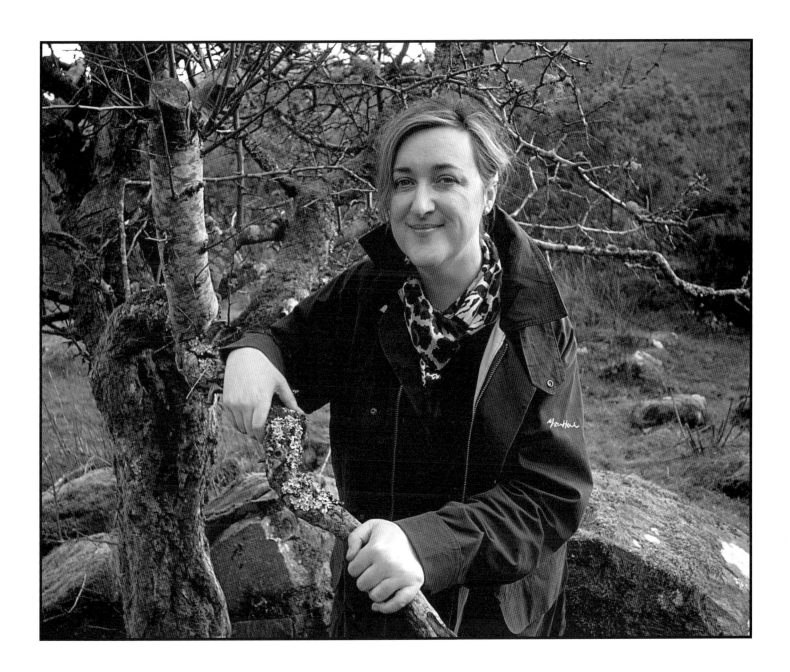

Máire Begley and Mary Conway-Knipper

Mary Conway-Knipper

Music has been a constant companion throughout my life.

We work and there's music

We cry and there's music

We're young and there's music

We're older and there's music

We're wise and there's music

We're foolish................... and there's music

We're pray and there's music

We die and there's music

There's music and we dance

There's music and we listen

There's music and we're with friends

There's music and we're alone

And of course Máire and I share 'Notes, Notions and Nonsense' on Friday nights with our listeners!!

Mary Conway-Knipper (right of picture) is originally from South-East Galway and comes from a musical family. She has been living in Kerry for the past twelve years. Mary has presented many programmes with Radio Kerry since its inception in 1990, including her current programme, 'Kingdom Céilí' broadcast every Friday night with Máire Begley.

Maire Begley

I was born in Baile na Buc, near Ballydavid where my father was born in Begleys Pub which was famous for music. Nearby my grandfather, Michael Begley, had a dance hall called The Shed, frequently visited by the clergy, but their efforts to quell the music and dance were in vain. My father played the button accordion and sang beautifully as did my uncles Mick, Johnny, Jim and aunt Mary Begley. My great grandfather on my mother's side Tomáisín Ferris Imleagh was a great fiddler and my mother Ellen Lynch is a beautiful singer. She's in Dingle Hospital now. My teacher, Kevin Kennedy, in Scoil Naomh Erc taught me a lot about tonic solfa. Coláiste Íde was another influence. Sr Rosari was great! My uncle Jim Begley bought me a piano accordion for working in his bar in Ballydavid, the first piano accordion in the peninsula! I went to the Presentation Convent Dingle and had one month's tuition from Sr Charles and that was it! I mainly play by ear. Being the oldest I used to gather the other eight siblings around the fire in Baile na Buc and sing, especially on Christmas Eve. We used to sing on our way to Midnight Mass, past the roaring Atlantic. Steve Cooney reminds me I was the first to bring a guitar to the Gaeltacht! When in Carysfort College, Mother Teresita gave me special permission to sing at the Oireachtas, where I was disqualified because I sang An Seabhac's 'Ó Beir mo Dhuthracht'. The adjudicator said the melody sounded Scottish! My sister Eileen and myself sang on RTE '64 and Club Céilí. My brother James and myself played the accordion on Dermot O'Brien's show and recorded several albums. My husband and I have a cottage near our home called 'Tínteán Ceoil', a 200-year old thatch cottage, turf fire, oil lamps, candles. I run Irish nights, Bothántaoícht on Monday nights all year round.

Maire Begley (left) is a mother, wife, musician, broadcaster, and *múinteoir náisiúnta* in Aughcasla National School. She presents the very popular 'Kingdom Céilí' with Mary Conway on Radio Kerry on Friday night. Maire is married to Michael Ó Sé and they live in Lios na Groí, Castlegregory. They have four children: Máire, Róisín, Neasa and Michael. Maire likes to meditate, and enjoys walking, calligraphy and music.

I am of
Kerry

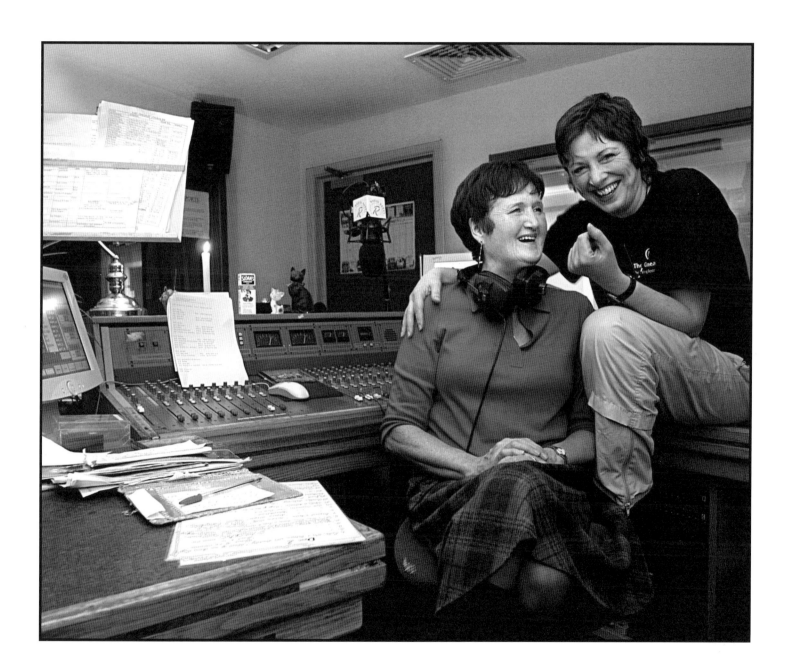

Joe Murphy

Evolution shows us that man as a species is most adaptable, yet nowhere is man more at peace and in harmony with himself and his environment than when he is close to nature. This above all else, will sustain the spirit in an excessively materialistic world. Kavanagh said 'that without the peasant base, civilization would cease'. Let gods make their own importance and behold the sound of silence! Nach iontach an t-oide an dúchas?

Joe Murphy is manager St John's Theatre and Arts Centre, Listowel. He was born in Inch, Listowel, and combined farming and teaching for thirteen years. He has been the *Fear an Tí* at St John's since October 1990. He is married to Jennifer and they have one daughter Marelle. Joe is still involved in farming and his pastimes include 'bullocks, reading, sleeping and scratching myself'!

I am of
Kerry

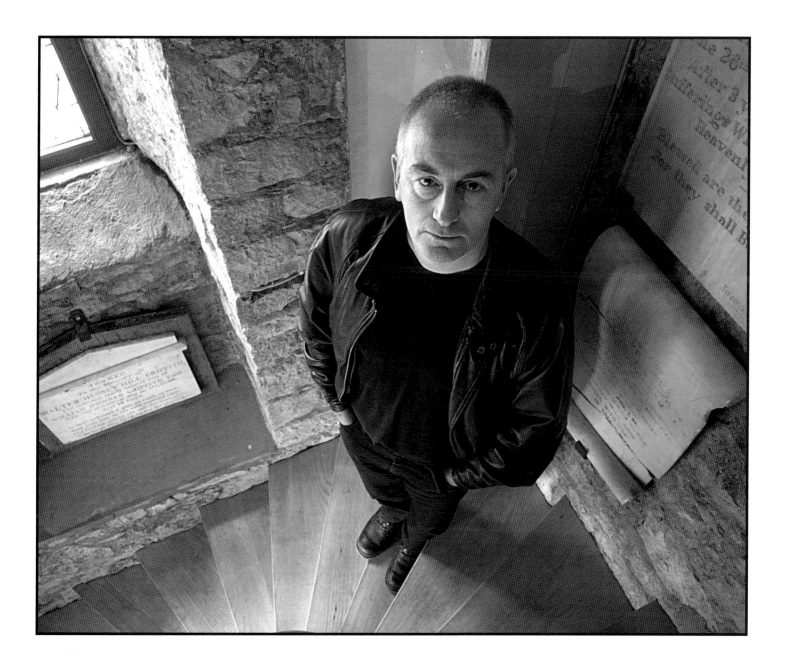

Tommy O'Riordan

Programme… Programme!

As anyone approaches any football ground in Ireland, Britain or anywhere else in the world, the familiar cry of the programme seller is there to greet you. Long queues of supporters form in front of the programme huts in order to secure their particular souvenir of the forthcoming match.

My first introduction to collecting match programmes was back in 1970 when my father took me to see my first League of Ireland match in one of Cork's, and indeed the country's, most famous soccer ground, Flower Lodge, home of the famous but now defunct Cork Hibs. As we passed through the gates, I can still remember the cry 'Programme… Programme'. From that day to the present I still have the bug for collecting.

It's a hobby, it's unique and indeed has become a labour of love, spending hours sifting through many of the hundreds of the programmes I have collected over the years, from cup finals, friendlies, internationals, benefit matches, testimonials. It's like going back through a time tunnel.

I then began to collect old soccer magazines, books, cards, coins and anything that was connected to soccer from all over the world. I was introduced to the art of looking after the material, putting them in plastic sleeves, binding them, logging and storing them. I have many friends who frequent soccer grounds around the world. The first thing I ask them when they arrive back 'was there a match programme?' The present day programmes are a lot different in many ways to the way they were produced in the past.

Soccer stadiums may change, players will change clubs, football chairmen will be replaced, but the one thing you cannot replace will be the loyal fans listening on match days for that cry 'Programme… Programme'.

Tommy O'Riordan has the biggest collections of football programmes and memorabilia in the county. He is the first Kerry referee to be appointed to the National League Seminar Panel. He is a passionate Leeds United supporter and a keen follower of Cork football. He started collecting soccer programmes when he was just ten years old. Tommy is a native of Blackpool, Cork City, and came to Killorglin in 1981. He works in the catering industry and is married to Eileen. They have one son Darren who plays Gaelic football with Laune Rangers and soccer with City Wanderers. As well as collecting programmes Tommy is fascinated with soccer statistics, he enjoys snooker, reading, and is a strong supporter of League of Ireland soccer.

I am of
Kerry

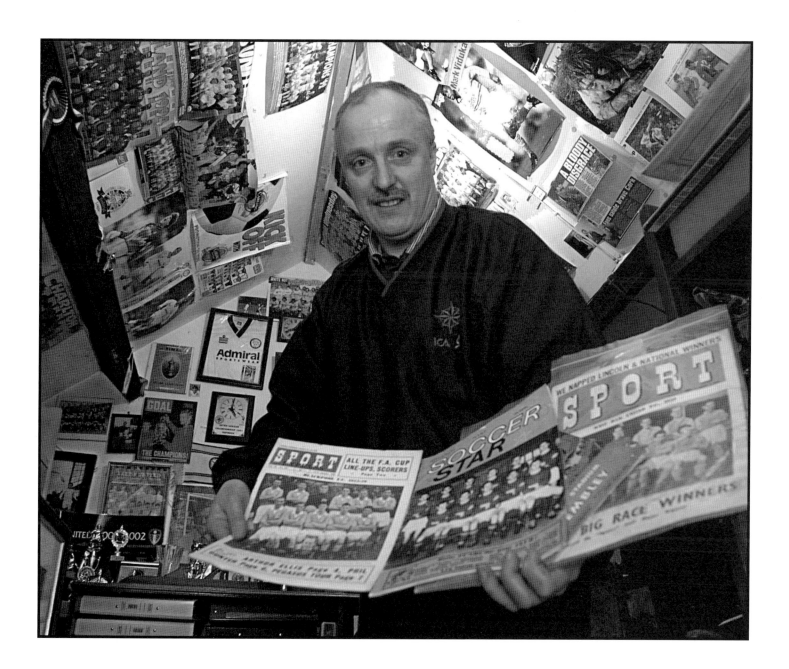

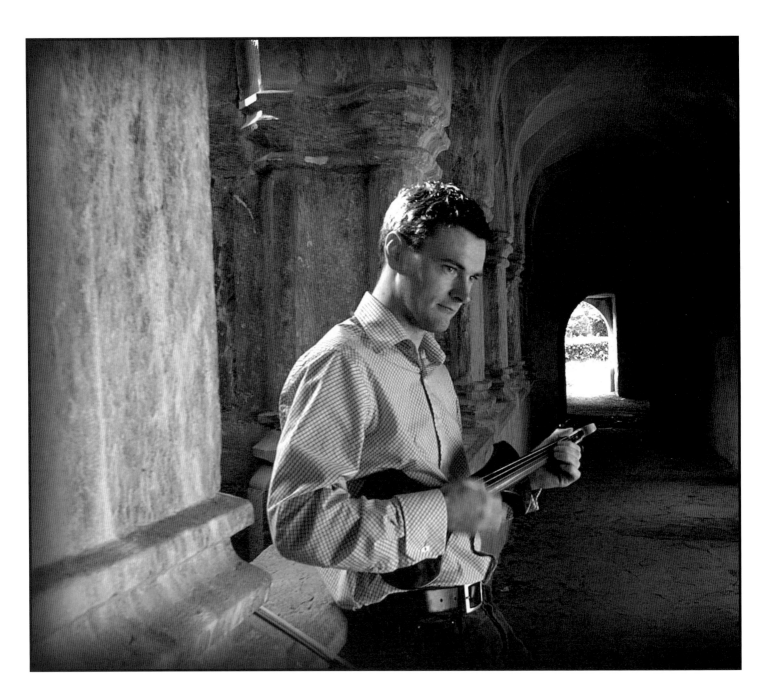

I am of
Kerry

I have so many happy memories of my childhood at home I couldn't have had a better upbringing. My father is a teacher and is principal in Kilgobnet National School. This is where I attended. My mother is a housewife, but also runs a business. She has a poultry farm and supplies shops, hotels and B&Bs with free-range eggs. One of the best aspects of my childhood was that we always kept animals. Pigs, sheep and poultry mainly. It was brilliant. There was never a dull moment and it was a great responsibility for any young person to be a part of that excitement. Family life was great we had a great relationship with our parents and with each other.

I was introduced to music at a very young age. My dad had organised music lessons in our school and we obviously had to attend. Music lessons were on every Saturday morning at 10.00 am. Our teacher was Padraig Moynihan. Each one of us started with the tinwhistle and then progressed on to our favourite instrument. Brendan played the accordian, Sean played the banjo, Patrick played the bodhrán and the maxtone drum and Maura played the concertina. I remember mom asking me one day would I like to learn the fiddle. I didn't give it much thought at the time and said 'yes'. I think the main reason she picked the fiddle was because its difficult and when I was that age I had no patience. My mother thought it might calm me down. Her theory worked I absolutely loved it. I spent my spare time practising and learning new tunes. This was the best thing to happen to me.

The word music is described in the dictionary as 'the art of organising or arranging sounds into meaningful patterns or forms including pitch, harmony and rhythm.' To me it means that but also so much more. Music has been an education. It has helped me to communicate with many races and creeds of people. It breaks down all language barriers and can lift the listener to a new state of mind.

Music plays such a part in people's daily life. It might be a companion for people, it might be a background sound in the workplace or in a car. It could be something soothing or relaxing whilst dining or could be loud and rhythmic in a bar or nightclub to help people to let go of their troubles. I think everyone takes something different from listening to music.

I often consider music as a passport to travel. Over the past few years I have travelled to many parts of the world, including the USA, Canada, the UK, France, the Czech Republic, Finland, Sweden and Sarajevo. I have performed in all of these places and each one has been a new experience. I have met with so many people on my travels and it has been amazing. Sarajevo has been the most inspirational of all. I have been there twice. The first time was just at the end of the war. The city was bombed to the ground and the people were in terror trying to pick up the pieces and get on with their lives. We were brought out to play music to show people there is hope of a new future. It was astounding. Twelve months later we were back again and the city had been practically rebuilt. People had continued living their lives to the full with the prospects of a brighter and peaceful future.

Much of my life so far has been dedicated to music. It has meant that a lot of my time is spent in public. This is wonderful, as I love meeting people. Everybody has a different story and you can learn so much by listening to people. One of the things I most enjoy is playing with my best friends who also happen to be my three brothers. We always have so much fun together. Music has given me a wonderful life so far. I am really blessed with this talent for which I am so grateful to my parents. I hope music can be a major part of my life in the future. I wish to continue learning, composing and above all performing.

Anthony O'Connor is a musician and composer and a member of Alanna, the new age traditional group. The group touches on traditional, jazz and rock influences. Anthony is the son of Pat and Mary O'Connor from Cappaganeen, Beaufort which lies beneath the McGillicuddy Reeks and Carauntoohll.

I am of

Bride Rosney

Being from Kerry gives you a certain feeling of independence. While the county is of the country, it is marked out in many ways, including location, landscape and accent, but most importantly by attitude. Kerry taps into the national grid but it has its own power supply, its own current, its own energy which fuel its attitude. The county's sheer physical beauty is one source of this energy. The stories, language, plays, poetry and music are informed by the physical landscape and Kerry has inspired outstanding literature, drama and music, from natives and visitors alike. The writer most closely associated with my native Caherciveen is Sigerson Clifford and lines from his poem 'I am Kerry' sum up my sense of the county:

> I am Kerry like my mother before me …
> Diarmuid dead inside his Iveragh cave …
> Whispering across the half-door of the mind,
> For always I am Kerry.

Bride Rosney is Director of Communications in RTÉ. She was born in Cahirciveen. Her father Diarmuid was a Cahirciveen man and her mother Eleanor (née Lucey) is from Waterville. She has one sister Mary, two brothers Paddy and Michael. Bride studied science and computer science in UCD and TCD respectively and worked in both second and third level education until appointment as Special Adviser to President Mary Robinson. After the presidency Bride travelled to work with Mrs Robinson in the UN for a further year and returned to Dublin in 1998. She worked in communications in both the private and public sectors. Bride's hobbies include 'reading, politics (with a small p), media and the arts.'

Michael Rosney

If God Almighty came down to Earth from the Heavens above
And if He looked me in the eye
And if He said to me
'Michael Rosney, for the rest of your life, you can never again leave The Kingdom of Kerry'
I would simply say to Him
'Thank you, God.'

Michael Rosney owns and personally manages The Killeen House Hotel, Killarney, with his wife Geraldine. He is a third generation hotelier. He admits to being 'born in Dublin but concieved in Kerry'. He worked with The Great Southern Hotel Group for many years and in 1992 purchased the Killeen House Hotel. They have developed their own brand of hospitality at the hotel, catering mainly for the golfing market. Michael and Geraldine have three children: Martyn, Elaine and Michelle. Michael enjoys family work and golf, 'you might as well have your priorities right in life,' he says.

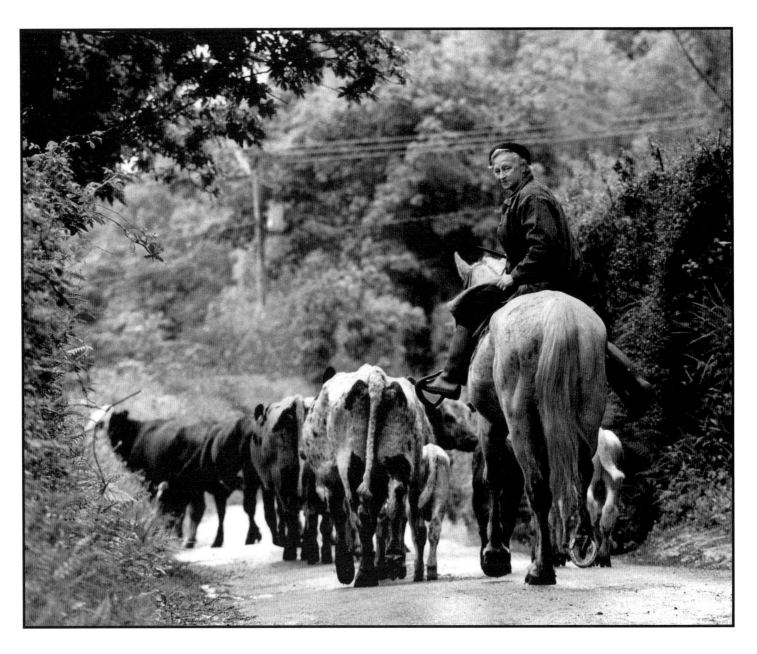

I am of

Fifteen sentinels of stone

Upon the velvet grass there stands,
Fifteen sentinels of stones,
Where dainty foxes softly pass
And winter winds moan.

The Druids and mighty chiefs of old
Their learned meetings held,
Within this stately circle of stone
On a summers night so mild.

The poem was written for Patricia's son Michael, in 1988.

Patricia Hand is a farmer and runs a riding stable with her son Michael in Dromquinna, outside Kenmare. She keeps a huge selection of animals: rabbits, ferrets, pigs, chickens, ducks, dogs, a pet fox, donkeys and peacocks. She is also an accomplished singer performing traditional Irish material, love songs and country and western. She drove a lorry for many years transporting everything from furniture, hay, and turf to hippies! She has collected over 300 individual types of mouth pieces for horses. Patricia raced in the point-to-point for thirty years. They opened the first riding stables in Kerry over fifty-four years ago and opened the first open farm in Ireland. Patricia owns Dunkerron Islands nearby, now stocked with horses.